AMERICAN NEO-CLASSIC SCULPTURE

Sculpture is born in clay, dies in plaster,
and is resurrected in marble.
—Attributed to Antonio Canova
or a member of his circle

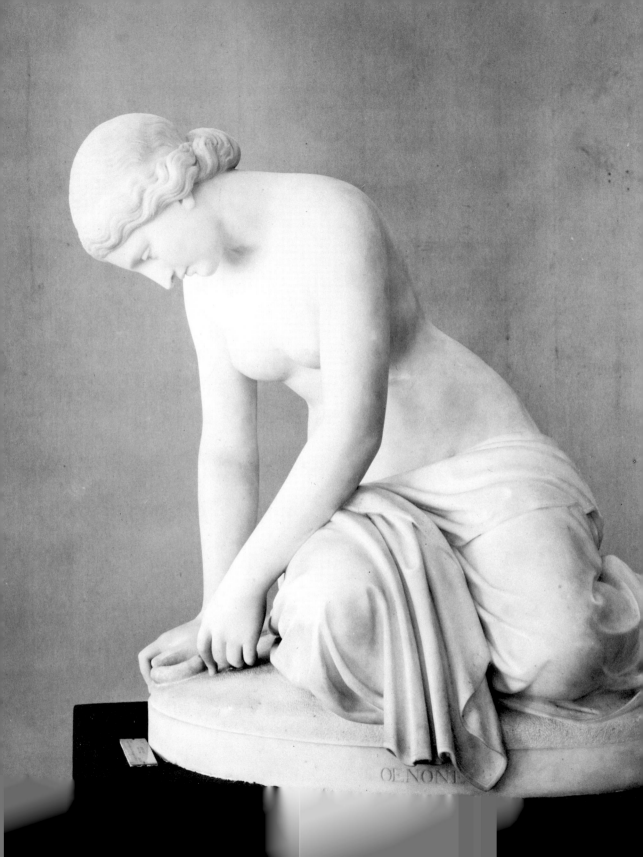

OENONE

AMERICAN NEO-CLASSIC SCULPTURE

THE MARBLE RESURRECTION

William H. Gerdts

A Studio Book · The Viking Press · New York

FRONTISPIECE: Harriet Hosmer, *Oenone*, 1857. Marble.
Gallery of Art, Washington University, St. Louis,
Missouri.

This book is dedicated to
Chandler Rathfon Post
and
Albert TenEyck Gardner

Copyright © 1973 by William H. Gerdts

First published in 1973 by The Viking Press, Inc.
625 Madison Avenue, New York, N.Y. 10022

Published simultaneously in Canada by
The Macmillan Company of Canada Limited

SBN 670-12002-2

Library of Congress catalog card number: 75-100972

Printed in U.S.A.

Designed by Christopher Holme

Table of Contents

FOREWORD

The story of American neoclassic sculpture has been told before—profusely, if primarily uncritically, during its own heyday and with perception and, at times, wit during the past thirty years. I do not mean to suggest, however, that all aspects of research necessary for a complete understanding of the subject have been accomplished. Much still remains to be done, and some problems may never be solved. Major examples of neoclassic sculpture, from a particular version of Hiram Powers' full-length *California* to Edmonia Lewis's *Freedwoman*, are still among the missing, and even basic information, such as the date of Miss Lewis's death, is not known.

There seems little point in duplicating what has already been recorded, particularly in recent books, beginning with Albert TenEyck Gardner's *Yankee Stonecutters*, still the most important volume written on the subject. My approach is not primarily chronological or biographical, but is concerned rather with criticism and individual topics. One area in particular need of greater study and emphasis is the relationship of American neoclassic sculpture to European prototypes and contemporary work. Too many studies, not only general books but also individual biographical monographs, seem to describe their subjects as though in a vacuum, dealing insufficiently with relationships between artists even among the Americans, and even less with the Europeans. How many American art historians are well acquainted with the work of Lorenzo Bartolini, Pietro Tenerani, or Giovanni Dupré, let alone Rinaldo Rinaldi (who may have carved Hawthorne's bust as Hawthorne's notebooks seem to suggest)? It is significant here that Dupré's memoirs were translated into English by the daughter of the American sculptor William Wetmore Story.

We are not nearly so well informed in this respect as the average traveler, art lover, and occasional art critic of the nineteenth century was. The Americans who went to Florence and Rome in the middle of the last century knew the works of these artists intimately. Many of these American "Grand Tourists" familiarized themselves with the European neoclassicists; they searched out the sculptors and their works with enthusiasm and sometimes even with a critical eye, although admittedly their criticism was untrained and often fulsome. What is more,

they left that criticism for posterity. Posterity may not have wanted it and may not appreciate it today, but it is there. Volume after volume of travel notes appeared, year after year, as Americans went to Europe. Most tourists had similar itineraries, although one or another might vary it with more side trips or, owing to limited time, omissions.

For the sophisticated cosmopolitan of the mid-twentieth century, these books have a certain naïve charm which quickly palls after the third, let alone thirtieth or three hundredth variation. One might admire their nineteenth-century enthusiasm and applaud the overcoming of the difficulties and hardships, from transportation to passports and visas, but wonder in a kind of horror at a public or, for that matter, a publishing world that could consume such repetition *ad nauseum*. These travelers, almost to a man and woman, commented upon the art they saw in Rome and Florence (and elsewhere) in great detail. They sought out the artists, the Americans particularly, and they described them and what they saw in their studios. Thus, for historians today, their writings are an invaluable record of what may have been visible when, and what the artists were working upon at any particular moment. They reported conversations with these artists, told of future plans, of their intentions in regard to careers or to individual works, and their opinions, which were often though not always derogatory, of colleagues and contemporaries.

This nineteenth-century criticism or commentary may sound like a foreign language to twentieth-century ears, but if we are to understand what neoclassic sculpture was all about, we must realize what it meant both to the artists and the public of its time. We may appreciate Bernini and condemn Thorwaldsen today as the nineteenth century did the opposite, but we may both be wrong, and I believe that even with the advantages of hindsight and a hundred years of art history, we should be able to appreciate one art form without having to justify it by condemning another.

It has become both habit and fashion to make fun of the ambitions and the achievements of the neoclassicists, and the fun has not always been good-natured. I can think of no field of which this has been more true, though attitudes seem to be changing today, as we note increased

8

numbers of recent museum acquisitions and exhibitions, of books, monographs, and periodical articles concerning neoclassic sculpture.

It is still true, however, that too little attention has been given to the art. In many studies of these artists, their biographies have been the focus with the sculpture itself tacked on as if to illustrate a moment in time. We are sometimes left with the impression that all the works of these artists "looked alike," as though the neoclassic canon were so rigid as to have obliterated any personal or conceptual variations.

This is not true. Perhaps to the uninterested viewer all neoclassic sculpture may appear identical, but this can also be true of particular types of Chinese porcelains, Renaissance Madonnas, and abstract expressionist canvases. And in the field of neoclassic sculpture, as in these other areas, there are enough problems to make the work of the connoisseur difficult. There is aesthetic canon, of course, to which our artists conformed, but the re-creation of the forms of antiquity was not the final object of their art. No one could ever confuse Powers' *Greek Slave* with an ancient Greek or Roman forebear, though such forebears exist.

It is often difficult to find neoclassic sculpture. It is large and heavy and preserved, in its final form, in a fairly permanent material. Nevertheless, despite the fame that so many individual pieces achieved, much of this sculpture has today disappeared. "Disappeared" may not be the correct word; to borrow a handy term from the New York Public Library, the sculptures may only have been "mislaid." In any case, even when access is possible, it is difficult. In the reaction that set in against neoclassic sculpture at the end of the nineteenth century, much of this material, which at one time had been donated to museums, historical societies, and other such institutions, was relegated to the basements where it has remained, often in crowded rows mockingly echoing the Latin cemeteries where sister works still proudly stand. Other pieces have been relegated even farther away than the institutional basement. The Pennsylvania Academy of the Fine Arts has sent away its significant and once renowned *Jerusalem* by William Wetmore Story to a rural cemetery. Story seems singularly unfortunate in this respect; the Metropolitan Museum of Art, one of the two major repositories of Story's work, has lent the artist's *Salome* to the museum in Port-au-Prince,

Haiti, where it seems likely to remain relatively inaccessible to those pursuing neoclassic sculpture.

At least these works are known, both in photograph and in location. Other major pieces seem to have simply vanished, although it is likely that some of the missing sculpture mentioned here will be flushed out by this very book. Where, for instance, are Story's *Helen* and his *Hero*, or, to go from the sublime to the ridiculous, his *Little Red Riding Hood* (and the wolf)? They were well-known sculptures in their own time, often praised by private viewers and public critics.

Thus such studies in the recent and distant past have been hampered by the loss—permanent or temporary—of the works themselves. Nevertheless, enough of this sculpture has come to light, thanks to the cooperation of hundreds of individuals from San Francisco to Sydney, to attempt a presentation of the works themselves. And this, really, is the crux and the essence of this book.

THE MARBLE RESURRECTION

When Horatio Greenough departed for Europe in April or early May 1825, he began an artistic migration that was to result in the first American school of sculpture and was to have an impact not only upon American sculpture but also upon the international art world.

The sculptors who first produced monuments in America were thought of then and are thought of today pretty strictly as craftsmen, as was in all likelihood true of the early portrait painters as well. But the anonymous limners were followed in the early eighteenth century by professional artists of training who elevated their craft into an acceptable art form, acceptable not only through their truly professional talents but also through their growing place in society and in the recognition by the members of that society.

This step was not to take place in the field of sculpture for more than a hundred years after recognition was achieved by painters. With few exceptions, readily recognizable *as* exceptions, the creators of three-dimensional art forms remained craftsmen into the nineteenth century. Their production divides easily into three major categories—tombstones, weathervanes, and ship figureheads—and these neatly divide into the three major sculptural media: stone, metal, and wood. It is true, of course, that these crafts at times related to professional sculpture—indeed, some of the major work of our neoclassic sculptors was created as memorial sculpture, and some of our earliest sculptors, such as William Rush and Hezekiah Augur, were carvers of figureheads. But in the growth of sculpture in America, the folk tradition was not nearly so integral as it was in painting, where the folk artist often represents a rural and untrained counterpart of his professional contemporary, and where his production often remained a transcription, sometimes as literal as he could make it, of the professional work he had seen and consciously tried to imitate.

Many artists have been referred to as America's first sculptors, from Shem Drowne, the early Boston weathervane maker, to Horatio Greenough, who worked a full century later. In terms of recognized professionalism, the title more deservedly belongs to Patience Wright, whose avocational pursuit of molded forms, first in bread dough and then in wax, led her to a position of artistic prominence in New York and later

11

in London, and eventually fostered a whole tradition of sculptors working in wax in America. At first these followers were members of her own family—her sister, Rachel Wells, and her daughter Elizabeth—but it eventually included visiting foreign artists, such as Giuseppe Valaperta, Johann Christian Rauschner, and, well into the nineteenth century, Robert Ball Hughes, all of whom followed a tradition of wax modeling already well established in England and on the Continent.

Patience Wright was a sculptor in that her work was three-dimensional, but her full-size works, modeled in the round, were essentially counterparts of the figures in Mme. Tussaud's waxworks, and her profile portrait miniatures were little more than raised equivalents of the miniature painting then popular, a derivation all the more apparent when the wax was tinted. Such work was a far cry from an American equivalent of the European tradition of monumental figure sculpture, as were the isolated sculptural efforts of such late eighteenth-century artists as Mrs. Wright's son, Joseph Wright, who in spite of his short life, is well known as the painter of several portraits of George Washington and who also modeled a clay bust of our first President; of Samuel McIntire of Salem whose rare figural carvings are related to carved furniture decoration; and of Simeon Skillin, Jr., whose garden figures in Salem are related to the Skillin family trade of figurehead carving.

Perhaps the title of first American sculptor most appropriately belongs to William Rush, who was certainly the first consistent and successful sculptor in America of monumental images. Rush, who worked in Philadelphia, was taught to model by Joseph Wright, and his skill in this regard is testified to by his busts in terra cotta, such as those of his daughter Elizabeth and of himself. More important were his carvings, his large figures of *Comedy* and *Tragedy* of 1808 for the Chestnut Street Theater, his *Charity* for the Masonic Hall, and his later figures of *The Schuylkill Chained* and *Freed* for the Fairmount Waterworks. While some of these sculptures definitely indicate a knowledge of European sculpture—his *Schuylkill Chained* is obviously related to antique river gods—Rush's background as a figurehead carver accounts for his skill and success in these forthright, dramatic images, which reflect also an

12

awareness of the decorative possibilities of sculpture as could be seen in imported garden pieces. Rush's achievements went far beyond figure-head carving into the realm of professional sculpture, but his influence in America went no further than the continuation of the figurehead tradition as taught to and practiced by such carvers as his son, John Rush. Meanwhile, American sculpture was to progress in quite different directions.

These directions were anticipated and accelerated by the visits to American shores of reputable foreign sculptors. The first, most famous, and most important of these came to America for an exceedingly short visit: Jean Antoine Houdon was in Virginia only at the end of 1785, coming over with Benjamin Franklin for the sole purpose of making a life mask of George Washington and returning to France by the end of the year. Yet the result of that visit, his statue of Washington for the State Capitol in Richmond (fig. 97), was not only important for American sculpture as a major modern work, admired by all who saw it, but it also served as a model for more images of Washington than any other life portrait. Houdon's impact upon American artistic life was felt in other ways as well; in the business contacts he achieved with famous Americans in France, and in the busts he did of such Americans as Franklin and John Paul Jones, whose portraits were among the most notable sculptural achievements to be seen in this country at the turn of the eighteenth century.

Houdon came first, but the many Italian sculptors who followed him stayed longer and did more work on this side of the Atlantic; moreover, they were more important for the development of the classical ideal as part of an American aesthetic. The most talented of these sculptors was Giuseppe Ceracchi, who, after working in London and Rome, made two visits to America in the early 1790s, executing busts of Washington (fig. 101), Franklin, Thomas Jefferson, and Alexander Hamilton, among others, as well as ideal allegorical figures; his portraits, too, were occasionally the bases for later representations of America's famous men, such as Trumbull's second Hamilton portrait.

Ceracchi was probably the first of the Italians to appear on the scene, as well as the best known, but he was followed by a host of others, who

wished to take advantage of the opportunity for sculptural work on the new United States Capitol. Among those who answered the call were Antonio Capellano, Giuseppe Franzoni and his brother Carlo, Francisco Iardella, Giovanni Andrei, Pietro and Georgio Cardelli, and later Enrico Causici and Luigi Persico. Some of the work of these artists consisted only of decorative carving, but such works as Capellano's original sandstone of *Fame and Peace Crowning George Washington, Justice*, attributed to Carlo Franzoni, and Causici's *Liberty and the Eagle*, which replaced the *Liberty* of Giuseppe Franzoni destroyed in 1814, illustrated the possibilities of traditional sculpture in the grand manner, not only in aesthetic terms, but also in terms of potential governmental commissions. The United States Capitol was not the only building in Washington upon which European artists worked; Causici created the important statue of Washington crowning the Washington Monument in Baltimore, and some sculptors, such as Capellano and Giuseppe Franzoni, also worked in Baltimore.

The sculptural production of these artists may well have inspired the carving of marble monuments by such early American artists as Hezekiah Augur and John Frazee. Augur was a New England wood carver from New Haven, better known today for several surviving stone sculptures. His known works include several marble busts, those of Alexander Fisher, and Chief Justice Ellsworth, in the United States Supreme Courthouse. These works are ambitious, considering the limited experience and the limited number of sculptural examples available to such an artist. Augur may have seen some works by the Italians, engravings of sculpture from the antique, and casts sent over from Europe for the American Academy of the Fine Arts and other organizations, but his sculpture reveals a sharp, blocky angularity which strongly suggests a direct translation of the wood carver's technique into stone. Augur's best-known surviving sculpture is his double-figured *Jephthah and His Daughter* (fig. 15), now at Yale, a Biblical theme of intensity and pathos which Augur interpreted in a baroque, melodramatic fashion.

More successful as a sculptor in marble was John Frazee of Rahway, New Jersey, who began his career as a stonecutter but soon progressed to carved lettering and decorative details in stone. He opened a marble

14

shop in New York City in 1818, where he created tombstone figures and mantelpieces, but none of the former, including the carving of *Grief*, a funeral monument for his deceased son, has survived. The Telfair Academy in Savannah owns two signed mantelpieces by Frazee which contain elaborate carved reliefs. Most of Frazee's surviving work today consists of portrait busts, about half of which are in the Boston Athenaeum. Frazee's earliest portrait bust was also a memorial, for John Wells, carved posthumously in 1824 from a portrait by Waldo and Jewett, for St. Paul's Chapel in New York. The Wells bust is not very subtle, but in the series at the Boston Athenaeum Frazee demonstrates an ability that ranks him as a worthy successor to the foreign artists who had introduced America to monumental carving. His works run the gamut from intense realism, as in the bust of Thomas H. Perkins, where the strength of old age is combined with detailed naturalism in the wrinkles and veins of the stern, commanding visage, to a dignified ennobling of such a sitter as Judge Story. Perkins wears classical garb, while Story is dressed in contemporary costume, with a cloak wrapped around him like a toga. The most popular of Frazee's busts seems to have been that of John Marshall, for in addition to the marble, Frazee made and sold a number of plaster casts. His own self-portrait is a slightly Byronic, idealized one and demonstrates well Frazee's stated goal of endowing his forms with classical nobility and classical realism. Frazee attempted also to gain a major commission from Congress, but his success was limited to an order for a bust of John Jay.

These attempts at professional sculpture by Rush in Philadelphia, Augur in New Haven, and Frazee in New York, as well as the fascinating series of life masks taken by John Henri Isaac Browers, or isolated works of sculpture by John Wesley Jarvis, Washington Allston, and Samuel F. B. Morse (the last two in preparation for paintings), were too isolated to produce a meaningful tradition of sculpture in America. At such a rate of development it is not surprising that the admittedly defeatist and cantankerous Colonel John Trumbull told Frazee that sculpture would have no support in this country for a century to come. Although sculpture did become a part of the American artistic idiom in the early nineteenth century, Trumbull was not totally incorrect. The

15

sculptures described above were created, if not in ignorance of contemporary European sculpture, at least apart from European development.

But in the second and third quarters of the nineteenth century a school of American sculpture and sculptors did indeed rise on a level with the work of their European colleagues. Much of the support for such sculpture came from America, and the sculptural forms did express an American ideal, but these forms were derived from non-American sources and iconography, and they were created, for the most part, on foreign soil. This was the neoclassic school of sculpture, in which two generations of American artists, many of exceptional talent equal to that of any of their European contemporaries, were involved.

These American artists first followed the lead of the Italian neoclassicist Antonio Canova, the sculptor to Napoleon and the sculptural equivalent of Jacques Louis David, and then that of Bertel Thorwaldsen, the Danish master who provided even closer inspiration and, in some cases, direct teaching for American artists. Canova was already dead when the Americans first began arriving in Florence and Rome, but Thorwaldsen was the leading European sculptor of his time, and his homelier, earth-bound interpretation of classical ideals was closer to the goals of the Americans than the more remote and more elegant work of Canova, which was often criticized by such Americans as Horatio Greenough as being too sensual, mannered, and effeminate.

American artists went to Italy for many reasons. England had been the goal for our painters in the eighteenth century, just as she had provided the greater number of artists who came to American shores, but beginning with Benjamin West, the tide began to reverse. Such artists as West and Copley voyaged, studied, lived, and worked in London, but dozens of others went there for study only, usually with West, and returned to America with their new learning. West and Copley had gone to Italy too, as did several others, but West's London studio remained the center of artistic education for many painters in the early nineteenth century. The pattern of Washington Allston, who went from London to Paris to Rome in 1804 and 1805, and John Vanderlyn, who joined him in Rome from Paris in late 1805, was to provide the model for American artists for decades to come.

16

Painters did not go to Italy to study with particular masters or in special schools of art as they had done in London. They went because they could find the monuments of a tradition of artistic excellence and progress unbroken since antiquity. They could find a congenial group of artists from all countries of the Western world with whom they could exchange ideas and share techniques. On the practical level, living was easy and inexpensive in Italy. And, for particular groups of painters, Italy had other advantages—the all-pervading luminosity of the Roman *campagna* for the scene painter, and the quaint and picturesque inhabitants of Roman streets for the genre artist.

For the American sculptor Italy offered all these advantages and more. The examples of antique sculpture, both Greek and Roman, that the artists wished to emulate were to be seen best in Italy. Italy was the source of the finest materials in which the sculptors wished to work—the pure white marble from the Carrara marble quarries outside of Lucca or from the quarries in nearby Serravezza. Also, Italy provided the workmen who did much of the actual labor of carving, men perhaps short in inventiveness but long on manual skill, and, like the living itself, inexpensive.

The actual labor that went into producing nearly all the monuments of neoclassic sculpture—both American and European—was supplied by talented "hired help." The artist himself would form a conception in plaster or clay, and this would then be enlarged to the full scale intended for the finished work. The artist would also acquire a block of marble large enough to be carved down to the size of the finished work, and this, together with the large plaster, would be turned over to the workmen. These men, with the aid of a pointing machine which acted as a three-dimensional guide in transferring proportions from plaster to marble, would do the actual carving. They might work for a time for one sculptor, at other times for another. Rates were pretty standard, but some carvers were abler than others, and American artists were known to pay better than Europeans.

This does not mean to suggest that the artists themselves were incapable of carving stone. They were extremely able, and some occasional works were carved completely by them. But it was a time-honored tradi-

tion that such work was handed over to these assistants or helpers, and in the field of stone sculpture it was not until the twentieth century that such artists as John Flanagan and William Zorach turned to "direct carving." For the neoclassic sculptor, the workmen were men of talent, the artists were men of genius, and the distinction was carefully maintained. Even here, however, the artists themselves often put the finishing touches to their work, going over the sculptures to insure not only proper carving and detailing but also proper surface treatment.

This explains, of course, how a diminutive lady sculptor could achieve a powerful life-size or over-life-size creation. It also explains how such an enormous body of work could be achieved by a single artist, for some of these sculptors produced many hundreds of works, though perhaps not so many different *conceptions*. When a wealthy collector purchased a sculpture, particularly an "ideal" piece, and brought it home to America with him, it was often admired by others who saw it in its owner's home or on exhibition, and the artist as a result frequently received orders for replicas. Replicas were made of many of the most famous neoclassic sculptures, sometimes in large numbers; twenty, forty, or even one hundred examples were not unknown. It was a simple matter for the sculptor, once he received a second order, to turn over to his talented workmen another block of marble and the large plaster to have another replica produced. Sometimes several replicas of a particular figure might be carved at the same time, by one or more workmen, and many artists were willing to accommodate the particular requirements of a client. If a full-size, full-length figure piece was too large or too costly for his patron, the artist could have a smaller, three-quarter-life-size version made. The artist might even have just a bust made from a full-length allegory, Biblical subject, or classical goddess, with the price adjusted accordingly. In this way the works of many artists were proliferated, and often a single conception was to be seen in many homes and several countries.

The patrons of the American artists were usually American, though not always so. Wealthy Americans, following in the tradition of their European, especially English counterparts, made the Grand Tour of European cities and countries as part of the final touch of their cultural

education, and visits to Florence and Rome were an important part of the tour. They visited the studios of the artists, American and European, sculptors as well as painters, and the Italian studios were usually open one day a week for this purpose. Guidebooks were issued locating and detailing the artists' studios.

The art patrons would visit the sculptural studios, and the sculptors, in turn, would offer their wares. There were usually bust portraits, some perhaps in the process of being carved and a series of plasters that had served for marble portraits in the past. Many an American patron would choose a sculptor from among the American residents in Italy and sit for his own quickly modeled bust in plaster, which would be transferred later to marble and picked up by the patron or sent back to his home after he had returned. Sometimes these commissions included not only the patron himself but also his wife and children.

Although portrait commissions could be duplicated, this was not often done. The "ideal" pieces were far more popular, and they were usually produced with the idea of replicas in mind. Unlike the portraits, the sculptor would often create his ideal figures in plaster on speculation, rather than on commission, although he might hesitate to transfer plaster to marble until a commission was assured. Occasionally, of course, an art patron might suggest a subject or an idea to the sculptor and the artist would try to accommodate his client. After an ideal work was commissioned on the basis of a plaster, it would be transferred by the workmen to marble and join its buyer back in America, usually after many months or even years had passed.

The portrait busts, particularly those of the ladies, were often idealized. They might be sentimentalized, particularly those of children, or they might be a direct imitation of Roman realism. These styles or traits were the stock in trade of the sculptors, and for many of them there were more commissions for portraits than for ideal figures.

But it was in the ideal figures that the artists poured forth their greatest creativity and in these that the neoclassic ideals were most fully expressed. Some of them were "conceits" or "fancies," playful subjects such as Harriet Hosmer's *Puck* (fig. 166), which was probably that artist's most popular work. But more often they were grave, sublime at-

19

tempts at achieving the ultimate in nobility, beauty, and pathos. They were usually female figures, as often naked or near-naked as not, a factor justified in the Victorian era by their traditional titles and subjects, although cries against their immodesty and their paganism were not unknown. One factor used successfully to justify nudity in sculpture was the situation in which the subject was placed; the figures in Powers' *Greek Slave* (fig. 1) and Palmer's *White Captive* (fig. 5), for instance, were both restrained and nude, *against their will*. But more important, the pure, virginal white marble itself provided an abstraction of form that made nudity acceptable. This accounts not only for the vastly different reception accorded the marmoreal ladies as compared to the warmly colored nudes of Vanderlyn, but also the hostility which greeted the suggestion of flesh-toned tinting of sculpture by the Englishman John Gibson.

The figures themselves, allegorical, classical, Biblical, or literary, were often indistinguishable one from the other, within the production of a single artist (often the model was the same woman), any differences, being limited to pose, hair style, and attributes. Surface treatment, too, had a generalized appearance, since the works were carved in a somewhat mechanical fashion. The use of white marble from the same quarries by all these artists also added to the similarity of the figures, although the artists of the time, such as John Gibson, knew that their antique prototypes were colored.

Although the sculptures were usually individual female figures, nearly all the artists created one or two male figures; it is significant, however, that the number of replicas of these never equaled that of their female counterparts. Indeed, William Henry Rinehart was commissioned to reproduce eight Heros but only two Leanders, though the two figures were designed as a pair. Related but separate figure sculptures such as the *Hero* and *Leander* or Harriet Hosmer's *Waking Faun* and *Sleeping Faun* were not infrequent; two-figured sculptures, however, such as Thomas Crawford's *Adam and Eve* (fig. 35) or his *Apollo and Diana* (fig. 165), were quite rare.

The concept of "dualism," by the way, is a little-studied but important one in American neoclassic sculpture. Countless statues were made

20

with pendants—religious, classical, and literary subjects, genre themes and "conceits" and even portrait figures. This involved not only an aesthetic balance of form, but a comparison or contrast of emotional and philosophic content of the two separate units of the sculpture meant to be understood and enjoyed singly, and yet losing its ultimate message unless both halves were seen and related, one to the other.

The majority of sculptures by the neoclassic artists were in the round —that is, they were free-standing sculptures that could be circumambulated, although they were usually conceived on a frontal axis. Nearly all the sculptors did an occasional relief sculpture, perhaps inspired by the fame and success of Thorwaldsen's reliefs, and several of the Americans, such as Erastus Dow Palmer and Margaret Foley, were relief specialists.

It was in the ideal pieces that the aesthetic goals of the neoclassic sculptor could be most clearly seen, for the form of his portraits was naturally conditioned, in part at least, by the subject and patron, while the artist could indulge his own concepts in the ideal works. The classical world, the world of ancient Greece, provided America with inspiration, from its democratic political goals to the classical temples that America turned into her homes, her colleges, her churches, and her government buildings. If classical forms were considered the symbol of an ideal way of life reborn, then a classical renaissance in sculptural terms is not surprising. The neoclassic sculptors reiterated the classical concept of the human body as the ultimate artistic ideal, an ideal of beauty rather than expressiveness. Indeed, in the earliest days of neoclassicism, expression and emotion were minimized as the artists aimed at a perfection of human form. Facial types and poses were often derived from antique precedents, and the modeling emphasized smooth planes and soft generalized transitions.

The products of this school have often been condemned as cold and lifeless. For the neoclassic sculptor, a nuance of expression and sentiment were enough to convey his ideas, and more than that would ruffle the serenity and composure that marked the superiority of their sculptured figures over their mortal viewers. Part of this negative response to neoclassic sculpture may be due to the way it is exhibited today, not in

the soft glow of the kerosene lamp but in the harsh glare of modern lighting. For when appropriately lighted, these sculptures can assume an evanescent beauty and a romantic aura without losing any of their serenity.

But one should be aware, too, of certain changes that took place even within the neoclassic aesthetic canon. It is customary to contrast the power and emotionalism of the work of William Rimmer, exemplified by his *Falling Gladiator*, with the glacial composure of Hiram Powers' *Greek Slave*. It should be noted, however, that the *Gladiator* was created almost two decades after the *Slave*, and that forms and goals had changed. Some of the later neoclassic sculptors, such as Rinehart and Chauncey B. Ives, remained more or less faithful to the classical ideals, but such a popular work as Randolph Rogers' *Nydia, the Blind Girl of Pompeii* (fig. 136) is, in its baroque way, as akin to Rimmer's expressiveness as it is remote from Powers' purity of form. The differing antique sources by our sculptors also reflect the changes that occurred in neoclassic sculpture.

Horatio Greenough was the first American to venture across the Atlantic in pursuit of neoclassic ideals in sculpture. Born in Boston, he began his sculptural studies there under the Frenchman, J. B. Binon, and he was encouraged early by Washington Allston, who, of all the artists in America at the time, was best equipped to inspire the young sculptor to establish a link between the present and the grand manner of the past. Allston knew some of the European artists working in Italy at the time, artists who had lived there when he was in Rome two decades earlier. Greenough went to Italy in 1825, via Gibraltar and Marseilles, bringing with him an introduction to Thorwaldsen, who was gracious and helpful to him. Though he returned home after two years, he was back in Florence in 1829, and settled there for good. He was an admirer and close follower of Lorenzo Bartolini, the leading Italian sculptor of the time, whose neoclassic ideals seem more apparent today than the new naturalism he was noted for having introduced into sculpture.

Greenough's first important commission, carved for James Fenimore Cooper, who was both friend and patron to the artist, was his *Chanting*

22

Cherubs of 1829–1831, based on infant figures by Raphael from the Madonna del Baldicchino in the Pitti Palace, as well as from life models, and now unhappily lost. Though undoubtedly as modest as its pictorial source, the work scandalized America when on tour in Boston and New York because of the nudity of the cherubs, and at one point an apron was tied around the waists of the infants so as not to shock or offend. A further criticism of the figures was that, although they were entitled as "chanting," they did not sing! We can have some idea about the sculpture today by looking at another Greenough work, variously entitled *Journey to Heaven*, or *Ascension of a Child Conducted by an Infant Angel*, of 1832. A far finer carving, however, is his *Cupid Bound* (fig. 55) of 1834 (also entitled *Love Captive* and *Love Prisoner to Wisdom*), a subject drawn from Petrarch and both more correct anatomically and less sentimental than its predecessor.

The adult equivalent to *Cupid Bound* was Greenough's *Venus* (fig. 57) of 1837–1841, a somewhat uninspired counterpart to the goddesses and graces of his European contemporaries but one of the earliest full-length nudes by an American sculptor. In general, the theme of Venus was a little too daring for the Americans, though it was certainly not so for the Europeans, and most Americans stayed away from it. Other more modest goddesses and classical figures, such as Proserpine or Ariadne, fared better, and more generalized allegories became acceptable as well. It is significant that many a classical subject was chosen, not at random, but because the legend associated with the figure had a Christian parallel and thus could embody moral ideals acceptable to the Victorians. Greenough himself created a number of religious works, such as his *Christ* (fig. 44) and *Lucifer* (fig. 43), the latter from Milton's *Paradise Lost*, and his *Angel Abdiel* (fig. 49). His earliest full-length ideal figure was *Medora* (fig. 132), a recumbent representation of the deceased heroine of Byron's poem *The Corsair*, an early example of borrowing from the romantic poets. Byron himself had been portrayed earlier by Thorwaldsen and Bartolini, and the young Randolph Rogers was to carve a bust of Byron early in his career. *The Corsair* was later to serve as the basis for an early opera by Giuseppe Verdi as well. Actually, a great deal of American neoclassic sculpture was derived from the work of the

English romantic poets, even when they had classical subjects; the significance of these writers for neoclassicism still awaits full study.

Most of Greenough's sculpture consists of figures in the round, but like nearly all of his colleagues he also carved reliefs. The best known of these is his *Castor and Pollux* (fig. 19), modeled in 1847. Like the *Cupid Bound*, it is a very stylized piece, and Lorado Taft has correctly noted a similarity to the work of Flaxman. To modern eyes the work may appear frozen and stiff, but it was, to contemporary critics, "full of fire and spirit," and in the subtlety of its low relief and careful differentiation of planes it offers a refinement not always found in Greenough's work. Low reliefs which are often seen but seldom noticed can be found on the sides of the great chair in which Greenough seated his famous *Washington* (figs. 90 and 91).

Greenough carved many portraits, including several modeled in Paris, such as one of his friend, the painter and inventor Samuel F. B. Morse, and a bust of Lafayette commissioned by Cooper, but the *Washington* (fig. 94) was his most ambitious depiction of a historical figure. Indeed, it was more ambitious than any other representation of our first President. Commissioned in 1832 and carved between 1833 and 1841, the portrait represents the climax of, though not the last testimonial to, the cult of Washington, which attracted almost all of America's painters and sculptors of the late eighteenth and early nineteenth centuries. Intended for the Rotunda of the Capitol, the portrait was also the first major governmental sculpture commission awarded an American artist. When it arrived in 1841, however, it was criticized both for the nudity of Washington's torso (indecency, again) and for its foreign and pagan source, the Olympian Zeus of Phidias. The light in the Rotunda cast a ghostly (and to some a ghastly) pall over the figure, which was removed outside to the Capitol grounds, there to be an object of curiosity to visitors and a victim of the vicissitudes of weather and birds. The sculpture was eventually brought inside again, first to the old Smithsonian Institution and recently to the new Museum of History and Technology where Washington holds forth in somewhat cramped splendor.

Greenough's other major government commission was for one of the groups on the East portico of the Capitol. Two groups were envisaged

and both commissions went originally to Luigi Persico, an Italian artist resident in Washington. Persico did carve *The Discovery* (fig. 149), but the appropriateness of giving such commissions to native American artists, now that they existed and were available, was encouraged by such politicians as John C. Calhoun, and Greenough was commissioned in 1837 to model *The Rescue* (fig. 89), a group of white settlers (and a dog) defending themselves against an attacking Indian. While the Indian himself is anatomically weak (although Greenough did study the cranial structure of Indian skulls) and there appears to be a scale discrepancy among the figures, it is a more spirited, exciting group than Persico's. The sculpture is not conceived as an allegory, and the Indian is not the noble savage of Cooper's novels or of such later sculptures as Thomas Crawford's. The artist appears to be emphasizing the superiority of the white man in both courage and moral nobility. The group was actually assembled after Greenough's death in 1852, and authorities are still not sure that its appearance for many years on the Capitol portico was as Greenough intended. Today this hardly matters since the sculpture is in storage.

Greenough made several trips to America later in his life, once in 1842 to deliver the *Washington* and again in 1851 because of the nationalistic struggles in Italy. He died the following year. As a theoretician Greenough exhibits a very different mind from the one revealed in his sculpture. His theory of functionalism in art, as expressed in his "Stonecutter's Creed":

> By beauty I mean the promise of function
> By action I mean the presence of function
> By character I mean the record of function

may well be derived from his experience as a sculptor, but his sculpture itself certainly does not seem to derive from or relate to his functional theories. Whether or not his work, if he had lived longer, might have been of a markedly different character is both hypothetical and doubtful.

Yet Greenough marked the path that the first group of professional American sculptors was to follow successfully for five decades. One of these sculptors was his younger brother, Richard Saltonstall Greenough,

who went to Italy more than a decade after Horatio. He always worked in the shadow of his more illustrious and pace-setting brother, although he lived far longer, dying in 1904, and produced well-regarded portrait busts and such ambitious religious works as his *Mary Magdalene* (fig. 40). In Italy he worked in Rome rather than in Florence, as did most of the later neoclassic sculptors, and he also, like few of his compatriots, worked in Paris.

The next important American sculptor to join the neoclassic school was Thomas Crawford. He had had an apprenticeship in New York City with John Frazee and his partner, Robert Launitz. Launitz, originally from Latvia, had studied under Bertel Thorwaldsen before coming to America, and it is possible that through Launitz Crawford actually received tutelege from this most highly acknowledged of all European sculptors of the time when he went to Italy in 1835. Crawford settled in Rome, which remained his home for the rest of his comparatively short life except for three brief trips back to America. With Greenough and Hiram Powers he was one of the triumvirate of leading sculptors in the first generation of the neoclassic school and the one who received the most government and official commissions.

Crawford's early work, of which his *Bride of Abydos* (fig. 129) of 1842 is a good example, is often marked by great beauty and simplicity. The subject, taken from a poem by Byron, is carved with great delicacy, and the stylized treatment of drapery folds, contrasting with the broad, wistful expression on the face, exhibits a lyricism often missing in his later figures and even in some of his earlier work, such as his 1839 *Orpheus and Cerberus* (fig. 9). Another relatively early but well-known figure by Crawford is *Genius of Mirth* of 1843, one of a series of playful infant figures. Crawford's attempt to express movement in his sculpture was to become more and more marked in the 1850s, and movement is particularly strong in his 1855 *Flora* (fig. 53), where the figure's wind-swept drapery and virtuoso top-heaviness furnishes a marked contrast to her expressionless visage. This baroque approach to sculpture, unlike the quiet serenity of many of Greenough's and Hiram Powers' figures, was to be adopted by other sculptors, including Randolph Rogers and Thomas Gould. Crawford has been criticized heavily for his attention to

minutiae and for his overelaborateness; this criticism could apply also to the *Flora* with her lush garlands and intricate drapery patterns in which the figure underneath is all but lost. A characteristic of much later sculpture of the neoclassic school is a tendency toward melodrama, which can be found in such an early work as Crawford's *Dying Indian Maiden* of 1848.

Although Crawford did carve an occasional religious work, such as *Adam and Eve* and the impassive, rather idealized angelic figure of *Peri at the Gates of Paradise* (fig. 47), the majority of his individual figures were either infant "conceits" or classical subjects. Several of the latter were relief sculptures, inspired perhaps by the success of his teacher, Thorwaldsen, in this medium. One of these is his *Venus as Shepherdess* (fig. 54), where the goddess of love is depicted as a rather domestic genre figure, perhaps because of the possible prudery of his American public or perhaps because of his own American background.

A number of hitherto lost works by Crawford have recently reappeared. Two versions of his statue of *Raphael* (or *Raffaello*) (fig. 107) have come to light. The name of the subject is carved on the base, along with the date, 1499, in Roman numerals. The figure suffers from a number of typical inadequacies—a rather vacant expression, weakness of form, and overworked details—but it is a testimony to the respect the sculptors of the nineteenth century felt for the great Renaissance artist. It is not insignificant that Crawford's figure leans against two lecterns, one Gothic and one Renaissance, and the sculptor thus designates Raphael as the artist who led the world from medievalism to modernism at the end of the fifteenth century.

Despite the reservations we may have today about Crawford's sculpture, Crawford in his own lifetime was hailed as one of the great geniuses of American art. He seems to have had an attractive personality and influential friends, and he was quite successful as his own press agent. To him fell a good many important commissions, one of which was for a statue of Beethoven, which he created in 1854 for the New England Conservatory of Music. This is a monumental bronze figure, cast at the most renowned foundry in Europe at the time, the Royal Foundry in Munich, because very little casting was yet done in America. An even

more ambitious bronze was his equestrian *Washington* (fig. 102), a commission he secured in a competition for which seventy designs were submitted to the state of Virginia in 1850. For this work, which was the first equestrian sculpture commissioned in America, although not the first completed (the work was finished in 1858, after Crawford's death, and the attendant figures at the base by Randolph Rogers were added later), the artist consulted portraits by Gilbert Stuart and Joseph Wright, and he was determined to avoid the criticism leveled at Greenough, by clothing Washington in contemporary dress as Houdon had done. Appropriately enough, Crawford's equestrian group stands outside the State Capitol, where the Houdon sculpture stands inside.

Three of Crawford's most ambitious works are to be found in, on, and atop the Capitol in Washington. One commission, received in 1850, was for bronze doors of the Senate, which were finished by William Henry Rinehart in 1866. They depict, in clockwise sequence, the history of the American Revolution, but their inspiration is obviously the series of panels for the second doors by Lorenzo Ghiberti on the Florentine Baptistery. This commission was finally cast at the first commercial foundry in America, in Chicopee, Massachusetts.

The most elaborate of Crawford's Capitol commissions was a pediment for the Senate wing, a group entitled *The Progress of American Civilization*, commissioned in 1853. In the center stands the allegorical figure of America, flanked by the Pioneer and the Soldier. Beside these, filling the triangular form of the pediment, are the Merchant, Teacher, and Mechanic on the left side, and the Indian Chief and his family on the right. The problems inherent in the classical pedimental form are worked out in a static but not unsuccessful manner as the figures change from standing to seated to reclining forms in the narrowing architectural space. The Indian Chief himself is better known and better seen in the replica at the New-York Historical Society. It is perhaps the most admired of Crawford's figures now, as it was in its own time by the writer Henry T. Tuckerman and the English sculptor John Gibson. The Indian symbolizes America's aboriginal past and the death of that heritage, and it is certainly one of the most anatomically successful of Crawford's figures, but nowhere does the dependence upon classical prototypes reveal itself

better than in the Apollonian visage.

This dependence is in marked contrast to Peter Stephenson's *Wounded Indian* (fig. 151), a work little known today but famous in its own time, and one that seems almost an ethnological retort to the classical nature of Crawford's sculpture. Stephenson was an unsuccessful sculptor who had begun his training in Buffalo and worked most of his life in Boston, with the exception of several years in Rome. His *Indian*, a beautiful, moving, and noble figure, was carved in Vermont marble, and it was exhibited at the Crystal Palace in 1851. Little is known of the artist's later life or other work.

The climax of Crawford's sculptural career is undoubtedly his *Armed Freedom* (fig. 144). It is probably the most famous and yet least known sculpture in America, for in spite of its tremendous height it is rather overshadowed by the pedestal—in this case the Capitol itself—since the work surmounts the dome. Captain Montgomery Meigs, the engineer of the Capitol who was responsible for so much of the painted and sculptured decoration produced in this period of the building's history, decided against the overproduced themes of Washington and America and advocated instead Freedom, Triumphant in War and Peace. The sculpture, in bronze, is of a female figure holding both olive branch and sword. She was originally supposed to wear the Phrygian liberty cap, but Jefferson Davis, then Secretary of War, objected to the use of a symbol of freedom among a people already free, and the compliant sculptor substituted instead a bunch of plumes to mark America's Indian heritage. The work was sent to this country in plaster, and it was cast in bronze in Washington, D.C., by Clark Mills in 1863, long after Crawford's death.

The greatest of America's neoclassic sculptors was Hiram Powers. He may not have been the innovator that Greenough was, nor did he receive Crawford's commissions, and later critics often preferred the ideality of William Henry Rinehart or Chauncey B. Ives, while others compared his work unfavorably to the more native realism of Erastus Dow Palmer. But Powers was the neoclassic sculptor *par excellence*: he was the first American sculptor to win international acclaim and, with his most famous work, *The Greek Slave*, he seemed to continue the succession of Canova and Thorwaldsen. (Indeed, if the ideals of neoclas-

sicism in sculpture were violated as much as adhered to, Powers at least did not stray from his appointed goals.)

Hiram Powers was born in Woodstock, Vermont, but grew up in Cincinnati, Ohio, where, as a young man, he was put in charge of the mechanical department of the Western Museum, creating wax figures for a representation of Dante's *Inferno* (perhaps a sculptural descendant of Philippe de Loutherbourg's eighteenth-century *Eidophusikon*, a melodramatic forerunner of cinema entertainment). These were favorably commented upon by Frances Trollope during her residence in Cincinnati in the late 1820s, a meeting that was to be of consequence for Powers' future career.

In 1834 Powers moved to Washington to create portraits there, and one of his subjects was Andrew Jackson, although the work was put into marble only years later. In 1837 he went to Europe, first to Paris and then to Florence, where he remained all of his life and where his studio remained more or less intact until recently.

Like all of his colleagues, Powers sculpted many portrait busts. These number among his finest works and vary in expressiveness from that of *Horatio Greenough* (fig. 109), which might be said to achieve the nobility and idealism of Periclean Greece, to the intense realism of the *Jackson*. This kind of variation in portrait style was and is acceptable enough, but the *Jackson* is unique in that it presages the art of a period when realism in all arts superseded the romantic classicism of the previous era. Also a form of "portrait" is *Loulie's Hand* (fig. 175), a sentimental fancy depicting the hand of the artist's infant daughter resting on a daisy. Grotesque as such a conceit may seem to us today, the sculpting of hands was not rare in the nineteenth century, and other American artists, from Harriet Hosmer to John Singer Sargent, were to create such works, as did their European counterparts. After all, the subjects available to the nineteenth-century sculptor were limited—the entire figure, single or in groups, the head, the hand (and even the foot!).

As with most of his contemporaries, Powers' fame rested principally upon his ideal works. There were many of these, such figures as *America* (fig. 143), *California* (fig. 141), two *Eves* (figs. 32 and 33), and several *Ginevras* (fig. 131). They were sometimes clothed, more often naked,

and their differentiation was sometimes difficult to determine; if full-length, the poses might differ, but if the representation was simply a bust, only hair style and attributes, such as diadems or leaves, could distinguish them. Facial expressions might vary slightly—some were stern and severe, others more gentle and wistful. The latter is certainly true of his *Proserpine* (fig. 81), the most popular of all his busts, which reveals a romantic softness and warmth that led to the creation of nearly one hundred and fifty replicas. But Powers' work attracted admirers and can still attract them through its simplicity and lack of overstatement. His adherence to the canons of human perfection and ideality, which marks the finest work of all neoclassic sculpture, may be tinged with early Victorian romanticism, but he always avoids both sentimentality and melodrama.

These qualities are true of nearly all his female figures, naked or clothed (and his one well-known male figure, *The Fisher Boy* [fig. 10]), but they find their highest expression in his *Greek Slave*, which his contemporaries on two continents wisely recognized as the apogee of neoclassicism. Indeed the *Slave* seems to have been the model for Powers' full-length figures and for those of many contemporaries as well, not only in pose and in nudity but also in the theme of captivity.

The *Slave* was not Powers' earliest ideal figure—*Eve before the Fall*, or *Eve Tempted*, was his first—but it was one of his first major works. In 1841 Edward Everett wrote that Powers had expressed the wish to execute a statue of a Grecian slave girl carried captive to Constantinople, her hands folded before her, and a chain around her neck with a cross. (In the final work, the chain and the cross became separated and each put in another spot.) The clay model was begun in 1842, and the finished clay was ready in March 1843. The *Slave* was one of many artistic monuments relating to the Greek War of Independence, which inspired such diverse figures as Lord Byron and Eugène Delacroix.

The sculpture depicts a young Christian girl made prisoner by the Turks and sold in the slave markets of the Ottoman Empire. She is naked and her clothes hang on a support to the left, along with a cross, symbolizing faith, and a locket, symbolizing love. She herself wears only a chain, which reaches from wrist to wrist and serves not only as a

symbol of her captivity but also as a barrier to her violation.

The antique source for this figure was probably the Venus of Knidos, of the late fourth century B.C. or, rather, a Roman copy of the same. Powers himself said that "it is not her person but her spirit that stands exposed," and while nakedness was a thorny problem for American artists, it was a problem finessed by Powers, not only through the purity of his own stated intentions, but also through the encomiums gathered up from responsible clergymen who saw the *Slave* as "clothed all over with sentiment, sheltered, protected by it from every profane eye." Nearly all contemporary criticism in America, in fact, stressed the purity of the work, in addition to speaking of its faultless beauty.

The first version of the sculpture was purchased by an Englishman, a Captain John Grant of Devonshire, who was brought to Powers' studio by Frances Trollope. After its purchase, Grant exhibited the work in London in the summer of 1845; the same version was shown again in London in 1851, this time at the Universal Exhibition in the Crystal Palace, and in 1855 it was seen in Paris. Meanwhile, the second and third of the six full-size versions toured America in the late 1840s and early 1850s. A fourth version of the *Slave*, now unlocated and perhaps destroyed, was made for Lord Ward, Earl of Derby. The fifth was executed for the Russian Prince Paul Demidoff, who lived outside of Florence and who was also a patron of Thomas Crawford. The last replica was carved considerably later for E. W. Stoughton of New York City and differs from all the rest in that the figure is bound by bar manacles rather than link chains, a substitution in the direction of more forceful realism at the expense of the more ornamental and decorative accessory.

The work was also reproduced in other forms. Powers himself had several small-size versions made, and many busts of the *Slave* were produced as well. The work was often translated into ceramic Parian ware, and even cheap souvenir reproductions were made.

Several authors and the press were also seized by the *Greek Slave* fever. Tribute poems to her abound, some by hack writers but others by fine, recognized professional poets, including Elizabeth Barrett Browning. Much criticism of the work can be found in the contemporary press,

nearly all of it laudatory and some even speaking of Powers' work as excelling the *Venus de Medici* because of the elevation and dignity of sentiment of the modern piece. Indeed, one reason for the contemporary popularity of neoclassic sculpture was its supposed superiority to classical art because it was imbued with Christian ethics and sentiment.

All of this, of course, led not only to the international recognition of the sculpture but to recognition of the sculptor as well. Furthermore, it placed the American contingent of neoclassicism firmly in line with their European colleagues. And for America, sculpture itself was no longer a *rara avis*; it was an accepted part of our artistic tradition, a form with which the growing artistically oriented public and patrons could feel comfortable. In a strange way Powers' *Slave* paved the way for the popular rustic humors of John Rogers and the Rogers groups.

The *Slave* also seems to have broken the strictures against the representation of the nude under which Powers' friend and colleague Greenough had suffered so greatly. The theme still had to be justified, but it could be done, and the *Slave* was followed by a whole rash of naked or partially naked figures, acceptable so long as they were "... so undressed, yet so refined ... ," as Henry James was to comment later on *The Greek Slave*, and endorsed by the clergy as well, if possible.

Powers went on to create many other figures, including his well-known *California*, which, with a shift of stance and different facial type, is nevertheless modeled upon the earlier, more famous work, perhaps in an attempt to achieve a similar success. Strangely enough, Powers never received any major government commissions, a fact which rankled him all his life.

With the deaths of Greenough and Crawford in the 1850s, Powers was patriarch of American sculptors in Italy, though he became increasingly isolated as more of his younger countrymen made their home in Rome rather than Florence. Comparisons were inevitable between the work of these younger artists and Powers' *Slave*, and these were usually unfavorable to Powers. From the 1860s on, a reaction set in against America's most famous white marble figure, a reaction that might champion a fresher artist and a fresher eye in the Roman colony; one that might see the superiority of the white marbles created by an Erastus Dow Palmer

who chose to remain at home in America; or eventually, one that might prefer the rising tide of realistic monuments being produced by a new generation of artists. Nevertheless, there were always perceptive critics able to see the beauty, the lyricism, and the taste of Powers' work. Even today the *Slave* seems still to reign supreme.

Greenough, Crawford, and Powers were the artists who really established America's participation in the neoclassic school of sculpture. They were followed by dozens of others, some of whom achieved significant national fame, many of whom did not. One successful artist in this group was Randolph Rogers, who grew up in Ann Arbor, Michigan. He went to Italy in 1848, studying with Lorenzo Bartolini, working first in Florence, but settling in Rome in 1851 for most of the remainder of his life. His earliest important ideal figure was *Ruth Gleaning* in the field of Boaz (fig. 30). It is a simple and moving sculpture, and in the ideality of the face and the harmony of pose and drapery it maintains a classical or neoclassical purity. This purity is lacking in Rogers' best-known later figures, such as his *Lost Pleiad* (fig. 64). This sculpture is typical of Rogers and of much later neoclassic art in general, with its rushing movement, expressed in wind-swept hair and flowing drapery, its intensity of expression, deep undercutting, and emphasis on the textural differentiation of clouds, cloth, flesh, and hair. An enumeration of the characteristics of the work might sound like a description of the sculpture of Bernini, and Rogers' work is indeed the most baroque of neoclassic sculpture. The personification of an astral being with an emphasis upon pathos and "lostness" is typical of later work of the school in which winds and stars were popular themes and in which pathos in theme and expression replaced the heroic dignity of George Washington, *The Greek Slave*, and numerous classical deities.

Ruth and the *Pleiad* were popular enough, but Rogers was and is today almost entirely identified with one work, *Nydia, the Blind Girl of Pompeii* (fig. 136). So popular was it that more than fifty replicas were supposedly carved, and one visitor recalled visiting Rogers' Roman studio and seeing seven of them being turned out at once—"a gruesome sight!" All the baroque features of the *Pleiad* are strongly evident in this figure based upon the late Hellenistic Greek sculpture, *The Old*

Market Woman. The theme is a literary one, derived from Bulwer-Lytton's very popular novel, *The Last Days of Pompeii*, and it depicts the heroine at the end of the story in which Nydia "hears" the way to Glaucus, her beloved, and to safety for her friends as Vesuvius erupts. The increased use of literary themes is another characteristic of the later neoclassic work. (It might be noted that Nydia was a popular subject in painting as well; she was represented in an early work of Emanuel Leutze, for example.)

Rogers was successful in obtaining official commissions also, including one left unfinished at Crawford's early death; Rogers created a number of figures at the base of Crawford's equestrian *Washington* in Richmond. In 1855 he received the commission for the bronze doors of the Capitol, a series of panels depicting the history of Columbus, coincidentally another favorite theme of the painter Leutze. In addition to these, Rogers created a number of Civil War memorials in later years.

Often coupled with Rogers' name is that of William Wetmore Story; both of them were leaders in the artistic-literary colony of Anglo-Americans in Rome during the second half of the nineteenth century. Story, who along with Greenough was one of the few American sculptors to come from a well-to-do family and to have had a thorough educational training, was graduated from Harvard, and he trained in and practiced law in Boston before he turned to sculpture. He had been an amateur painter and modeler, and the decisive change in his career took place when he was called upon to design a memorial to his father, Associate Justice Joseph Story, who had been the subject of an early bust by John Frazee. Story went to Italy to secure the needed additional training and decided to devote himself to sculpture and ultimately to remain in Rome. There he became an intimate of such cosmopolitan figures as the Brownings, James Russell Lowell, and Henry James, who became his biographer.

Story's most famous sculpture was *Cleopatra*, (fig. 138), of which he modeled three versions, though only one is known at the present time. (It exists in several replicas; in addition to the one in the Metropolitan Museum of Art, there is another version in Mamma Leone's Restaurant in New York City.) His *Cleopatra* was the subject of much writing by the artist's friend Nathaniel Hawthorne, who not only mentioned it in

35

his *Note-Books* but also used it as the chef-d'œuvre for his fictional artist, Kenyon, in *The Marble Faun*, where the piece is described at great length. Story was also a writer, a not unsuccessful novelist and a poet; probably his most famous poem is also a "Cleopatra," a more impassioned representation than the sculpture.

Albert TenEyck Gardner has noted the morbidity of Story's chosen themes, such as *Cleopatra, Medea* (fig. 124), and *Salome* (fig. 37), all figures of violent passions, but this choice is strangely at odds with the representations themselves. Hawthorne wrote of the *Cleopatra* that she was "fierce, voluptuous, passionate, tender, wicked, terrible, and full of poisonous and rapturous enchantment, and again, a terribly dangerous woman; quiet enough for the moment, but very likely to spring upon you like a tigress," and perhaps this is what Story was seeking—a representation of restraint and of potential passion. It should not be surprising, then, that Story voiced a preference for Michelangelo over Raphael.

Nevertheless, Story's intentions often seem dissipated in the heaviness of his figures and in the accumulations of archaeological details of costumes and accessories. Story had a fondness for seated figures, unlike most of his contemporaries, but seated figures became more common with time, and indeed, Story's *Cleopatra* seems to have been the inspiration for other seated works, much as Powers' *Slave* had been for standing ones. Some of Story's later conceptions and such figures by other artists as Franklin Simmons' *Jochebed* seem related to the *Cleopatra*. The theme of Cleopatra was tremendously popular among the later neoclassicists, from the modest and demure figure by Margaret Foley to the sensual versions by James Haseltine and Thomas Ridgeway Gould and the grotesquely realistic *Cleopatra* in her death throes by Edmonia Lewis (the last known today only through nineteenth-century descriptions).

Story's fame was greatly increased when his *Cleopatra*, along with his almost equally well-known *Libyan Sibyl*, another seated figure, were exhibited in the International Exposition in London in 1862. The favor they found may have been due partially to the fact that it was Pope Pius IX himself who paid for the shipping of the works there, to be shown in the Roman section of the exposition. The success of the *Cleopatra* and its

subsequent identification with Story to the exclusion of all his other work, except perhaps the *Sibyl*, has been detrimental to an evaluation of his sculptural achievement; he appears to have been one of the most individual major figures in the movement.

On the other hand, probably the best of this second generation was William Henry Rinehart of Baltimore. Rinehart has been admired almost continually since the beginnings of his own achievement. He has attracted a number of perceptive biographers, and even critics of neoclassicism have generally if grudgingly acknowledged his quality, a commendation also seconded by Chandler Rathfon Post in his *History of European and American Sculpture*. Furthermore, as the only major sculptor of Baltimore origin in the nineteenth century, he has enlisted a good deal of local pride and admiration, reinforced by his generous donation of his estate to the Maryland Institute, where he had studied as a youth, to finance scholarships to send young American sculptors abroad.

Much of Rinehart's sculpture still remains in Baltimore, some in the collections of the various institutions there, and it is possible to study his development in some detail. His early work, done before he went abroad, is typical youthful production, although his relief of *The Smokers*, after a painting by David Teniers, of 1851 is particularly surprising for its low-life subject and Flemish baroque source. The neoclassicists rarely translated painting into sculpture in any case, but it was one thing for Greenough to pick a Raphael Madonna and another for Rinehart to choose a "vulgar" Teniers!

Although most of Rinehart's sculpture consists of figures in the round, he did a number of reliefs early in his career, both portraits and ideal pieces. One beautiful pendant pair are his *Morning* (fig. 68) and *Evening* (fig. 69) of 1856, the artist's first works after arriving in Italy in 1855. These immediately call for comparison with Thorwaldsen's famous *Day* and *Night*, which must have supplied the general inspiration for Rinehart's choice, as they did also for other similar neoclassic representations. Other comparisons may also be made between Rinehart's work and Thorwaldsen's, yet it is surprising that their spirit is *not* that of the early years of the nineteenth century, but rather a graceful, elegant

sensuousness which seems closer to the rococo and the work of such artists as Etienne Maurice Falconet. Even the oval shapes of the reliefs, as opposed to the circular ones of Thorwaldsen, are more rococo. These sculptures are evidence of the strange undercurrent of rococo feeling that can be found in mid-nineteenth-century art, including American art. This tendency is easily recognizable and acceptable in the decorative arts, but so far unstudied in painting and sculpture.

Another pair of sculptures created by Rinehart early in his career abroad were his *Hero* and *Leander* (fig. 11). The subject, although never a popular one in classical times for monumental sculpture, was eagerly taken up in the nineteenth century by painters and sculptors alike—undoubtedly due to the fame of Lord Byron's successful attempt in 1810 to duplicate Leander's feat of swimming the Hellespont. Such artists as Turner and William Etty used their brushes to depict the tragic story of the priestess of Aphrodite whose nocturnal lover drowned when her guiding lantern was extinguished by the winds, and numerous other neoclassic sculptors essayed the subject, including William Wetmore Story in a relief now unlocated.

What is interesting is that Rinehart conceived of the two figures as independent monuments, though obviously related in scale (all known replicas are the smaller, half life-size) and in compositional direction. In other words, patrons could acquire them singly or together, each having independent beauty and appeal. This conception is relatively rare in American sculpture, and while it may seem to suggest some comparison with the first American ideal group—Augur's *Jephthah and His Daughter* (fig. 15), which are also both separate figures—the latter group would not make conceptual or formal sense one without the other. Rinehart's group does work, although, as I pointed out earlier, the figures were often sold separately. In recent years the Newark Museum has acquired a replica of each figure, reuniting at last the star-crossed lovers.

The figure of *Leander* is probably the most beautiful male nude in all of American neoclassicism. It also reflects the growing eclecticism in artistic sources chosen by these sculptors, for the figure, the head, and some of the pose finds its source directly in Michelangelo's *David*. *Hero* is a quiet, simple, and more compact figure, and exceedingly classical,

38

too, although Lorado Taft has perceptively noted her similarity to the popular *Ariadne on the Panther* by the German neoclassicist Johann Heinrich von Dannecker. Indeed, the absence of melodrama, the solidity and simplicity of the sculptural mass, and the preservation of classical purity, or of the ideals of neoclassical purity, are what makes Rinehart's work stand out. Sometimes his neoclassicism becomes rather tepid with too much archaeological elaborateness, as in his rather rigid and lifeless figure of *Antigone*, 1867, but this occurs seldom in his work, usually in later pieces, and even this figure has a dignity and majesty that is noteworthy. Also, the theme of Antigone pouring libations over the body of her brother Polynices perhaps warrants a more stately interpretation than Story's becalmed human tigresses.

Seldom did Rinehart emphasize violent movement in his sculpture; his *Atalanta* is almost the exception to prove the rule, and in general there was little tendency toward the baroque in his work. What suggestion of motion or action is indicated in his sculpture is usually slow, thoughtful, and stately. On the other hand, his sculpture seldom tends toward the sentimental, although his most popular work, the *Sleeping Children* (fig. 74) of 1869, is certainly sentimental, and the twenty or more replicas of it bear witness to its appeal. Rinehart was very popular and very able in the handling of the child form, and this is true not only of his ideal works but also of his portraits of children. In this respect he may have drawn inspiration from the work of Thomas Crawford, who seems to have created more sculptures of children than any other American neoclassicist; indeed, the *Sleeping Children* is very similar to Crawford's *Babes in the Woods* (fig. 76) in spirit and composition, though both actually derive from the much-admired Robinson memorial group of 1817 by the Englishman Sir Francis Chantrey in Lichfield Cathedral.

Rinehart's finest female nude is not *Hero* but *Clytie* (fig. 7), the first version of which was finished in 1869. Indeed, it is generally considered the finest single figure of his generation of neoclassic sculptors. This representation of the nymph enamored of Apollo is conceived with a mastery of form and a quiet serenity characteristic of Rinehart, who was not at all concerned with virtuoso treatment, rushing movement, or fussy details. *Clytie* suggests an ideality not unlike Powers' *Slave*, although

the two are more than twenty-five years apart, and the facial type is, if anything, more classically inspired than Powers' work.

But even here that twenty-five-year-old difference tells. *Clytie* is still part and parcel of the neoclassic movement, and Rinehart is worlds away from the already current realist reaction of Henry Kirke Brown and the young John Quincy Adams Ward, or from the genre pieces of John Rogers and the intense expressionism of William Rimmer's art. Still, at least in his concern with accurate anatomical definition and the specific musculature of the torso, Rinehart shows that he was not unaware of the growing realism that affected even neoclassicism in diverse ways.

Rinehart's last major ideal group was his *Latona and Her Children* (fig. 51) of 1871, a depiction of the goddess of darkness beloved by Zeus, and her children, the infants Apollo and Diana. Only one replica of this sculpture was finished before the artist's death. It is an intimate group of three figures, with an emphasis upon sentiment, but it is not sentimental or saccharine, relieved of these qualities by both its formal complexities and the dignity of the figure of Latona, all goddess and all mother.

Rinehart received only a few public commissions. His first was the commission to complete the bronze doors for the House of Representatives, a commission which Thomas Crawford had received just before his death. The single commission from the General Assembly of his native state of Maryland was for a statue of Chief Justice Roger Brooke Taney, which was modeled in 1871, cast in Munich in 1872, and now stands outside the State House in Annapolis. It is a dignified, intensely realistic monument, very much a part of the realist tradition of historical monuments, and a far cry from neoclassic inspiration.

First Greenough, Powers, and Crawford, then Rogers, Story, and Rinehart: these were the two triumvirates of American sculptors working in Italy during the dominant years of neoclassicism, but there were many other successful artists in the school. Although my emphasis has been on the ideal work of these six artists, all of them did many portrait commissions; several of the other sculptors, however, were specialists in portraiture.

40

One of them was Shobal Vail Clevenger from Cincinnati, who was encouraged by the local art patron, Nicholas Longworth, who had also assisted Powers; it was Longworth who lent Clevenger the money to go to Europe to study in 1840. But illness and death at the age of thirty-one ended a promising career that had resulted in a number of fine, incisive portrait busts, better than most perhaps because of Clevenger's study of anatomy at Ohio Medical College.

Joel Tanner Hart of Kentucky was, in turn, influenced in pursuing a sculpture career by Clevenger, whom he met while Clevenger was making a portrait of Henry Clay. Hart went on to devote the major years of his life to producing statues and busts of Henry Clay (fig. 85), with which subject he is almost solely associated today, despite other portraits and an ambitious ideal group of *Woman Triumphant* (fig. 8), on which he worked for thirty years and which was destroyed in a fire in the Lexington, Kentucky, courthouse. Hiram Powers called Hart "the best bust-maker in the world at this time." Launt Thompson was another sculptor better known for his able production of portraits.

Among the other notable sculptors of the movement should be mentioned Chauncey Bradley Ives of Connecticut, who is supposed to have worked with Augur in New Haven; he created portrait busts in Boston before going to Italy, partially for reasons of health, in 1844. He worked first in Florence but finally settled in Rome. Many of his sculptures are fancies of childhood, but he also created a few Biblical subjects, such as *Ruth* and *Rebecca at the Well* (fig. 31), and many classical subjects, of which his bust of *Ariadne*, his *Undine* (fig. 73), and especially his full-length *Pandora* (fig. 6) were the most popular. At his best, Ives preserved a classical purity in his ideal works almost equal to that of Rinehart, a purity that remained with him throughout his career, as evinced in his late *Egeria*. He, too, created a good many historical monuments, particularly for his native state of Connecticut, where his *Roger Sherman* and his *Jonathan Trumbull* (fig. 103) are housed in niches in the Old State House in Hartford; several other Ives statues represent Connecticut in Statuary Hall in the United States Capitol. Trinity College in Hartford has on its grounds a statue of Bishop Brownell, and the city of Newark, New Jersey, founded by settlers from Connecticut, has

in Lincoln Park a rare three-figured group of the *Willing Captive*. The theme is taken from Bancroft's *History* and depicts the story of a white bride of an Indian, who had been taken by the tribe when only a little girl, and who later refused the freedom to return to her mother's arms, preferring to remain with her aboriginal mate. The Indian subject matter, the contrast between red man and white man, and the pathetic drama of individual lives are typical of the later neoclassic school.

Joseph Mozier was a businessman who gave up commerce for art in 1845 when he went to Italy, first to Florence and then, like Ives, to Rome. He was successful enough in his own time that he did not have to occupy himself with portrait busts, but rather with ideal figures and groups. These include the standard subjects of Biblical and classical inspiration; it is noteworthy how often the same themes were essayed over and over again by different artists of the movement. Mozier, too, sculptured such figures as *Jephthah's Daughter, Peri* (fig. 46), *Rebecca at the Well*, and *Undine* (fig. 70), all of which we have noted before. In addition, his art mirrored the growing literary inspiration in sculpture, and he produced a well-known, rather stylized *Pocahontas* (fig. 156), mentioned by Hawthorne in his *Italian Note-Book*, while Mozier's most famous work was *The Wept of Wish-ton-Wish* (fig. 134), taken from a novel by James Fenimore Cooper.

These sculptors were all expatriates, and a certain sentimental, romantic glow attached itself to the lives of several of them who showed great promise, only to die abroad at an early age, cut off in their prime in a foreign land with their careers unfulfilled. One of these was Edward Sheffield Bartholomew of Connecticut, who died in Naples at the age of thirty-six. There is a delicacy and frailty in some of his works, such as *Eve* (fig. 34), *Sappho*, and *Shepherd Boy* (fig. 59), as well as in his simple but affecting relief sculpture. He was fortunate in his patrons— who included Daniel Wadsworth of Hartford and George Read and Enoch Pratt of Baltimore. The major part of his known work today is in the collection of the Wadsworth Atheneum in Hartford. Connecticut claims him as a native son, and it is not surprising, therefore, that Lydia Sigourney, the "Sweet Singer of Hartford," whom Bartholomew had admired and portrayed in marble, wrote an affecting and

treacly poem commemorating him after his death.

Another artist who died at thirty-six was Alexander Galt, the leading Virginia sculptor and the one Civil War casualty among the neoclassicists. He went to Florence in 1846 and was one of the relatively few sculptors to remain there with Powers after the middle of the century instead of moving to Rome. Like that of Ives and Rinehart, his work preserves a classical purity in its form as well as in its traditional iconography of bacchantes and Psyches, and allegories such as *Hope* and *The Spirit of the South* (fig. 142). He created relatively few full-length sculptures, notable among these being his *Aurora* (fig. 65). This was a subject also essayed by the Englishman John Gibson, and is one of a number of celestial subjects in the work of the neoclassicists. In his short life Galt also created many portraits, including those of such Confederate leaders as Jefferson Davis, which he modeled in plaster in 1862. One historical work was his bust of *Christopher Columbus* (fig. 147). Due to the inspiration of the writings of Washington Irving, Columbus was a favorite theme of American painters and sculptors beginning with Emanuel Leutze's many depictions from the 1840s on, and including Randolph Rogers' Capitol doors.

Galt's most famous commission, on which he worked much of his short life, was a full-length sculpture of one of his native state's favorite sons, Thomas Jefferson, a gift of the legislature to the University of Virginia. Galt traveled to Charlottesville to consult the Gilbert Stuart portrait of Jefferson as preparation for making a sculptured likeness. After returning to Florence to work on the figure, Galt came back to Virginia in the hope of being present at the installation, but the Civil War intervened and Galt offered his services to the Confederacy. He contracted smallpox on a trip to an encampment late in 1862 and died shortly thereafter.

Benjamin Paul Akers of Maine was a third sculptor who died at the age of thirty-six, though on a return trip to America. He spent less time in Italy than many of the other artists did, arriving first at the end of 1852 apparently to study with Hiram Powers. He was an erudite man and wrote some perceptive articles on American art and artists of the time. He is particularly remembered for one work, *The Dead Pearl Diver*

(fig. 75), one of a series of recumbent figures of dead or sleeping youths, soft and graceful like Rinehart's *Endymion* (fig. 12). The intricacy of the carving of the fishnet over the diver's loins, with its textural and spatial complexity, has a suggestion of the virtuoso treatment so favored in the eighteenth century in Naples, where it can be seen today in the chapel of Sansevero, in the works of Antonio Corradini, Giuseppe Sammartino, and Francesco Queirolo. This virtuosity was revived around 1850 by some Europeans, particularly Italian nineteenth-century carvers such as Raffaelle Monti and Giuseppe Croff. In general, this predilection for amazing and incredible technical effects in marble had little interest for the American artists, though Akers exhibits it here, and Mozier's *Undine* also demonstrates an amazingly deceptive "see-through" drapery covering. Horatio Greenough carved an *Héloïse* swathed in a veil, and Randolph Rogers created a similar memorial veiled figure—"flying"—in relief. Franklin Simmons, who went to Rome as late as 1867, was one of the last of the neoclassic sculptors who continued to work in the traditions of that school long after their ideals had been superseded by new forms and purposes. Like Akers, Simmons came from Maine, and on his death he bequeathed his entire estate to the Portland Art Association.

All the artists so far considered produced their major work in Italy, in the congenial atmosphere provided them by their—spiritually, at least—adopted land. Neoclassicism was also pursued in America, though with certain attendant difficulties, as illustrated by the careers of a number of more independent-minded artists, notably that of Erastus Dow Palmer of Albany. Palmer's career and success were often used in his own time to demonstrate that Europe was not necessary for the re-creation of antique ideals, an important factor in a country that was striving in many cultural areas to cast off the yoke of foreign dependency and to foster a purely "American" art.

Palmer came from upper New York State and settled permanently in Albany in 1846. He went to Europe late in his career, in 1873–1874, and then only for a short time. His best-known figure is his *White Captive* (fig. 5) of 1859, an obvious "home-grown" reply to Powers' earlier *Greek Slave*. His first major ideal figure was his *Indian Girl*, or *The*

Dawn of Christianity (fig. 154), an obvious implication of the superiority of the white man and his religious heritage. *The White Captive* was captive of the Indians, demonstrating again the fascination shown by neoclassic sculptors with typically native American subject matter in spite of their devotion to classical themes and forms.

In addition to these figures in the round, Palmer produced a series of fine relief sculptures, a heritage from his early experience as a cameo cutter. With Margaret Foley, who was also a carver of cameos, he may be considered something of a specialist in this area. His *Morning* (fig. 66) and *Evening* (fig. 67) are obviously inspired by Thorwaldsen's famous pair of reliefs, *Day* and *Night*. Palmer's best-known relief is his *Peace in Bondage* (fig. 18), carved in 1863, which is very much reflective of the holocaust of the Civil War. Indeed, of all the ideal monuments produced by the neoclassic sculptors at the time, this is the one that most fully reflects the current national tragedy. He did not win any government commissions, although he did try, early in his career, to get a commission for a pediment for the Capitol.

Like Powers, Palmer was able to win the quick approval of the clergy for his spiritually sound, if nakedly daring, sculptures. This approval may have been aided by the religious or at least moralistic overtones of so many of his sculptures, and it is perhaps not surprising that a group of clergymen even arranged for an exhibition of Palmer's work in New York City in 1856. This show took place at the hall of the Church to the Divine Unity on Broadway, and brought such attention to the upstate artist that it may have assisted in bringing him enough patronage to make a trip to Europe unnecessary.

Palmer's career at home was used by critics of the time to prove the lack of necessity for European training and expatriation. The fact remains, though, that while in form, in theme, and in general inspiration Palmer's work can be likened to that of Powers and the rest, it is, at the same time, different in several ways. These differences were noted not only by Palmer's supporters, who used them as proof of the superiority of his work, but also by both the apologists and detractors of neoclassicism in general. *The White Captive* may stand in a pose like her sister *Slave*, but she is a suppler, "fleshier" figure. Her face is *not* that of a

Greek goddess, but is individually and freshly observed, though the artist himself wrote an interesting article on "The Ideal in Art." Distinct sensual overtones can be found in both Palmer's three-dimensional figures and the relief sculptures. This may be only a difference in degree rather than in kind from the work of his colleagues in Italy, but even so, the degree is marked and significant, underrating the relative freedom possible for the artist who remained at home and also the growing realism in American—and European—art in the 1850s and later.

It is not surprising that these men, of both high and low stations, should associate themselves with the grand tradition of sculpture and consider themselves heirs not only to Canova and Thorwaldsen but also to Michelangelo and the sculptors of antiquity. It is perhaps astonishing, however, that a large number of women, the group referred to by Henry James as "The White Marmorean Flock," should join their male counterparts and establish careers and reputations alongside them in the field of sculpture. Women were not new to the arts; indeed, women artists are reported as far back as classical Greece and ancient Egypt. From the Renaissance on, a number of women essayed what was traditionally a masculine profession, though these were often women attached to the households of male artists, and only a few of them, such as Rosalba Carriera and Elisabeth Vigée-Lebrun, achieved a reputation equal to that of their male counterparts. In America women did figure early in the arts, and one of the first professional painters—Henrietta Johnston of Charleston, South Carolina—and the first professional sculptor—the wax modeler Patience Wright—were women. The number of distaff artists grew in the early nineteenth century when women entered in numbers into the fields of still-life and miniature painting, but the ladies who assembled in Rome in the middle of the nineteenth century constituted something of a movement. In any case, never before had so many women from one country achieved such relative prominence at one time in the sculptural field. On the other hand, given the techniques and procedures of neoclassic sculpture, it is not so surprising. The artist did not have to battle away with a piece of marble twice her size, but, like the men, modeled her ideas and left it to the talented "hired help" to do the actual carving which she might supervise and finally touch up.

46

These women congregated about the figure of Charlotte Cushman, a well-known actress and lecturer of her day, who lived much of her life in Rome and whose home was something of a salon for the lady sculptors of America. Indeed, one of them, Emma Stebbins, who studied under Paul Akers in Rome and is best known for her *Angel of the Waters* fountain (fig. 27) in New York's Central Park, was Miss Cushman's biographer as well as portrait sculptor.

The most famous of the ladies was Harriet Hosmer. She grew up in St. Louis, where she studied anatomy in the medical department of Washington University and where a number of her finest and best-known statues may be found today. In Rome she was as well known for her unconventional behavior, her tomboy attitude, her fearlessness and forthrightness, as she was for her art, but she did produce a number of impressive and beautiful monuments. Her teacher in Rome, where she went in 1852 with Charlotte Cushman, was John Gibson, the leading English sculptor there, famous for his "tinted Venuses." Her head of *Hesper* (fig. 63) was one of her earliest sculptures; in 1855 she completed her first full-size work under Gibson's tutelage, a representation of *Oenone* (see frontispiece), inspired by Tennyson's poem of that name and depicting the shepherd wife from Mount Ida that Paris deserted for Helen. It is a simple piece, quite restrained and moving, with a classic grace a little like Rogers' early *Ruth*.

Perhaps her most beautiful sculpture is *Beatrice Cenci* (fig. 140), the late sixteenth-century Roman maiden who was executed for murdering her cruel father and who became a symbol of beautiful grief for artists, from Guido Reni in the seventeenth century to those of the nineteenth century. It is a moving, expressive figure, and one of the most successful reclining sculptures of the neoclassic movement. It was exhibited in London at the Royal Academy in 1857. Its source, readily available to Miss Hosmer, was Stefano Maderno's *St. Cecilia* in St. Cecilia in Trastavere. This, too, is a recumbent figure wrapped in draperies, but Miss Hosmer has varied her figure by exposing the pathetic face and contrasting the softness of her body with the hardness of her pallet. It is a symbol of private grief, private passion. Lorado Taft criticized the sculpture for its "annoying" accessories. It is true that the ring in the

stone slab, the beads and crucifix, and the patterned slipper are quite pronounced, but they do not obtrude into the graceful over-all composition.

Archaeological emphasis dominates Harriet Hosmer's largest, most renowned sculpture, *Zenobia, the Queen of Palmyra* (fig. 139), which was modeled in 1859. The artist made thorough studies for the costume of her queen, but the statue seems today a lifeless re-creation of a classical Athena. In fact, Nathaniel Hawthorne perceptively noted a relationship between *Zenobia* and a cast of the *Minerva Medica* in Miss Hosmer's studio. Hawthorne found the *Zenobia* full of dignity, and so it is, but the suggestions of music and uproar and the quality of beauty that he discerned must have been lost on the way from clay to marble. The subject itself, a strong-willed queen defying the Romans, was a near-Eastern equivalent of the popular Cleopatra, and it is not surprising that such subjects appealed to these artistic feminists who were determined to make their way in a man's world as the royal ladies of the past whom they portrayed had done.

Many titled visitors came to Harriet Hosmer's studio and patronized her work. The Queen of Naples posed for a statue by her, and the Prince of Wales was one of more than thirty patrons who purchased her *Puck* (fig. 166). This was the most popular of her sculptures and one of the most popular neoclassic works by any artist; indeed, one example traveled as far as Australia and is in the gallery in Sydney today. It is a rather high-spirited "fancy" or "conceit," playful, if absurd, like its mate *Will-o'-the-Wisp* (fig. 167), also popular though not to the extent of the *Puck*. Harriet Hosmer was apparently more successful with her more tender subjects than with the ambitious figures such as *Zenobia*.

Miss Hosmer was the best-known but hardly the only popular female artist in Rome. The most exotic was certainly Edmonia Lewis, who was half Negro and half American Indian. She had begun modeling in Boston, and then went to Rome, where she specialized in subjects related directly or indirectly to her racial heritage. Several of her sculptures were Indian subject matter taken from Longfellow's *Hiawatha* (fig. 161), and she also carved a sculpture of *The Old Indian Arrow Maker and His Daughter* (fig. 159), perhaps relating to her own background.

Of the works known today, the more impressive are those reflecting her Negro background and the struggle for freedom, such as her *Forever Free* (fig. 158) and her *Hagar*, which is a depiction of the Biblical heroine driven into the wilderness and thus a symbol of the alienated position of the Negro.

Margaret Foley was a sculptor from Vermont who was best known for cameos and portrait reliefs, of which she seems to have made something of a specialty. In addition, she modeled a number of sculptures in the round, one of which, her *Young Trumpeter* (fig. 26), returned to Vermont. She was one of a whole host of sculptors to depict Cleopatra, though hers is by far the most sedate of them. Margaret Foley's health was extremely delicate, and she died in Europe, in the mountains of Austria, where she had gone to recuperate.

The last of the women of this movement was Anne Whitney, who lived a prodigious life and did not die until after the start of World War I. She early attended William Rimmer's anatomy lectures and then went to Rome, and elsewhere in Europe, but much of her work was done in Boston, where she was a symbol of emancipated womanhood. Like Franklin Simmons, she continued the ideals of neoclassicism long after they had been discarded and superseded on both sides of the Atlantic.

The grand finale of the neoclassic school was offered to the public in the Centennial Exposition in Philadelphia in 1876. Major works by many of the artists here mentioned, both recent sculptures and older ones, were exhibited in the exposition. But along with them were countless examples of industrial manufacture; even in 1876 the spotless white marbles, produced by an older generation of artists working on foreign soil, must have looked strangely and sadly outmoded to the young American visitors keen on admiring the examples of America's technological progress. Indeed, while that exposition represented the largest collection of neoclassic American sculpture ever brought together, it also represented the swan song of that school of art.

In another way, however, that swan song was begun ten years or more earlier. The effects of the Civil War upon American painting and sculpture have not yet received the study due it, the attention that has been paid to other areas of American cultural, social, and economic life.

Nevertheless, we are aware that the effect of the war upon our art and artists was devastating.

Principally, it laid waste the illusion that America represented a new divine birthright. The vision of the American Eden was destroyed, and nowhere did this have a greater effect than upon the neoclassic sculptors. It is true that most of them were geographically shielded from the war's effects, and it is, therefore, not surprising that Palmer, the one major neoclassic sculptor working in America, should produce the first significant sculptural monument relating to the Civil War. But even in Italy, where the trumpets of *verismo* were in any case sounding, from the naturalism introduced by Bartolini and continued by Giovanni Dupré, Vincenzo Vela, and others, to the realism spilling over the border from France, the artists could not remain unaware of what was going on around them. Their public and their patrons were Americans, but not the same Americans of the pre-Civil War days, and they did not share and enjoy the same youthful ideals. The neoclassic sculptor was as alien to post-Civil War American society, which had cast off the Jeffersonian idealism out of which neoclassicism grew, as he was to the foreign land where he had chosen to live and work.

The American neoclassic sculptor had not created a new aesthetic world, for when Greenough, Powers, and the rest went to Europe, they found already active and dominant the aesthetics of neoclassicism, a heritage of the eighteenth century. Their models and their mentors awaited them. They entered into this world with confidence, assurance, and talent, and created their own niches within it. They rose to the fore among their contemporaries. The challenges that existed they accepted; they sought their place in the sun without consideration of any limitations from a provincial background. In the fine arts the neoclassic sculptors were the most direct link between the prewar Eden, a land of unspoiled freshness, and the golden age of the past, as reinterpreted in neoclassic ideals.

Whatever restrictions we bring to neoclassic sculpture with our twentieth-century vision and our ideas about "progress" in art, it is true that these artists were among the first Americans to cast off the heavy mantle of provincialism. A few had done it before—such artists as West and

Copley, who effectively became English painters in their approach to historical painting. Gilbert Stuart had brought back to America a polished and cosmopolitan portrait style, and other American artists of the nineteenth century, such as Thomas Cole and Thomas Sully, created something fine in their provincial adaptation of romantic ideals. But the neoclassic American sculptors were every bit as good and as sophisticated as their European contemporaries. Powers' *Greek Slave* was more of an international sensation than any work of Lorenzo Bartolini; Rinehart's *Clytie* stands easy comparison with any of Gibson's *Venuses*.

These sculptors knew their goals and their ideals. They knew, too, their techniques and procedures, strange and uninspired though they may seem to us now. They knew the art of the past and the present, and they knew how to draw freely upon it. Their sources were not only antique but also increasingly Renaissance, baroque, and rococo. In some ways they should perhaps not be called neoclassic at all, though much of the basic inspiration of form and materials depended upon the classical world. While they turned more and more from generalized to personalized expression, that expression was still conceived in terms of nobility, high tragedy, and deep sentiment, at least in their more serious, non-capricious ideal works.

The work of these artists may seem remote to us today and far removed from, let us say, the art of Rodin and other "impressionist" sculptors whose styles were so completely to overshadow their "moribund classicism." But "moribund" art has a way of coming back to life, of finding new interest and new champions. Excluding the strictly incompetent, there is no bad art; there are only limited and prejudiced viewers. The neoclassic sculptors were not working with a remote and alien ideal; rather, their classical gods and goddesses, their romantic allegories and literary heroines, and their sentimental figures were real to them, for they were part of that eclecticism that was the Victorian Age.

The Greek Slave

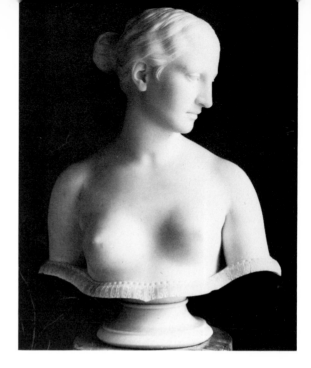

1. Hiram Powers, *The Greek Slave* (full-length), 1869 (original clay finished in 1843). The Brooklyn Museum, Brooklyn, New York.
2. Hiram Powers, *The Greek Slave* (bust). The J. Paul Getty Museum, Malibu, California.
3. Hiram Powers, *The Greek Slave* (bust). The Dayton Art Institute, Dayton, Ohio.
4. Hiram Powers, *The Greek Slave* (full-length), 1851. Yale University Art Gallery, New Haven, Connecticut. Olive L. Dann Fund.

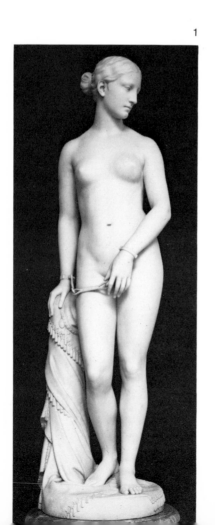

1

By far the most famous sculpture produced by an American in the nineteenth century was Hiram Powers' *Greek Slave*. Although the six full-size, full-length versions and the three half-size, full-length examples hardly equal the number of *Nydias* that Rogers produced, and although the nearly seventy busts of the *Slave* that were made constitute only half the number of Powers' *Proserpines, The Greek Slave* was seen by more people than any other sculpture. Several examples of the work were sent on tour throughout the country, and it was shown in the Crystal Palace exhibition in London in 1851. It was written about in newspapers, magazines, diaries, and travel books, and reproduced in photographs, in marble, in Parian ware, and in cheap ceramic. If imitation is the sincerest form of flattery, the number of captive maidens, by other sculptors, such as Palmer's *White Captive,* is eloquent if mute testimonial to the success of the *Slave*.

The sculpture depicts a young Christian girl taken prisoner by the Turks and about to be sold in the slave market of Constantinople. A cross, symbolic of her faith, and a locket, indicative of her longing for home and family, hang conspicuously with her piled-up clothes. She looks away, mournfully but disdainfully, from her captives, and the chains connecting her wrists act not only as a symbol of her cap-

52

merous busts are also known today (figs. 2 and 3), including several with the marks of the pointing process clearly indicated in the unfinished work.

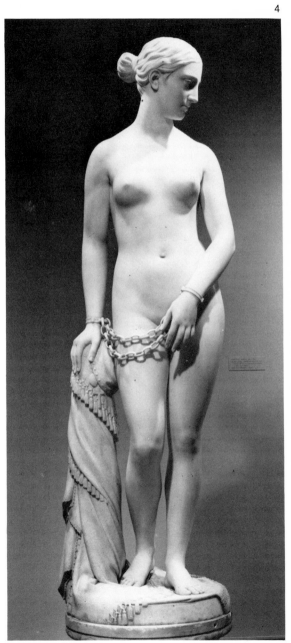

4

tivity but also as a barrier to her violation. Her nudity was acceptable to Victorian America, because of her helpless state, the purity of her white marble medium, her sleek, abstracted form, and the influential commendations of such ministers as the Reverend Orville Dewey, who found the work "clothed all over with sentiment, sheltered, protected by it from every profane eye."

The work had strong appeal to nineteenth-century America because of her sympathy for Greece in the War for Independence and in her identification with Greek democracy as well as the Greek struggle for liberty. Furthermore, the sculpture was made during a period of the antislavery controversy; although the figure is a white rather than a black captive, the sculpture has been called "American art's first antislavery document in marble."

The first replica of the *Slave* is in Raby Castle, England. The second, third, and fifth are, respectively, in the Corcoran Gallery in Washington, the Newark Museum, and Yale University Art Gallery (fig. 4); the fourth has disappeared. The sixth, in the Brooklyn Museum (fig. 1), was made significantly later and differs from the others in that the link chains have been replaced with bar manacles, which, Powers felt, imparted greater strength and realism than the ornamental links. Nu-

The Female Nude

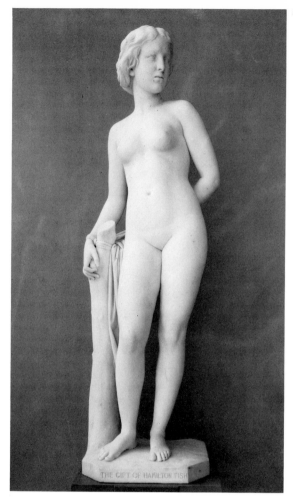

5

5. Erastus Dow Palmer, *The White Captive*, 1859. Marble. The Metropolitan Museum of Art, New York City. Gift of the Hon. Hamilton Fish, 1894.
6. Chauncey B. Ives, *Pandora*, 1864. Marble. The New Hampshire Historical Society, Concord, New Hampshire.
7. William Henry Rinehart, *Clytie*. 1872. Marble. The Metropolitan Museum of Art, New York City. Gift of Mr. and Mrs. William H. Herriman, 1911.
8. Joel Tanner Hart, *The Triumph of Chastity*, or *Woman Triumphant*, 1865–1877. Marble. Destroyed by fire in the courthouse in Lexington, Kentucky.

The full-length depiction of the female nude represented the highest ideal for our sculptors. It was the subject in which they sought the greatest expression and for which they strove for critical acclaim. The nude was a treacherous and daring subject for Victorian America, and our sculptors could well recall the condemnations leveled at John Vanderlyn when he exhibited his beautiful painting of *Ariadne*.

Fortunately, Hiram Powers, in his second full-length female nude, *The Greek Slave*, was able to open the way for the depiction of this theme by combining a neoclassic abstract ideal with a virtuous theme and by winning clerical support for its spiritual innocence. Although some Americans still disapproved, the nude became an accepted form, provided there was a thematic excuse for the nudity (if not an actual repugnance on the part of the subject for her shameful state) and provided that Christian or otherwise moral ideals could somehow be expressed. And of course marble had an advantage over painting in that flesh tones were not approximated and the whiteness could be made to express virgin purity.

Powers' *Greek Slave*, in addition to setting an important precedent, became the established aesthetic ideal against which subject nudes were measured. Palmer's *White Cap-*

tive (fig. 5), even more nude in a sense, was felt to exceed Powers' work because both the subject (a captive of the Indians) and the Albany-based artist were more truly American. Some critics preferred Ives's masterpiece *Pandora* (fig. 6), which was fuller and more classical than Powers' *Slave*; Pandora was an acceptable theme since she was equated with Eve, who had also unleashed sin upon the world.

Probably the finest nude by a second-generation neoclassicist was Rinehart's most beautiful *Clytie* (fig. 7), who holds the sunflower, a symbol of her unending love for Apollo. Although Clytie's face is certainly classical, her body nevertheless reveals the anatomical accuracy common to the later sculptors.

Nudity could even be used as a symbol of female virtuousness, as exemplified by the now destroyed *The Triumph of Chastity* by Joel Tanner Hart (fig. 8). Also known as *Woman Triumphant*, this ideal work depicts a nude woman holding the arrow of love beyond the reach of Cupid. The figure is quite similar to Powers' *Slave*, which is not surprising since the two were close friends and colleagues in Florence.

The Male Nude

9. Thomas Crawford, *Orpheus and Cerberus*, 1839–1843. Marble. The Boston Athenaeum, on loan to the Museum of Fine Arts, Boston, Massachusetts.
10. Hiram Powers, *The Fisher Boy*, 1848. Marble. The Metropolitan Museum of Art, New York City. Bequest of the Hon. Hamilton Fish, 1894.
11. William Henry Rinehart, *Leander*, 1859. Marble. Private collection, Piermont, New York.
12. William Henry Rinehart, *Endymion*, 1874. Marble. The Corcoran Gallery of Art, Washington, D.C.

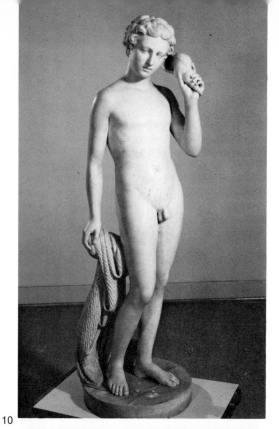

10

9

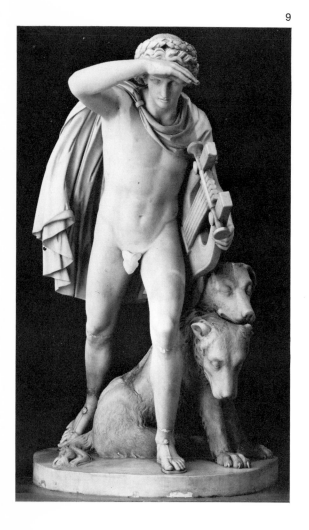

11

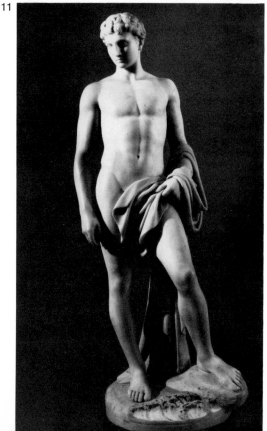

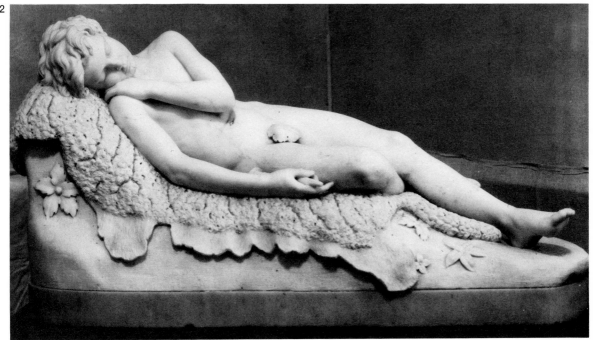

The male nude was also depicted by our sculptors, but far less often than the female, partly because of general preference for the female theme and partly because of the traditional belief that the female form embodied the ultimate ideal of beauty. Also, the neoclassic sculptors undoubtedly knew that the two American nudes that had met with severe disapproval had both depicted males—the pair of infants of Horatio Greenough's *Chanting Cherubs* and his half-nude *George Washington*.

When the male nude was represented, the genitals were seldom revealed; they were usually hidden by drapery or a leaf. Thomas Crawford used the latter in his *Orpheus and Cerberus* (fig. 9), a work that achieved real success for the artist and was probably the first full-length mature male nude by an American sculptor. The plaster was completed late in 1839, and thanks to the support of the artist's major patron, Charles Sumner, who obtained pledges in Boston for the money to defray the cost of carving and shipping the marble, Crawford was able to complete the work for an exhibition held in the spring of 1844 at the Boston Athenaeum—the first one-man sculpture show held in this country.

Hiram Powers' only male nude was *The Fisher Boy* (fig. 10). Although the figure is shown completely nude like Crawford's *Orpheus*, it is a representation of a young boy, rather slight and unformed, like most American male nude subjects. Powers considered this work a "modern" allegory, but at the same time it was called an "Apollino" and certainly shares with *The Greek Slave* a tendency toward classically abstracted form.

Another, similarly youthful figure is William Henry Rinehart's *Endymion* (fig. 12), the shepherd who was loved by Diana and who chose immortality through perpetual sleep, a theme implicit in the immortal beauty of the sculptor's work. A replica in bronze was placed in 1881 on the sculptor's grave in Green Mount Cemetery, Baltimore.

Rinehart's finest male figure, and perhaps the finest by any of our neoclassicists, is his taut and muscular *Leander* (fig. 11), a figure that owes some debt to Michelangelo's *David*. Leander was a popular subject in the nineteenth century, not only because of Lord Byron's poem but also because of Byron's highly publicized duplication of Leander's feat of swimming the Hellespont.

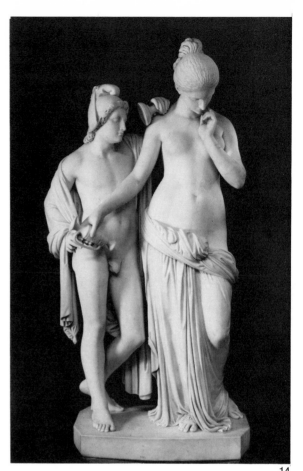

14

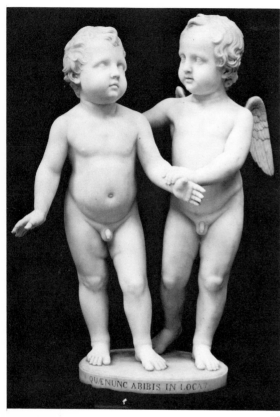

13

13. Horatio Greenough, *Angel and Child*, 1832–1833.
Marble. Museum of Fine Arts, Boston, Massachusetts.
Gift of Lawrence Curtis.
14. Thomas Crawford, *Hebe and Ganymede*, 1842.
Marble. Museum of Fine Arts, Boston, Massachusetts.
Gift of Charles C. Perkins.
15. Hezekiah Augur, *Jephthah and His Daughter*,
1828–1831/1832. Marble. Yale University Art Gallery,
New Haven, Connecticut. Gift of the citizens of New
Haven, 1837.
16. Joseph Mozier, *The Prodigal Son*, Marble. The
Pennsylvania Academy of the Fine Arts, Philadel-
phia, Pennsylvania.

Although most ideal sculptures consisted ei-
ther of busts or single full-length figures, the
artists occasionally created more complex
groups. These groups were easy enough to
represent in relief, but sculpture in the round
presented greater problems.

There were a number of ways to solve these
problems, and our sculptors investigated sev-
eral of them. The neoclassic aesthetic estab-
lished by Canova and Thorwaldsen demanded
that the figures be approached frontally. Al-
though the sides and backs of the figures
would be carefully defined, the sculptures
were not intended to be viewed from all sides,
and thus the intricacies of multiple composi-
tional forms within a single work of sculpture
could usually be avoided. Hezekiah Augur, in
his *Jephthah and His Daughter* (fig. 15),
demonstrated one solution for the double-
figured group by conceiving of his two figures

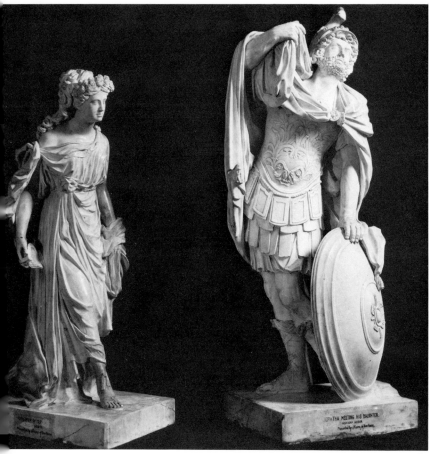
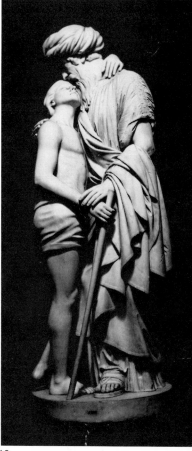

15 16

as separate entities. They were meant to be seen together but to exist separately, as two single blocks, which can be appreciated independent of each other.

Mozier's *Prodigal Son* (fig. 16), the artist's most praised work, on the other hand, unites the aged father and the errant youth into a single columnar block. Space hardly exists between the two figures, and the artist appears almost to be treating a single form, while making careful distinctions between youth and old age, naked and clothed form.

The most common solution was to present the two figures intertwined, as one finds in Thomas Crawford's *Hebe and Ganymede* (fig. 14). Here solid form contrasts with open space, but the sculpture is still intended to be seen only from the front. Not only in the general aesthetic, but also in this specific subject and its treatment, Crawford reveals himself

as one of the most traditional and European of our sculptors. Canova and Thorwaldsen had both interpreted the theme of Cupid and Psyche in much the same way.

This frontal treatment of two intertwined figures was probably employed also in the earliest such American work done in Italy, Horatio Greenough's now lost *Chanting Cherubs*, which is believed to have inspired his *Angel and Child* of a few years later (fig. 13). Contemporary critics made much of the contrast between the strong-willed angelic babe and the soft, questioning mortal child, but this seems hardly noticeable to us today.

Very few American group sculptures included more than two figures; Greenough's *Rescue* group for the Capitol is the most famous of these (fig. 89); another is Ives's *Willing Captive,* installed in bronze in Lincoln Park, Newark, New Jersey.

59

Relief Sculpture

The two basic sculptural forms are sculpture in the round and relief sculpture. In the work of the American neoclassicists relief sculpture was usually reserved for ideal subject matter rather than for portraiture, although a few relief portraits are known by such artists as Powers and Margaret Foley. Powers

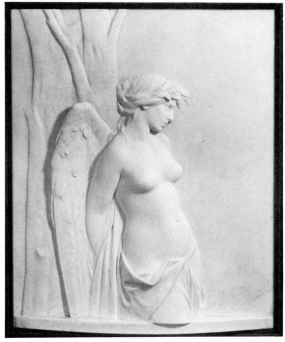

18

17

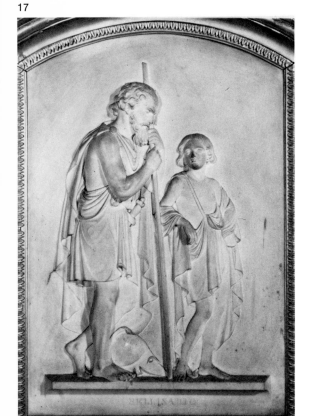

actually did very few of these (and few reliefs generally), but some of our artists seem to have been particularly drawn to this form of sculpture. It is difficult to generalize, however, since in some cases, particularly those of Thomas Crawford and William Wetmore Story, many of the reliefs are missing, though much sculpture in the round still exists.

The impetus for relief sculpture may be in part due to the example set by Bertel Thorwaldsen, the Danish master who was still active in Rome when our first sculptors settled in Italy. Although Thorwaldsen was equally proficient in both aspects of marble sculpture, he was particularly famous for his reliefs, such as the great *Alexander Procession* of 1811, designed for the Quirinale Palace, and finally carved for the Villa Carlotta in Northern Italy, which some critics likened to the Parthenon frieze. The Parthenon frieze was certainly the inspiration for Horatio Greenough's best-known bas-relief, *Castor and Pollux* (fig. 19), which depicts the Dioscuri, the sons of Jupiter and Leda. Reliefs were often used as subsidiary decorations on monumental sculpture, such as those on the chair of Greenough's *Washington*, and those

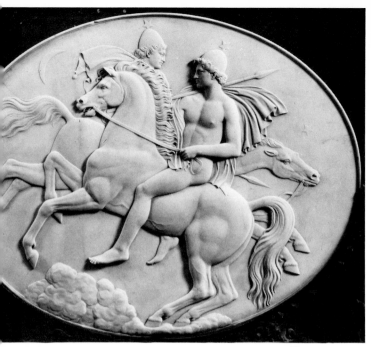

19

20

decorating the base of Story's statue, *John Marshall* (fig. 84).

The artist best known for and most adept at relief sculpture was Erastus Dow Palmer, the leading American neoclassicist to remain at home. His proficiency is undoubtedly due to his early training as a cameo carver. Many of his reliefs reflect his preference for religious or spiritual subject matter. His famous *Peace in Bondage* (fig. 18) was carved in 1863 and is probably the most effective representation of the Civil War in neoclassic sculpture.

Of the sculptors who worked in Italy, Miss Foley and the short-lived Edward Sheffield Bartholomew seem to have been particularly adept at relief. Bartholomew's early training as a painter may explain the great variety in relief depth in his work, and the resulting illusionism, as shown in *William George Read in the Character of "Belisarius"* (fig. 17).

Randolph Rogers' *Flight of the Spirit* (fig. 20) is a rare example of see-through illusionism in relief, a popular sculptural approach in Italy in the mid-century. A replica of this relief marks Rogers' own resting place in the Campo Verano in Rome.

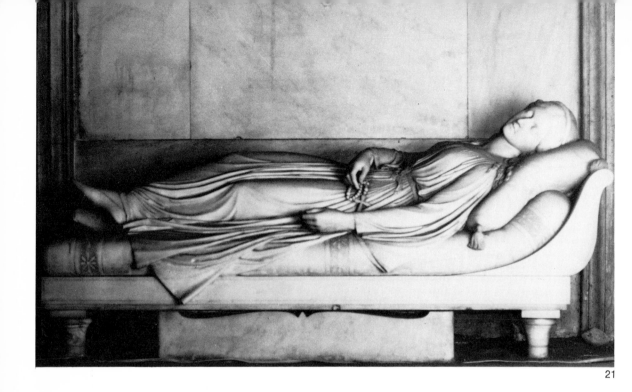

Funeral Monuments

Throughout the history of sculpture, funeral monuments have offered the artist some of his most important and lucrative commissions. Not only have such memorials often commemorated well-known individuals, but they have also usually been erected in public or semipublic places, where the skills of the artists have thereby been on public display.

In Italy, where most of our neoclassic sculptors worked, the most important repositories of funerary art have included, in addition to the outdoor cemeteries, the church of S. Croce in Florence and St. Peter's in Rome. In the latter the sequence of monuments to successive popes truly constitutes a history of sculptural styles from the Renaissance onward, including major monuments by the leading nineteenth-century neoclassicists, Canova, Thorwaldsen, and Tenerani.

Unfortunately, not only Italian nationalistic proclivities but also the usually anti-Catholic and anti-Papist spirit of the American artistic émigrés precluded their participation

in this rewarding area of sculptural endeavor. There are, however, in the English cemetery in Florence and in the Protestant Cemetery in Rome major monuments by such sculptors as Richard Greenough, Franklin Simmons, Launt Thompson, and William Wetmore Story. And, back home in America, a number of sculptors received important commissions for cemetery sculptures—particularly Franklin Simmons, William Henry Rinehart, and Erastus Dow Palmer. We have illustrated one such relief by Randolph Rogers (fig. 20). However, with the exception of the Paca tomb of 1863 in S. Maria in Campitella by the German sculptor Ferdinand Pettrich, who had spent some time in America, the only American sculptor to receive a commission for a funeral monument in a Roman church was Harriet Hosmer, who carved in 1857–1858 the tomb of Mlle. Falconnet in S. Andrea della Fratte (figs. 21–23). In one of the artist's most beautiful sculptures she depicts the young deceased woman in the sleep of death,

emphasizing her simple Christian humility. She eschews the abundant allegory so often involved in neoclassic tomb sculpture, so that the Falconnet monument bears some similarity to one of the major Italian sculptures of the previous generation, the tomb of the Princess Zamoyska in S. Croce by Lorenzo Bartolini. This commission for the monument to a sixteen-year-old English girl is one indication of Miss Hosmer's appeal to the English, and may have resulted from her having studied with John Gibson, the leading English neoclassic sculptor in Rome.

21–23. All three illustrations: Harriet Hosmer, *Monument to Mlle. Falconnet*, 1857–1858. Marble. S. Andrea della Fratte, Rome.

22

23

Fountain Sculpture

One form of complex monumental sculpture that attracted a number of American artists was that of fountains. Rinehart, for instance, created a drinking fountain for the Old Post Office in Washington, a bronze sculpture now in the Capitol, depicting a contemplative Indian upon a rock. Far grander was the fountain sent by Hiram Powers to his patrons, the Prestons of Columbia, South Carolina, a token of his gratitude and appreciation for their assistance. One of Pierce Connelly's major works was also a fountain.

In general, however, fountain sculpture was a specialty of the American women sculptors. The reasons for this are not known, although the specialization may stem in part from the inspiration and example of one woman. Harriet Hosmer, our leading woman sculptor, created more fountains than any other artist. Her first was the *Fountain of Hylas*, which had a dolphin spout, and the figure of Hylas on a pyramid, with nymphs reaching up toward him; this fountain remained in the courtyard of her studio. She created a *Siren Fountain* for her close English friend, Lady Marion Alford, part of which still exists today (fig. 25). And she modeled a fountain described as a *Triton and Mermaid*, now destroyed, for another Englishwoman, her patron, Lady Ashburton.

Perhaps influenced by Miss Hosmer, other female sculptors essayed the genre. Margaret Foley's most ambitious work was the fountain that was exhibited at the Philadelphia Centennial Exposition of 1876. Her hopes for its success, however, were dashed when it was

24

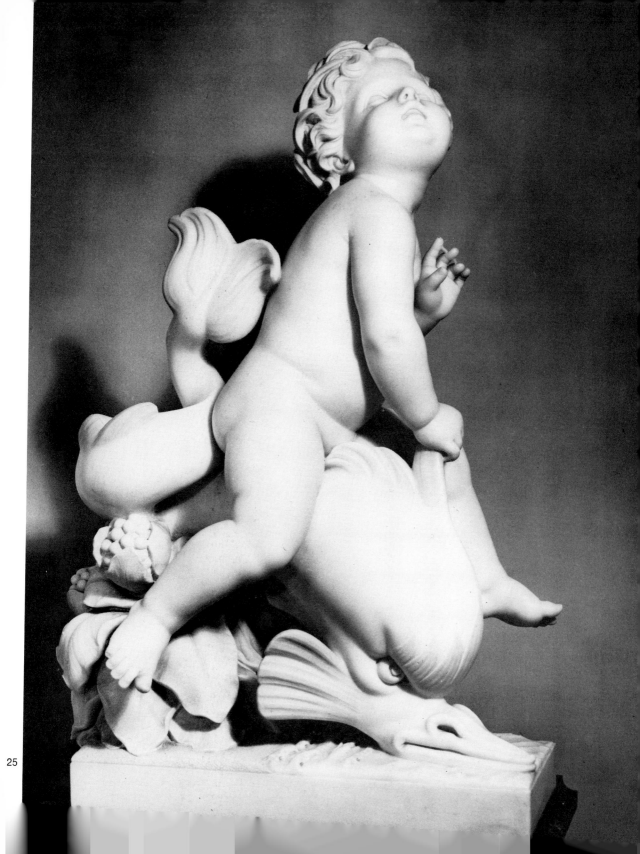

26. Margaret Foley, *Young Trumpeter*, 1874. Marble. Bixby Memorial Library, Vergennes, Vermont.
27. Emma Stebbins, *Angel of the Waters*, by 1871. Bronze. Central Park, New York City.

26

THE YOUNG TRUMPETER

shown in Horticultural Hall rather than in the Art Exhibition. The work depicted three children at the base: a boy, a girl, and a trumpeter on a conch shell; the last figure still exists (fig. 26).

Anne Whitney, too, created a fountain of children playing among calla lilies, begun in 1887 and finished in 1891; it was exhibited in the Columbia Exposition in Chicago in 1893. A bronze replica was presented by the artist to the city of Boston, and another was presented to the city of Newton, Massachusetts, and erected in West Newton in 1903. Vinnie Ream Hoxie designed a fountain of *America* for the state of Missouri, with four figures indicating the four directions. This work, supposedly in a St. Louis park, has not been located, but a single figure of *The West* (fig. 24) may relate to this conception.

Undoubtedly the most famous of all the fountains is Emma Stebbins' great bronze *Angel of the Waters* in Central Park, New York, at the Bethesda Pool (fig. 27). At the base are bulrushes, with figures of Health, Temperance, Purity, and Peace, while the Angel atop is just alighting, scattering heavenly blessings of health and invigoration. James Jackson Jarves wrote that the subject was the Angel stirring the waters of Siloam, the latter a pool southwest of Jerusalem. There may be some confusion here between Siloam and Bethesda, also a pool in Jerusalem. According to St. John, there came to Bethesda:

> ...an angel went down at a certain season into the pool, and troubled the water: whosoever then first after the troubling of the water stepped in was made whole of whatsoever disease he had.

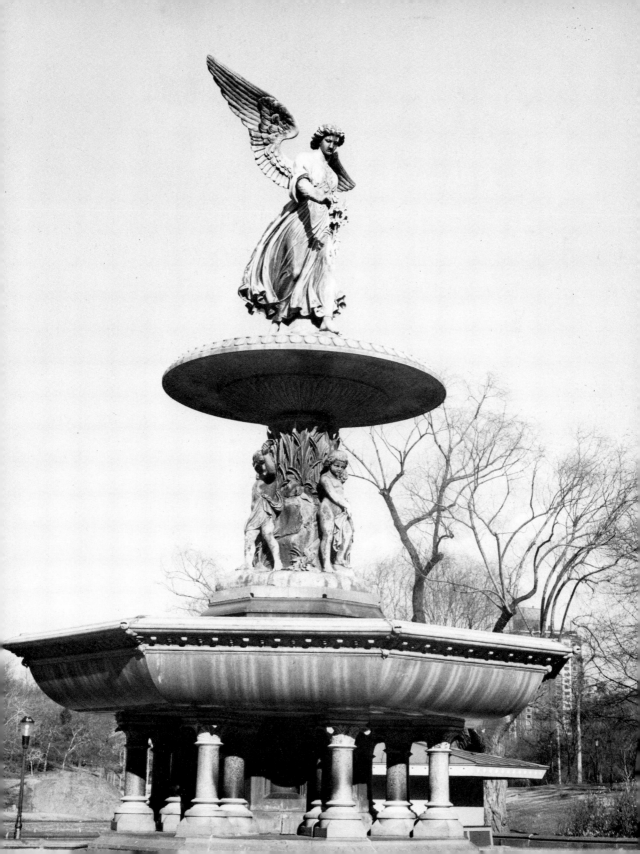

The Old Testament

28

29

Biblical themes were certainly as popular with our sculptors as classical subjects, but within this category the Old Testament seems to have figured much more prominently than the New. Undoubtedly this is due partially to American suspicions that New Testament subjects and Christian themes in general smacked of popery and Roman Catholic idolatry, despite the admiration of so many American artists for Thorwaldsen's *Christ and His Disciples*. The Old Testament was safer and also offered many more subjects comparable to popular themes in classical mythology.

A few of the Old Testament prophets were depicted, such as Akers' *Isaiah*, Margaret Foley's *Jeremiah*, and Emma Stebbins' *Samuel*. William Wetmore Story in both his Biblical and classical depictions chose themes of grand passion, such as his *Saul, Delilah, Judith*, and *Miriam*, as well as his tragic *Jerusalem on Her Desolation*. But in general tender and pathetic themes predominated. One of Franklin Simmons' best-known works was his *Jochebed, the Mother of Moses*, which emphasizes the ever-popular maternal theme. Young and attractive Biblical heroes and particularly heroines predominated, however. Brown, Mozier, Palmer, and Ives all carved *Rebecca at the Well*; indeed, this representa-

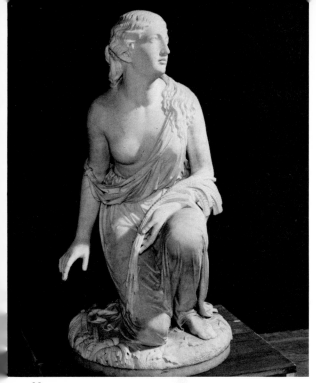

30

carved reliefs of the subject, Ives did a very popular bust of Ruth, and Richard Greenough interpreted her in an early work, but the best-known full-length depictions were a standing figure by Henry Kirke Brown (fig. 28) and a crouching one by Randolph Rogers (fig. 30). Brown's derives from a poem by Keats, who describes Ruth as standing; Rogers, whose first major success this was, may have chosen the alternate pose in conscious contrast to Brown's figure.

31

tion of the cousin of Isaac, chosen for him as a bride, was Ives's most popular and most often reproduced work (fig. 31). Isaac himself was the subject of several works by Randolph Rogers; the crouching figure illustrated here (fig. 29) shows the young man awaiting the sacrifice by his father, Abraham. Fortunately, the Lord sent an angel to stay the hand of Abraham; Jephthah's daughter was not so fortunate, and her father, a victorious Hebrew leader, had to make good his promise to sacrifice the first person who met him on his return home. This was the subject of Hezekiah Augur's major work, the first ideal group by an American artist; it was followed by versions carved by both Mozier and Ives. Such subjects as Isaac and Jephthah's daughter had natural appeal in presenting the conflict between loyalty to God and love of family.

Rizpah by Mozier and *Rachel* by Rogers were only two of many such Old Testament heroines, but the most popular seems to have been *Ruth*, not only with Americans but with Europeans too. This popularity led James Jackson Jarves to speak of the prevalent "Ruth fever"; the subject seems to have had special appeal to transplanted Americans who may have felt that they, too, were toiling in an alien land. Bartholomew and Palmer each

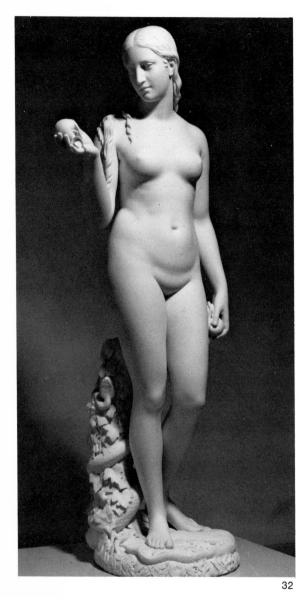

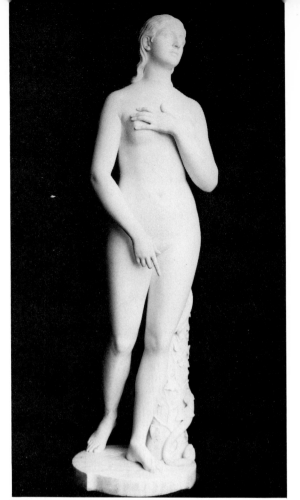

33

32. Hiram Powers, *Eve Tempted*, 1839–1842. Marble. National Collection of Fine Arts, Smithsonian Institution, Washington, D.C. Purchased in memory of Ralph Cross Johnson.
33. Hiram Powers, *Eve Disconsolate*, 1871. Marble. The Hudson River Museum, Yonkers, New York.
34. Edward Sheffield Bartholomew, *Eve Repentant*, 1858–1859. Marble. The Wadsworth Atheneum, Hartford, Connecticut.
35. Thomas Crawford, *Adam and Eve*, 1855. Marble. The Boston Athenaeum, Boston, Massachusetts.

The most popular religious subject among the American neoclassicists was Eve—understandably so, for she enabled the sculptor to use the nude female form while clothing it in acceptable religious symbolism. Christian sentiment could thus augment the perfection of antique form and produce a work of art superior in nineteenth-century terms even to the products of classical Greece and Rome.

One of the earliest full-length nude female statues by an American sculptor, excepting only the slightly earlier *Venus* by Greenough, was Hiram Powers' *Eve Tempted* (fig. 32). This figure predated his *Greek Slave* by several years and is probably his most beautiful sculpture. It was praised by the aging Thorwaldsen, who is supposed to have left in the clay the imprint of his thumb, which was preserved by Powers. The work did receive some

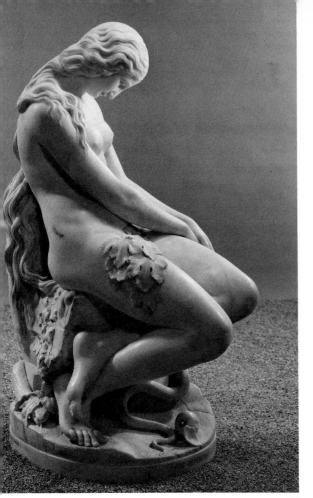

34

conception, an Eve awakening to the wonders of creation, one hand throwing her hair back and her face beaming with pleasure, hope, and surprise as she listens to the sound of Eden's music. Randolph Rogers' *Eve* is unlocated to-

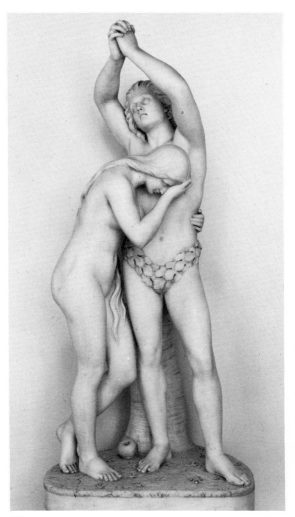

35

criticism at the time for not revealing Eve's anguish, and so toward the end of his life Powers created another Eve, the *Eve Disconsolate* (fig. 33). This represents Eve after the fall, and thus she wears a mournful expression. The later *Eve,* of which two examples are known, reflects the late neoclassical predilection for sculptural movement and also reflects a growing interest in the quattrocento. The figure bears some relationship to the famous painted Eve by Masaccio in the Carmine in Florence, and the delicate treatment of the features suggests the works of Desiderio and the brothers Rosellino.

Bartholomew also carved an *Eve Repentant* (fig. 34), which includes the apple, with the fatal bite complete with teeth marks carefully indicated. Descriptions of Thomas Ball's *Eve,* which is now lost, record a very different

day, as is a two-figured group by John Adams Jackson of *Eve with the Dead Abel,* much praised in its own time. Thomas Crawford's double-figure group of *Adam and Eve* (fig. 35) is one of his most impressive sculptures and is, as far as we know, the only representation of Adam by an American sculptor of the period.

The New Testament

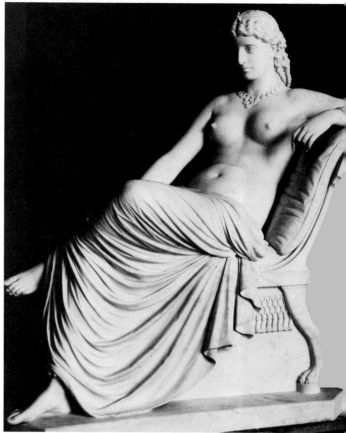

37

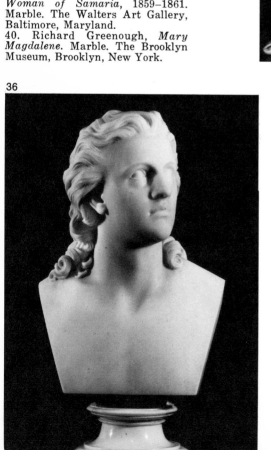

36

Although, with the exception of Christ himself, New Testament and Christian themes seem to have been less popular than those derived from the Old Testament, there were, of course, exceptions. One of Richard Greenough's most monumental figures, more dramatic than much of neoclassic sculpture, was his swooning figure of *Mary Magdalene* (fig. 40). William Henry Rinehart created a noble representation of *The Woman of Samaria* (fig. 39), a New Testament counterpart to *Rebecca at the Well*. The most notable parable representation was *The Prodigal Son* by Mozier (fig. 16), which was often considered by contemporary critics to be his finest work and as a two-figured group certainly his most ambitious one known today. In its own time it was attacked for being a plagiarization of a French work. Horatio Stone carved a relief of *The Three Marys at the Tomb*, destined as a gravestone for his mother, in Jackson, New York.

Perhaps the most popular of all of Thomas Ball's marble sculptures in the neoclassic aesthetic was his *St. John the Evangelist,* a full-length figure purchased by a Boston collector and later removed to Forest Hills Cemetery in Boston; at least five busts deriving from this figure are known today (fig. 36). Both Akers and Foley also carved now unlocated depictions of St. John; whether these were John the Evangelist or John the Baptist is not recorded. Salome was the subject of

38

39

40

several carvings, one by Thomas Crawford and a well-known one by William Wetmore Story (fig. 37). His seated representation of the temptress has been praised and damned both, as his finest and his most vacuous work, respectively. Figures of the saints are exceedingly rare among Americans, though there are *St. Cecilia* by Rinehart and two examples of a *St. Elizabeth of Hungary* by Akers; the latter, a medieval saint, was the daughter of the King of Hungary, famed for her charity and her ministrations to the sick.

One other Christian subject, the source of which may have been literary but which is not known at present, is Thomas Crawford's *Christian Pilgrim in Sight of Rome* (fig. 38). The work exists today in a large version and also as a statuette. Crawford had designed a number of other Christian subjects, but some of these may not have even been put into marble, and others, such as his *Christ Blessing Little Children,* are lost today.

73

Christ and Satan

41. Thomas Ridgeway Gould, *Satan*, ca. 1864. Marble. The Boston Athenaeum, Boston, Massachusetts.
42. Hiram Powers, *Christ*, 1864. Plaster. National Collection of Fine Arts, Smithsonian Institution, Washington, D.C. Purchased in memory of Ralph Cross Johnson.
43. Horatio Greenough, *Lucifer*, 1841–1842. Marble. Trustees of the Boston Public Library, Boston, Massachusetts.
44. Horatio Greenough, *Christ*, ca. 1845–1846. Marble. Trustees of the Boston Public Library, Boston, Massachusetts.

41

42

The most famous New Testament subject for these sculptors was, naturally enough, that of Christ. The infant Christ, as part of a composite Holy Family, is known to have been carved by both Randolph Rogers and Edmonia Lewis. The latter work was purchased by the Marquis of Bute, but neither one has been located today. Also missing are these two scenes from the life of Christ: Joseph Bailly's *Christ Blessing Little Children* and Horatio Stone's *Ecce Homo*.

At least six sculptors created busts or figures of Christ—Horatio Greenough, Powers, Akers, Gould, Rinehart, and Story. Story's must have been the most distinct, for his standing figure was garbed in Oriental costume as an Arab sheik, an outfit lent to the sculptor by the poet Wilford Scawen Blunt, who lived near Cairo and had married Byron's granddaughter. The statue was much praised

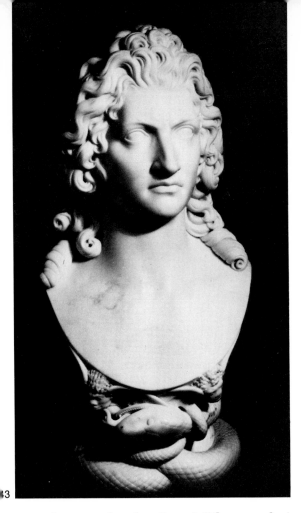

Two different versions of busts of Christ by Greenough are known.

Both Greenough's and Gould's heads of Christ were meant as companion pieces to busts of Satan—another example of that dualism that so permeates American sculpture. Gould's head of *Christ* is missing today; the *Satan* (fig. 41) suggests a derivation from some specific Roman imperial portraiture. Greenough's bust is of the *Lucifer* from Milton's *Paradise Lost* (fig. 43); both this and its companion rest upon coiled serpents, one accompanied by two miniature devil heads, the other by angelic ones. Another example of dualism can be found in two works by James Haseltine, now lost—his *Christian Mother*, contrasted with his *Heathen Mother Sacrificing Her Child to Moloch*—Moloch being third in rank in the Satanic hierarchy, after Satan and Beelzebub, according to Milton. Emma Stebbins created a heroically armored *Satan Descending to Tempt Mankind*, which provoked James Jackson Jarves to speculate about the popularity of the devil with Americans!

44

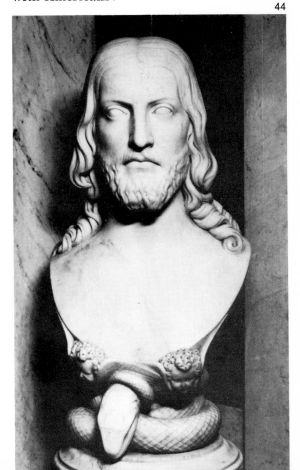

as a "sermon in stone" and "the grandest idealization of Divinity."

The other depictions probably all related to some extent to the famous and much-admired *Christ* by Thorwaldsen in the Church of Our Lady in Copenhagen. This is certainly true of Rinehart's *Christ*, which was part of the Fitzgerald memorial at the Loudon Park Cemetery in Baltimore, and it seems more true of Powers' bust (fig. 42) than of Greenough's (fig. 44). Powers was forced to change his rather strong, humanized conception to a more idealized one, closer to Thorwaldsen, at the direction of his patron, Henry Aspinwall. Greenough, on the other hand, seems to have been somewhat disenchanted with Thorwaldsen's work; in 1838 he wrote to his brother Henry: "I see his work with a different eye from formerly. I have not changed my opinion of the *Christ*, yet I find it a little hard...."

Angels

Angelic figures were extremely popular with American sculptors; undoubtedly the artists were fascinated by the chance to depict winged forms. Angels are found both in relief sculpture, as we have seen in Palmer's *Peace in Bondage,* and in full-length statues in the round. Horatio Greenough's figure of *The Angel Abdiel* (fig. 49) is one of his most majestic; firm-jawed and intense, the work is typical of Greenough's somewhat assertive style. Although not paired with a statue of

Satan, it is meant to suggest a combination of the angel's compassion and his defiance of the devil when, according to Milton, Satan attempted to persuade the angels to revolt against God. The subject was suggested to Greenough by his friend the painter Washington Allston. The work is related to the *Apollo Belvedere* of antiquity, and indeed, Greenough was reported to have planned another figure of Abdiel the size of the classical sculpture; the *Abdiel* was also referred to as a "heaven-born Achilles." A variant bust of the *Abdiel* by Greenough also exists.

Larkin Goldsmith Mead's career is critically bound up with his statue of the *Recording Angel* (fig. 45), which he first made out of snow as a young man. Reports of this snow angel attracted the attention of the Cincinnati art patron Nicholas Longworth, who encouraged Mead's career; later, Mead reproduced the subject in the more enduring medium of marble.

One of the most popular angelic variants was the Peri, derived from *Paradise and the Peri* in Thomas Moore's poem *Lalla Rookh.* The Peri, of Persian origin, became in the poem a fallen angel who, in an attempt to gain re-entry into Paradise, was instructed to bring to God the gift He most desired. After several unsuccessful attempts the Peri brought the tears of a repentant old man, which gained her admission. "Her" is emphatically the proper pronoun for the plump, Rubensian nude by Joseph Mozier (fig. 46); Thomas Crawford's figure is more modestly clothed (fig. 47). Other *Peris* were created by Palmer and the English pupil of Hiram Powers, Charles Fuller.

Emma Stebbins' *Angel of the Waters* in Central Park, New York (fig. 27), is perhaps the most monumental and best-known angelic figure, but the most moving and personal one is certainly that by William Wetmore Story in the Protestant Cemetery in Rome, the kneeling *Angel of Grief* attending the sepulchral monument to the sculptor's beloved wife, Emelyn (fig. 48). This sculpture was copied for a memorial to the victims of the San Francisco fire and earthquake of 1906, and the reproduction was placed on the grounds of Stanford University.

45 46

45. Larkin Goldsmith Mead, *Recording Angel,* 1856 and after. Marble. Location unknown.
46. Joseph Mozier, *The Peri.* Location unknown. Photograph courtesy of the New York Public Library.
47. Thomas Crawford, *Peri at the Gates of Paradise,* 1855. Marble. The Corcoran Gallery of Art, Washington, D.C.
48. William Wetmore Story, *The Angel of Grief,* 1895. Marble. Monument to Emelyn Story in the Protestant Cemetery in Rome.
49. Horatio Greenough, *The Angel Abdiel,* 1839. Marble. Yale University Art Gallery, New Haven, Connecticut. Bequest of Edward E. Salisbury.

76

47

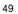
49

48

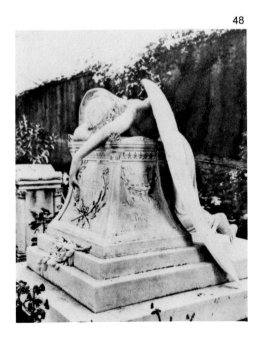

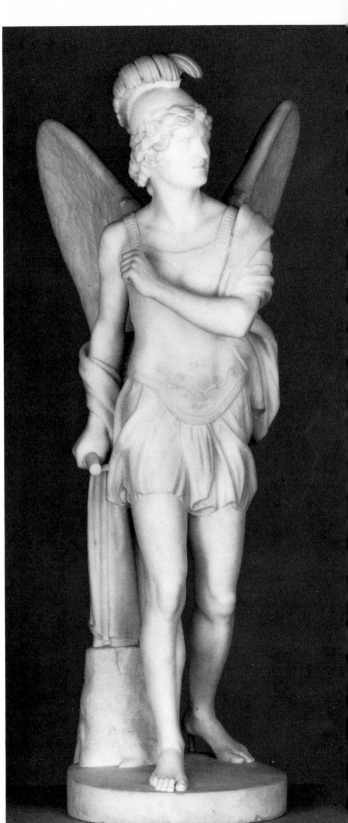

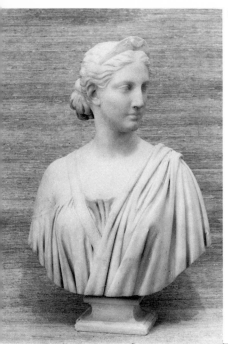

Goddesses

An important category of subject matter for our sculptors was that of the gods and goddesses of classical mythology. The goddesses far outnumber the gods, to the extent that no representations of Mars or Vulcan or Mercury, for instance, are even known. Even among the goddesses some such as Juno are totally absent from the American neoclassic pantheon. In fact, American sculptors usually chose their subjects for specific reasons. We tend to think today that they dipped into a book on mythology almost at random, but the truth is usually the reverse. Subjects such as Psyche or Pandora, so very popular in the nineteenth century, were interpreted precisely because they had meaning to Victorian Christianity—as symbols respectively of the immortal soul and of Eve or the introduction of "sin" on earth. Virtue saved and fidelity, as

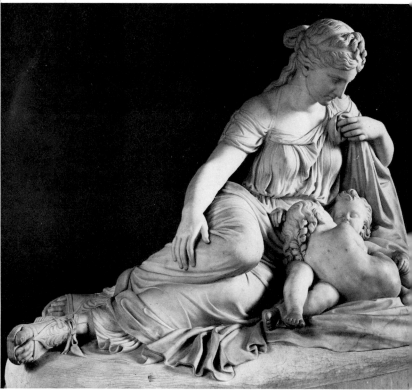

51

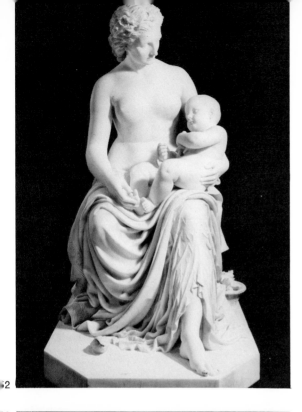

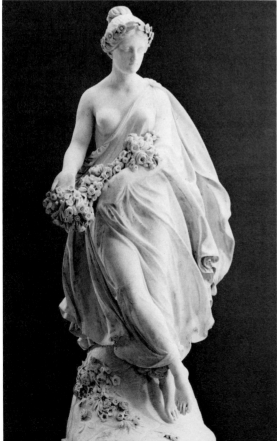

represented by such figures as *Daphne, Egeria,* and *Oenone,* were also popular, as was the theme of maternity, emphasizing the moral superiority and virtuousness of woman. Ives produced an abstract allegory of *Maternity,* but two of the most ambitious such representations took classical guise, Rinehart's *Latona and Her Children* (fig. 51) and Pierce Connelly's *Thetis and Achilles* (fig. 52); Story is supposed to have created the latter subject also. These two treatments are quite different stylistically, Connelly indulging in a kind of *beaux-arts* breaking up of surfaces, and Rinehart emphasizing a monumental, pyramidal structure, at the same time offering a touchingly restrained maternal sentiment.

We cannot always find Christian or moralistic bases underlying the choice of subject. For instance, Powers modeled a bust of *Diana* (fig. 50), one of his most classical works, which may have been one reason why it had particularly great appeal to the English. Bartholomew had earlier carved a *Diana,* of which several versions are known, and the goddess appears in several two-figure groups, *Apollo and Diana* by Crawford and a lost *Diana and Endymion* by Akers.

Several subjects served the changing aesthetic within neoclassic sculpture, such as Rinehart's *Atalanta,* with her rushing movement, wind-swept drapery, and deep undercutting. Particularly significant here is the later *Flora* of Thomas Crawford (fig. 53). This is a piece of virtuoso carving, with the large marble figure seemingly swept up off her precarious connection below, with deep-ridged drapery and a fantastic display of elaborate garlands of flowers. As a symbol of beauty, Flora was also sculptured by Palmer and Ives.

50. Hiram Powers, *Diana,* after 1863. Marble. The Glasgow Art Gallery and Museum, Glasgow, Scotland.
51. William Henry Rinehart, *Latona and Her Children,* 1874. Marble. The Metropolitan Museum of Art, New York City. Rogers Fund, 1905.
52. Pierce Connelly, *Thetis and Achilles,* 1874. Marble. The Metropolitan Museum of Art, New York City. Gift of Mrs. A. E. Schermerhorn. 1877.
53. Thomas Crawford, *Flora,* 1853. Marble. The Newark Museum, Newark, New Jersey. Gift of Franklin Murphy, Jr., 1926.

Love

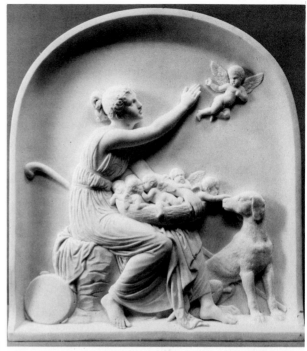

54. Thomas Crawford, *Venus as Shepherdess*, ca. 1840. Marble. Museum of Fine Arts, Boston, Massachusetts.
55. Horatio Greenough, *Cupid Bound*, 1834–1835. Marble. Museum of Fine Arts, Boston, Massachusetts.
56. Edmonia Lewis, *Poor Cupid*. Marble. Private collection, Piermont, New York.
57. Horatio Greenough, *Venus*, 1837–1841. Marble. The Boston Athenaeum, Boston, Massachusetts.

54

Comely, sensual Venuses, the symbols of physical love, seem to have been produced far less often by American than by European artists, who were more at ease in the classical tradition and felt fewer restraints from puritanism and Victorian morality. There are nude *Venuses* by both Horatio Greenough (fig. 57) and William Wetmore Story, but it is significant that when Crawford chose to copy a representation of *Venus* by Thorwaldsen, he chose an amply clothed relief of *Venus as Shepherdess* (fig. 54), in which the concept of love is purely symbolic and quite tame, represented in the form of pudgy infant cupids. The subject here is an old one in neoclassic art; an early example is the *Seller of Cupids* by Joseph M. Vien, the teacher of Jacques Louis David, which was in turn based upon a classical prototype. But even the erotic aspects of Vien's art are carefully expunged in the Crawford relief. The full interpretation of the relief is as follows: One love is not yet awake; faithful love caresses the dog; the third is soothed by laying his head on the arm of the shepherdess; two others kiss passionately; and fickle love flies away, into the air.

Cupids themselves were extremely popular among Americans; one of the best known and finest, in form, sentiment, and restraint, is Horatio Greenough's *Cupid Bound* (fig. 55), far more crisp and attractive than his *Angel and Child* of the same period. Greenough here, of course, gives the subject a proper Victorian interpretation, for love is carefully restrained and contrasted with the symbol of wisdom, an owl perched on a rock at the figure's feet. Indeed, its variant title is *Love Prisoner to Wisdom*. A similar, more heavy-handed version of the same theme is Edmonia Lewis's *Poor Cupid,* or *Love Ensnared* (fig. 56). Here the rather aggressive-looking contorted winged infant has his hand caught in a large trap. It is a more playful interpretation of the theme and may be considered a "conceit," a form of sculpture with which Miss Lewis and Harriet Hosmer, particularly, seem to have achieved much success. Probably not unlike this theme was the now unlocated *Cupid Breaking His Bow* by Randolph Rogers. John Adams Jackson, Thomas Crawford, and Richard Greenough also sculptured now missing statues of Cupid.

80

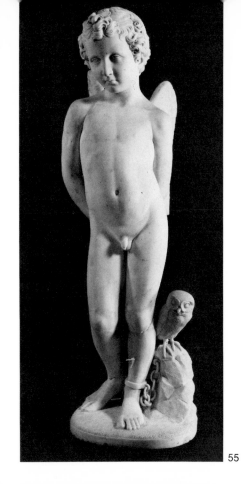

55

56

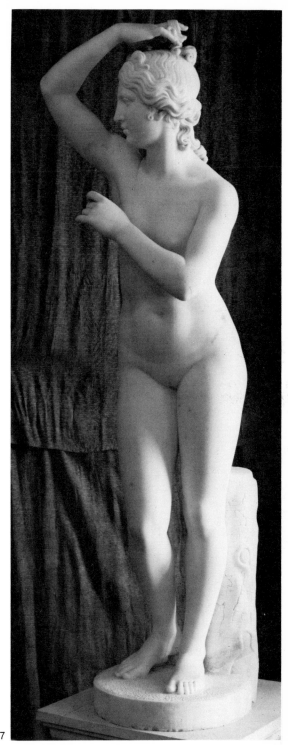

57

Music

Sculpture is to be seen and not heard, and the formal majesty of neoclassicism may seem even less related to the musical arts than the rococo aesthetic that preceded it. Musical allegories, as such, are not common, but sculptures relating to music and sound are plentiful. Horatio Greenough's lost *Chanting Cherubs* indicates an early neoclassic interest in musical themes; in fact, one of the diatribes directed against the group of infants when the work was exhibited back in America was that the sculpture was deceitful since the marble figures did not actually sing! Musical attributes were plentiful among the figures created by Americans; we will see this, for instance, in the many representations of Sappho with her lyre, and there are the various interpretations of Jephthah's daughter with her tambourine in hand. Shepherd boys are always accompanied by their pipes, which underline their simple, rustic, pastoral innocence with their sweet and simple music (figs. 58 and 59).

One of the most fascinating pair of subjects with a musical theme is Thomas Crawford's *Dancing Jenny* and *Boy with Tambourine* (figs. 60 and 61). Jenny is the happy figure, to whom movement and life are imparted through music, as represented by the dance. The boy is a still and melancholy one, because he has been deprived of music, which symbolizes, in a sense, the source of life. The sculptors, in using music to suggest vitality, seemed to have infused that vitality into artistic conceptions, as if to transcend the immobility inherent in their marble medium.

Another kind of musical consideration can be noted in the relationship of many sculptural themes to contemporary opera. Opera was not in the nineteenth century a rarefied cultural expression, but rather a form of popular entertainment for the same class that

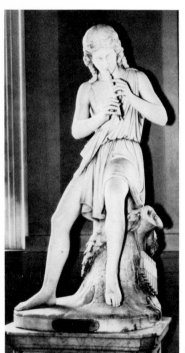

58. William Wetmore Story, *Arcadian Shepherd Boy*, 1852. Marble. Boston Public Library, Boston, Massachusetts.
59. Edward Sheffield Bartholomew, *Shepherd Boy*, 1854. Marble. The Peabody Institute, Baltimore, Maryland.
60. Thomas Crawford, *Dancing Jenny*, 1855. Marble. Private collection, Piermont, New York.
61. Thomas Crawford, *Boy with Tambourine*, 1855. Marble. Private collection, Piermont, New York.

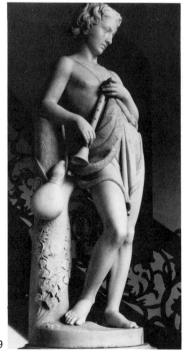

58

59

60

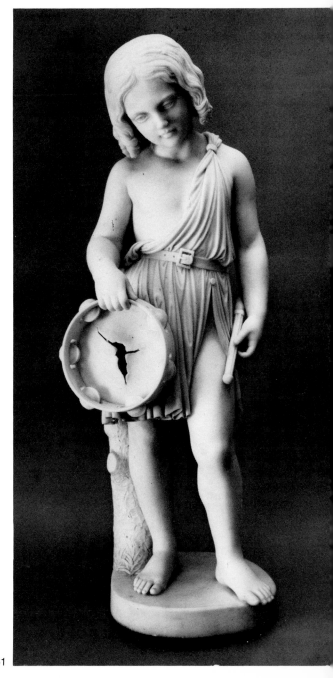

provided artistic patronage. Such diverse
subjects as *Marguerite* (Story), *Undine*
(Ives, Mozier, and others), *The White Lady
of Avenel* (Mozier), *La Somnambula* (Rog-
ers), and *Semiramis* (Story) were undoubt-
edly familiar to prospective clients through
their appearance in popular operatic form.
This reincarnation in marble could be said to
have provided the figures with a form of
musical "life."

61

Aerial Themes

62. Thomas Ridgeway Gould, *The West Wind*. Marble. The Mercantile Library of St. Louis, St. Louis, Missouri.
63. Harriet Hosmer, *Hesper*, 1852. Marble. Watertown Free Public Library, Watertown, Massachusetts.
64. Randolph Rogers, *The Lost Pleiad*, after 1874. The Brooklyn Museum, Brooklyn, New York.
65. Alexander Galt, *Aurora*, 1859–1860. Marble. Kirby Collection, on loan to the Chrysler Museum, Norfolk, Virginia.

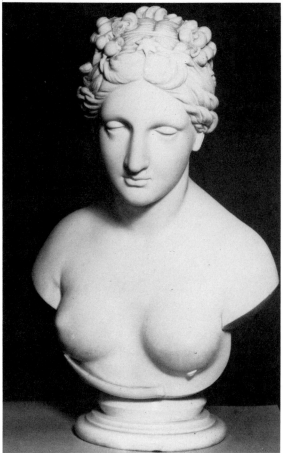

63

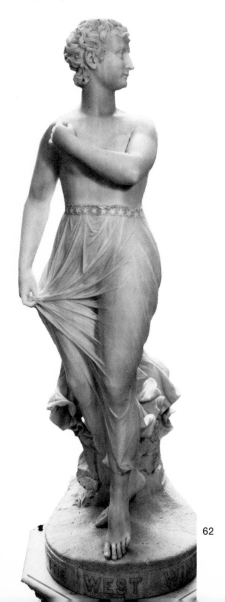

62

Even more prevalent than musical themes among our neoclassic sculptors, particularly after 1850, were aerial subjects, not "earthbound" forms but heavenly ones. The concept involved in these works reflects the artists' growing interest in representing movement and change in their artistic imagery. At first the idea of representing wind and stars in solid white stone seems extremely unlikely and dichotomous. Yet it shows the degree to which even these conservative sculptors were affected by the new concepts that were infecting the art world at the time. Witness the paintings of the Barbizon school, the late Corot and even the early impressionists, which show these artists moving away from the solid, timeless elements of rocks and mountains to the more evanescent elements of wind, sky, clouds, light, and atmosphere.

Harriet Hosmer's first major sculpture, which not only won the approval of the En-

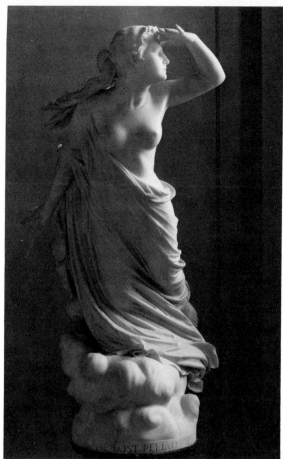

64

viewing the constellation of the "Seven Stars," we usually see only six. The aerial nature of the theme is emphasized by the movement implied in the extreme *contrapposto* of the figure, in her wind-swept hair and drapery, and particularly in the puffy clouds billowing below her. With the deeply undercut drapery and the broken silhouette, the *Pleiad* represents the ultimate in baroque interpretation within an ostensibly neoclassic aesthetic. Other similar works include a *Pleiades* by Henry Kirke Brown and *Morning Star* and *Evening Star* by Bartholomew.

Probably the most famous American aerial theme was *The West Wind* by Thomas Ridgeway Gould (fig. 62), a subject also treated by Vinnie Ream Hoxie. Like the *Pleiad* of Rogers, her delicate drapery is wind-blown, and the figure turns sharply to increase a sense of movement and lightness. That at least seven examples of the sculpture were made is a testimonial to the contemporary popularity of the work.

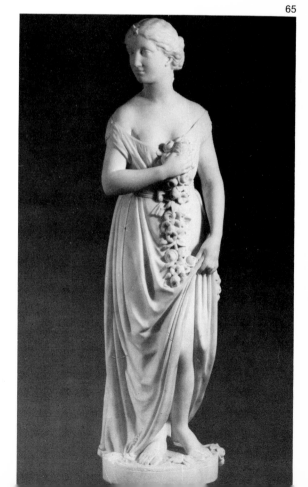

glish sculptor John Gibson but also convinced him to take her on as a pupil, was her bust of *Hesper,* the evening star, which she had carved in America (fig. 63). It was replete with symbolism: hair entwined with poppies, a star on the forehead, and a crescent moon under the breasts. Similar subjects carved by Miss Hosmer were her reliefs of *Night and the Rising of the Stars, Morning and the Setting of the Stars,* and *Phosphor and Hesper*; all of these helped to secure her acceptance among the Roman art colony.

One of Alexander Galt's few full-length sculptures was his *Aurora* (fig. 65), the goddess of the dawn, a subject previously undertaken by Gibson. Randolph Rogers' *Lost Pleiad* was that sculptor's last—and most nude—ideal statue, a depiction of the outcast daughter of Atlas and Pleione who had married a mortal, Sisyphus (fig. 64). According to legend, she hid herself in shame, so that in

Day and Night

Allied to the concept of the aerial theme, and even sometimes incorporated into it, as in Bartholomew's *Morning Star* and *Evening Star*, were the depictions of day and night. By stressing the transience of time, such subjects, like the musical themes, seem to extend the traditional range of sculpture, and even to negate some of its fundamental principles.

There are many examples of this theme, such as John Adams Jackson's *Dawn*, Ives's full-length *Night*, and Randolph Rogers' early bust of *Night*. But most of the subjects were conceived as pairs, such as Rogers' bas-relief of *Night and Day*. This work is lost today, but two similar surviving pairs, also bas-relief medallions, are the winged heads of *Morning* and *Evening* (figs. 66 and 67), of 1850 and 1851, respectively, by Erastus Dow Palmer. William Henry Rinehart depicted the same subjects in oval form in 1856 (figs. 68 and 69). In both cases several sets were made; we know of at least eight pairs of the Rinehart medallions. Rinehart's figures are full-length and in higher relief than Palmer's. They are among the most beautiful nude figures in American neoclassicism, and in both

66

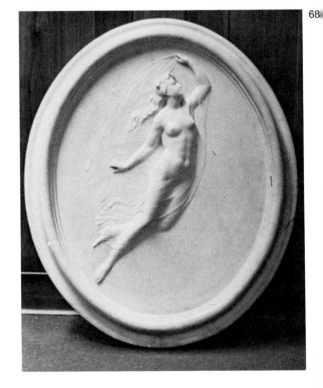

68

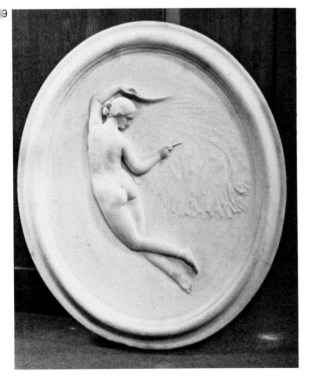

their oval format, their gently sinuous curves and countercurves, they testify to the revival of the spirit of the rococo.

The sources for these paired reliefs can be found in the figures of *Night* and *Morning* by the great patriarch of neoclassic sculpture, Bertel Thorwaldsen. These were probably the most famous relief sculptures of the nineteenth century, and reproductions and engravings after them found their way into many American homes. They were reproduced in shell, in gems, in plaster, and in bronze, and it is not surprising that American sculptors working in the neoclassic idiom both in Italy and back home tried to rival the Danish master.

66. Erastus Dow Palmer, *Morning*, 1850. Marble. Albany Institute of History and Art, Albany, New York.
67. Erastus Dow Palmer, *Evening*, 1851. Marble. Albany Institute of History and Art, Albany, New York.
68. William Henry Rinehart, *Morning*, 1856. Marble. The Peabody Institute, Baltimore, Maryland.
69. William Henry Rinehart, *Evening*, 1856. Marble. The Peabody Institute, Baltimore, Maryland.

Water Themes

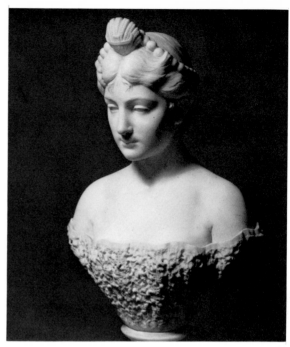

71

70

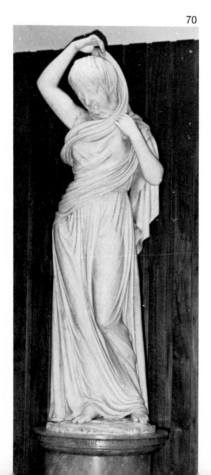

We have seen marble examples of such improbable subjects as air, stars, time, and music—subjects that seem incompatible with their medium but which reflect a desire to expand the constricting traditional forms and themes. Another, similar area of subject matter, which produced some of the most ambitious work, was water. There are two general kinds of water themes: the water spirits, in this section, and watery death, dealt with in the next section.

As with the aerial theme, the fluidity and transparency of water were a challenge to the artists, as was the case with the female subjects related to the sea, such as *Virginia Dare* with her fishnet, and the many fountain subjects, such as Harriet Hosmer's *Water Nymphs, Sirens*, and *Mermaids*. It is perhaps significant that, in Randolph Rogers' pair, *Indian Fisher Girl* and *Indian Hunter Boy*, it is the girl who is associated with the sea, although Hiram Powers did make a youthful *Fisher Boy*. One of the two major works by William Randolph Barbee was his *Fisher Girl* (fig. 72). One of the attractions of these works is the virtuoso carving of see-through fishnet.

The most popular water figure of all was *Undine*. At least five of our artists essayed

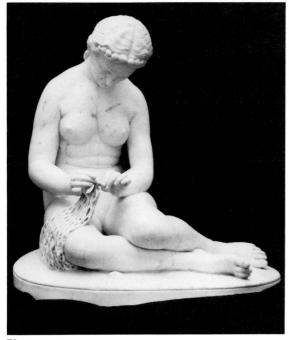

72

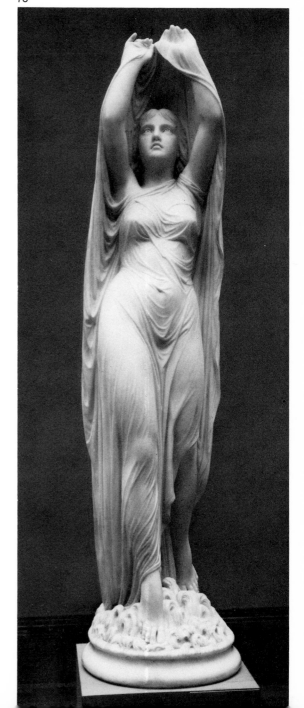

this subject—Ives, Mozier, Gould, Akers, and
Lander—though only the works by the first
two are known today. Undine was the heroine
of a romance by Baron de la Motte-Fouqué,
a water sylph who fell in love with a mor-
tal and received a soul, only to be rejected
by her lover, whose death she ultimately
caused. The popularity of the subject was
further enhanced by Albert Lortzing's pop-
ular operatic treatment of 1845. Chauncey
Ives depicts the watery nymph rising to re-
ceive her soul, her beautifully modeled body
covered with wet, almost transparent drapery
(fig. 73). Mozier went even further in his
representation of *Undine,* where the drapery
swathes and yet reveals both figure and face;
it is one of the most notable American ex-
amples of the see-through illusionism popular
in Italy at mid-century (fig. 70).

Another notable watery subject is Larkin
Goldsmith Mead's *Venezia,* his most popular
work (fig. 71). Mead was the one sculptor to
spend much time in Venice, often substituting
for his famous brother-in-law, William Dean
Howells, who was the American consul there.
In his representation this city built upon the
sea appropriately rises out of the foam and is
crowned with a cockleshell.

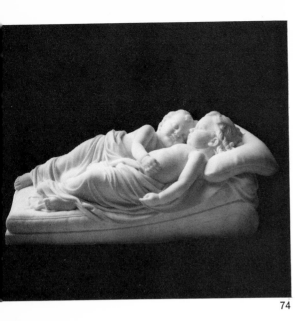

74

Death

Water figures predominate in a number of spectacular neoclassic depictions of death. The themes of death and mourning were closely associated with neoclassicism from its inception, especially in tomb monuments, yet these later marmoreal representations do not depict the noble or heroic aspects of death so much as the sense of horror and despair. The

75

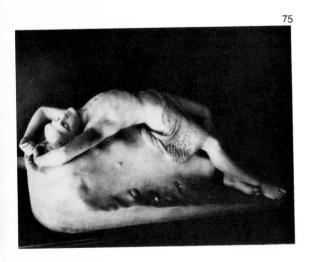

theme of personal tragedy is implicit in Palmer's *Mariner's Wife* and Bailly's *Shipwrecked Sailor Boy*. Edward Brackett's most famous work, his *Shipwrecked Mother and Child* (fig. 77), is a particularly melodramatic interpretation, combining nudity, motherhood, sentiment, and watery death, all made more poignant since it was, in a sense, a memorial to the recently drowned writer, Margaret Fuller, Marchioness Ossoli.

With the perils of both travel and travail at sea so constant in the minds of Americans, watery death was a particularly appropriate subject for American sculptors. Paul Akers seems to have had a special penchant for the subject, and his best-known sculpture was *The Dead Pearl Diver* (fig. 75), the male counterpart of Brackett's work. This beautiful figure enabled Akers to demonstrate his skill in carving see-through fishnet drapery. Other subjects by Akers, now unlocated, were his *Diver from Schiller*, a youth who died by drowning in search of lost treasure, and his *Drowned Girl*, inspired by Thomas Hood's "The Bridge of Sighs."

Not all the themes of death involved drowning. We shall see dying *Indians* and dying *Cleopatras*, and dead heroes and heroines of literature, and there were also such subjects as Vinnie Ream Hoxie's *Dying Standard Bearer*. The death of young children was a subject bound to pluck the heartstrings of Victorian America and inspired two particularly impressive works, both depicting the sleep of death of two children: Thomas Crawford's *Babes in the Woods* (fig. 76) and Rinehart's *Sleeping Children* (fig. 74). Crawford's work derives from an old English ballad, "The Norfolk Gentleman's Last Will and Testament," and from the nursery rhyme "Babes in the Woods." Rinehart's sculpture was created as a memorial to the deceased Sisson children for the Green Mount Cemetery in his native Baltimore, but it became his most popular sculpture. The original conception of both works can be traced back to the exceedingly popular *Robinson Memorial* by Sir Francis Chantrey in Lichfield Cathedral, England; at least one replica of the Chantrey sculpture is known to have been brought back to America.

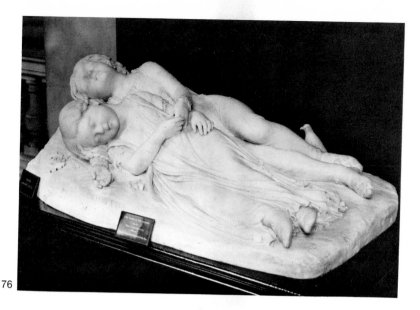

74. William Henry Rinehart, *Sleeping Children*, 1869. Marble. National Collection of Fine Arts, Smithsonian Institution, Washington, D.C. Gift of Mrs. B. H. Warder.
75. Benjamin Paul Akers. *The Dead Pearl Diver*, 1858. Marble. Portland Museum of Art, Portland, Maine.
76. Thomas Crawford, *The Babes in the Wood*, 1851. Marble. The Metropolitan Museum of Art, New York City. Gift of the Hon. Hamilton Fish, 1894.
77. Edward Augustus Brackett, *Shipwrecked Mother and Child*. 1850–1851. Marble, Worcester Art Museum, Worcester, Massachusetts.

76

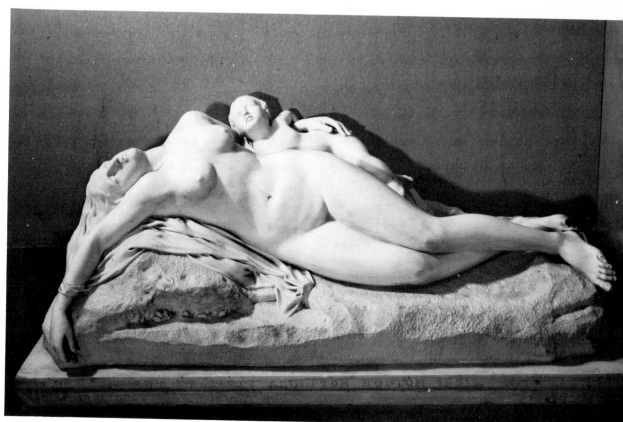

77

Ideal Busts

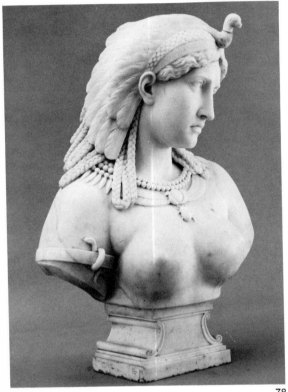

78

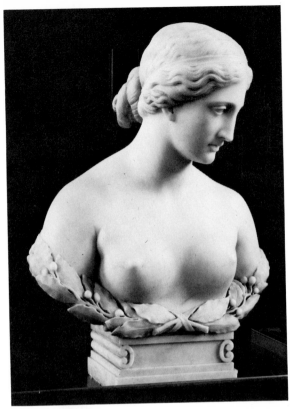

79

78. James Henry Haseltine, *Cleopatra*, 1868. Marble. The Newark Museum, Newark, New Jersey. Gift of Mrs. Jacob Polevski, 1940.
79. Harriet Hosmer, *Daphne*, 1853. Marble. Washington University Gallery of Art, St. Louis, Missouri.
80. Randolph Rogers, *The Artist's Daughter, Nora, as "The Infant Psyche."* Marble. Collection of the Ira Spanierman Gallery, New York City.
81. Hiram Powers, *Proserpine*, first carved in 1839. Marble. Cincinnati Art Museum, Cincinnati, Ohio. Gift of Reuben R. Springer.

Broadly speaking, the work of the neoclassic sculptors divide into two general categories —ideal works and portraits—though these were sometimes combined, as in the example by Randolph Rogers shown here (fig. 80). While the most ambitious works by these artists would naturally be their full-length sculptures, many patrons who wished to own an example of the sculptor's art either could not afford the costs involved or could not accommodate them in their homes. Full-length pieces also involved more expense and danger in transatlantic shipping than did the ideal busts.

Like the full-length sculptures, the ideal busts were usually available in two sizes— life-size and about one-half to two-thirds life-size. Sometimes busts were available of the upper part of full-length works; none of the pieces illustrated here, however, are known to have existed full-length. Since the artists kept the plasters of their sculptures, they

could have duplicates made easily. Powers' *Proserpine* (fig. 81), indeed, was the most popular of all the sculptures made by our artists; well over one hundred are known to have been created, and many of these have been located today. He originally designed the piece with the form rising, as here, from a bunch of acanthus leaves (Powers was bothered by the "cutoff" appearance of the arms of undraped busts), but later he sometimes substituted a simple molding sweeping across from arm to arm.

Rogers also used the device of the bust rising from leaves, perhaps inspired by Powers' work and its amazing popularity. The subject of Psyche was a very popular one, since, in spite of its classical origin, it had a Christian counterpart as a symbol of the soul; the butterfly is traditionally symbolic of the immortal soul, and it figures in Palmer's relief of *Immortality*, for instance. Rogers carved many replicas of this piece, and a number of

Psyches are also known to have been made by Powers, by the brothers Greenough, and by Alexander Galt. Rogers' *Psyche* is one of several neoclassic sculptures known where a specific individual is portrayed in classical guise—in this case, the five-year-old daughter of the artist.

Harriet Hosmer's *Daphne,* one of the sculptor's first works carved in Rome, with her laurel leaves, is also similar (fig. 79). James Haseltine's *Cleopatra* (fig. 78) is one of the most sensual neoclassic busts, and one of the most archaeologized too; as we shall see, the subject of Cleopatra was an extremely popular one after about 1860.

Historical Portraits

82

83

While portraiture as such might be no more than bread-and-butter work for many of our sculptors, historical portraiture was something else again, particularly when it involved a commission from a governmental agency. These portraits sometimes commemorated the living, sometimes the dead; they were usually full-length affairs, which the average private portrait was not; and they usually involved substantial sums of money. Most important, they were always put on view in public places, accompanied by impressive unveiling ceremonies with attendant critical reviews, which often enhanced the sculptor's reputation and brought on more commissions.

Success engendered success in a number of other ways also. Joel Tanner Hart, one of the few sculptors whose career was willingly given over almost completely to portraiture, achieved his success with one subject, *Henry Clay* (fig. 85). His directly conceived, unidealized statue of Clay was placed in the Virginia State Capitol, close to Houdon's *Washington* (fig. 97), but Hart received many other commissions for both busts and full-length versions of the same subject. The choice of costume in which to garb such historic figures was a matter of constant controversy. Many found contemporary costume ugly and ill-fitting and preferred the simplicity and timelessness of classical robes, while others, including Hart, felt the allusion to antiquity meaningless for modern subjects. Clay was one of a number of men—Edward Everett and William Henry Seward were two others—who were the subject of a good many portraits, both busts and full-length public commissions.

William Wetmore Story created relatively few portrait busts, but he was involved with nine public and semipublic commissions. The two most significant were probably those in Washington, that of *Joseph Henry*, the first secretary of the Smithsonian Institution, commissioned in 1881, and *Chief Justice John Marshall* of the following year, erected in

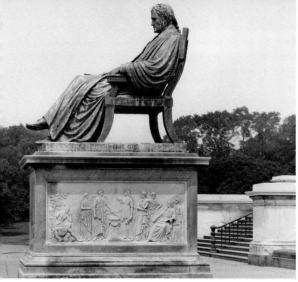

84

85

1884 outside the West front of the Capitol (fig. 84). The seated figure of *Henry*, which was cast in bronze in Rome, surmounts a pedestal with neoclassic allegorical reliefs. *Marshall* is swathed in judicial robes, a sort of compromise solution between classical and modern costume. (This device was utilized by other sculptors, too, including Harriet Hosmer in her heroic statue of *Senator Benton* in St. Louis.)

Public portrait commissions figured little in William Henry Rinehart's career, but his statue of *Chief Justice Roger Brooke Taney* (fig. 83), commissioned in 1867, finished in 1871, and cast in Munich in 1872, is one of the most sensitive, yet strongest likenesses of the period; it was installed in Annapolis, and a replica was placed in Baltimore in 1887.

The most exotic and spectacular portrait monument, both in appearance and location, is surely Thomas Ridgeway Gould's portrait of the Hawaiian king, *Kamehameha I* (fig. 82).

82. Thomas Ridgeway Gould, *Kamehameha I.* Bronze. Honolulu, Hawaii, Photograph courtesy of the Honolulu Academy of Arts.
83. William Wetmore Story, *Chief Justice Roger Brooke Taney*, 1869–1872. Bronze. Annapolis, Maryland. Photograph courtesy of the Index of American Sculpture, the University of Delaware, Newark, Delaware.
84. William Wetmore Story, *Chief Justice John Marshall*, 1882–1884. Bronze with marble pedestal. Washington, D.C. Photograph courtesy of the Architect of the Capitol.
85. Joel Tanner Hart, *Henry Clay*, 1846–1859. Marble. Virginia State Capitol, Richmond, Virginia. Photograph courtesy of the Virginia State Library.

The United States Capitol

Undoubtedly the most sought-after sculpture commissions were those for the United States Capitol. The first sculptors to work for the Capitol were the Italian carvers who came over to do not only the architectural carving but also reliefs and figures in the round to be located inside and outside the building. These artists included Enrico Causici, Antonio Capellano, Carlo Franzoni, and Giuseppe Valaperta, but the most successful of them was Luigi Persico, who carved the figures of *War* and *Peace* outside the East portico and the *Genius* of America in the pediment above.

Persico also sought the commissions for the two groups for the East front steps, but by the 1830s the nation had one major native son working in Italy, Horatio Greenough, who had already received from the United States Congress the order for his heroic statue of *George Washington* (fig. 94). A compromise was effected whereby Persico received a commission for the *Discovery* group (fig. 149), and Greenough received one for *The Rescue* (fig. 89). The latter is a multifigured arrangement with a heroic frontiersman restraining a near-naked, savage Indian, while a mother cowers in fear, holding her baby. Persico and Greenough appear to have worked in harmony, but the two groups are vastly different; Persico's figures stride forward, while the Greenough is a triangular group, in which the action moves from side to side. *The Rescue* remained the most ambitious and complex group sculpture by any American neoclassicist.

Thomas Crawford received the greatest number of Capitol commissions, while Hiram Powers, the third of the early triumvirate of major American sculptors, disdained competitions and thus made himself ineligible. Congress wanted Powers represented, however, so a sum of $25,000 was set aside for a

86

work by him. At one point it seemed that his ill-fated *America* might come to Washington, but finally the sum was allocated for two portrait statues, *Thomas Jefferson* and *Benjamin Franklin* (fig. 87). A replica of the latter is in Benjamin Franklin High School in New Orleans.

Vinnie Ream Hoxie's *Abraham Lincoln* (fig. 88) probably engendered the greatest controversy of any work in the Capitol. Vehement opposition was aroused to the awarding of a commission for a full-length *Lincoln*, shortly after the President's assassination, to an unproved teen-age girl, despite the fact that she alone of our sculptors had had personal sittings with the President previously. Charles Sumner led the opposition, pointing up the superior merits of Story, Powers, Palmer, and Brown. Not all the sculptors represented in the Capitol achieved the fame of Greenough, Crawford, Powers, or Vinnie Ream Hoxie. Another woman, Sarah Fisher Ames, is known today only for her bust of *Lincoln* in the Capitol (fig. 86).

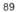87

88

89

86. Sarah Fisher Ames, *Abraham Lincoln*, acquired 1868. United States Capitol, Washington, D.C. Photograph courtesy of the Architect of the Capitol.
87. Hiram Powers, *Benjamin Franklin*, 1862. Marble. United States Capitol, Washington, D.C. Photograph courtesy of the Architect of the Capitol.
88. Vinnie Ream Hoxie, *Abraham Lincoln*, 1866–1871. Marble. United States Capitol, Washington, D.C. Photograph courtesy of the Architect of the Capitol.
89. Horatio Greenough, *The Rescue*, 1838–1851. Marble. United States Capitol, Washington, D.C. Photograph courtesy of the Architect of the Capitol.

Greenough's Washington

The first major commission for a work of sculpture for the United States Capitol, and one of the best-known and most controversial of all American neoclassic works, was Horatio Greenough's heroic *Washington* (fig. 94). With the persuasion of James Fenimore Cooper and Washington Allston, Congress awarded Greenough the contract for this work in 1833. Congress was pleased to be able to offer the commission to an American artist, since all the previous depictions of Washington—by Houdon, Canova, and Chantrey—had been done by Europeans, but rivalry developed, particularly with John Frazee, who tried to persuade Congress that the commission should go to an artist working in America, not in Italy.

Greenough's conception was based on a lost antique masterwork, the Phidian *Zeus,* as reconstructed and published by Quatremere de Quincy in 1814. Nathaniel Parker Willis called Greenough "the American Phidias," a sentiment echoed by Emerson, but detractors were quick to pounce upon "George Jupiter Washington." The partial nudity of the statue also brought admonishments to the work, but Edward Everett defended it as "one of the greatest works of sculpture of modern times." Greenough declared that he wanted to present a poetical abstraction of Washington's whole career, rather than emphasize any one deed; he chose to represent Washington seated with classical pose and drapery, as distinct from Houdon's standing figure in modern civilian dress, Canova's classical armor, and Chantrey's standing and cloaked figure.

In 1841 the work was shipped to America, but its setting in the Rotunda proved unfortunate, with the lighting both ghostly and ghastly. It was removed to the grounds of the Capitol, where it rested open to the depredation of both the elements and the pigeons, and finally received shelter, first in the Smithsonian Institution administrative building and then in the new Museum of History and Technology.

The work itself is well known, but much less published are the details on the side and back, illustrated here. Surmounting the back of the chair on which Washington sits are two small figures, of Columbus and an Indian (figs. 93 and 92), one representing the European background of the founding of America, the other its primitive state. On the sides of the chair are reliefs, one depicting Apollo in

90

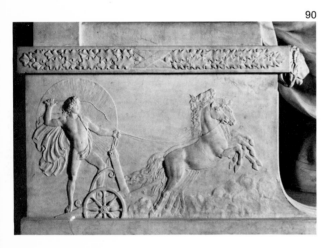

90–94. Horatio Greenough, *George Washington,* and four details: *Apollo in His Chariot, Hercules and Iphictus, Indian, Columbus,* 1832–1841. Marble. National Collection of Fine Arts, Smithsonian Institution, Washington, D.C.

91

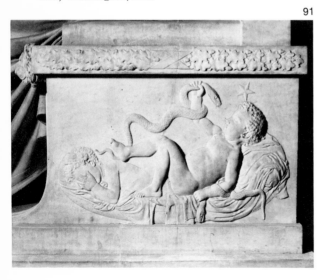

his chariot (fig. 90), the other the infants Hercules and Iphictus (fig. 91). Iphictus, symbolizing South America, shrinks in dread from the serpents, which represent the obstacles and dangers threatening the incipient civilization, while Hercules, as North America, successfully struggles and overcomes them.

94

92

93

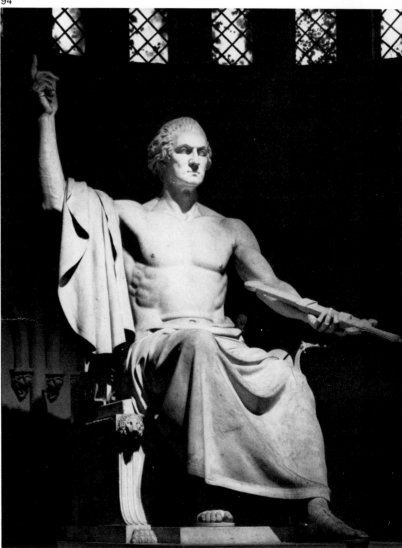

George Washington

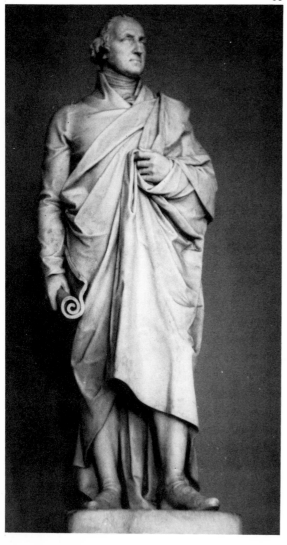

95. Sir Francis Chantrey, *George Washington*, 1826. Marble. Massachusetts State Capitol, Boston, Massachusetts. Photograph courtesy of the Index of American Sculpture, the University of Delaware, Newark, Delaware.
96. Antonio Canova, *George Washington*, 1818–1820 (destroyed 1831; remade and installed 1971). Marble. North Carolina State Capitol, Raleigh, North Carolina.
97. Jean Antoine Houdon, *George Washington*, 1788. Marble. Virginia State Capitol, Richmond, Virginia. Photograph courtesy of the Virginia State Library.

Although Greenough's statue was the most famous American depiction of the first President, Washington was the portrait subject of many an American sculptor, and of Europeans as well. There is, indeed, an equivalent sculptural counterpart to the artistic cult of Washington, marmoreal equivalents of the paintings of Gilbert Stuart, the Peales, Trumbull, and countless other portrait painters. However, there were significant differences between the sculptors and the painters. The sculptors came later, and none of them had known Washington firsthand. The painted likenesses of Washington are fascinating, if only because of the range of interpretation given to him by the artists, reflecting their own styles and visions, as well as their varying reactions to him. In this regard the sculptors were curiously inert.

The Americans who interpreted Washington, Greenough included, based their versions of Washington upon the one portrait bust that was taken of the great man in his lifetime, that of the Frenchman Jean Antoine Houdon (fig. 97). Houdon had been selected by Benjamin Franklin to visit America to make the likeness for the statue commissioned by the state of Virginia in 1784; he sailed on July 22, 1785, and arrived at Mount Vernon on October 2. He took a life mask of Washington, modeled a bust of him, took the measurements for the full-length statue, and left on October 17. His first plan was to depict Washington in antique dress, but the President himself favored modern costume, and this was what Houdon finally adopted, depicting Washington as the hero returned to civilian life. The clay model was finished in 1788 and the final statue set up in 1796. Though Houdon's visit to this country was of extremely short duration, his work here became the basis for the development of monumental sculpture in America. American sculptors seem never to have used the various and varying painted likenesses of Washington as anything but a secondary source; Houdon's image remained the only accepted sculptural one.

Houdon had seen and studied the President, and this gave him an advantage no other foreign artist could claim. Antonio Canova was commissioned by the state of North Carolina for a full-length statue of Washington at the end of 1815. The Italian artist began

his likeness in 1819, and the work was unveiled in Raleigh in 1821, only to be destroyed in a fire in 1831. One hundred and fifty years later a "new" Canova was installed in the Raleigh State Capitol, based upon the surviving Canova plasters housed in the Canova museum in the artist's native town of Possagno, Italy (fig. 96). Canova chose to represent Washington as a seated Roman general, and much controversy ensued over this choice, mainly because the costume was only symbolic. The Englishman Sir Francis Chantrey swathed Washington in a Roman toga with contemporary dress beneath for his 1826 statue for the state of Massachusetts, a work still at the Boston State House (fig. 95).

The earliest and most famous Italian artist to visit America was Ceracchi, who arrived in 1791. He presented Washington as a Roman emperor, or perhaps a deity, the most intense image to have been carved (fig. 101). One of the ablest of the Italian sculptors who came

the monument in contemporary military uniform, yet another variation in the manner of dress.

Native American artists, from Greenough onward, continued to produce busts and occasionally full-length statues of Washington. Powers carved a number of them beginning in 1846; he seems to have created about thirty busts, some in contemporary garb, some in antique robes, and all of them based upon the Houdon likeness (figs. 98 and 100). He also created two full-length statues of Washington, both of which were ultimately destroyed. One, for the Louisiana State Capitol, was damaged in the Civil War and later destroyed completely in a fire. The other, for the Masonic Lodge in Fredericksburg, Virginia, was completed in 1859 and destroyed in a fire in Richmond, Virginia, where it was moved for reasons of safety during the Civil War.

Other busts were created by Crawford and Story; Bartholomew carved a full-length

96

97

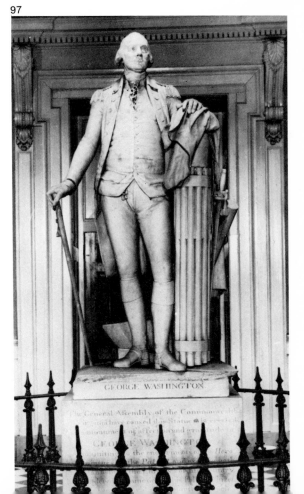

to work on the United States Capitol was Antonio Capellano, whose bust of Washington, based on Houdon's likeness, is extremely sensitive and attractive (fig. 99). Capellano was one of the sculptors who competed for the Washington Monument in Baltimore, but the commission went instead to another Italian, Enrico Causici, whose work was installed in 1829. Causici presented Washington atop

98

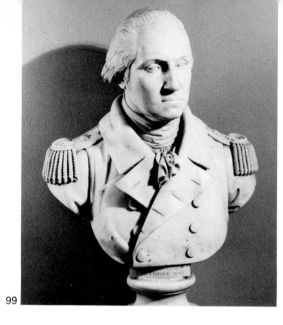

99

pedestrian statue now in Druid Hill Park, Baltimore, and equestrian groups in bronze were made by Henry Kirke Brown and

Thomas Ball, but these are conceived in a later sculptural spirit. The most famous equestrian *Washington* by a neoclassicist was that by Crawford for Richmond, Virginia (fig. 102). It was the artist's first major commission; he had originally planned to depict Washington as a Greek general, but when this appeared too obscure, he willingly changed to contemporary dress, basing the likeness on Houdon and the costume on Joseph Wright's oil portraits. The work, cast in Munich, was greeted with great enthusiasm and was

deemed fitting to "grace our own Capitoline," as one Virginian said, where it now stands outside the building housing the statue by Houdon.

98. Hiram Powers, *George Washington*. Marble. M. Knoedler & Co., Inc., New York City.
99. Antonio Capellano, *George Washington*, 1823. Marble. The Peale Museum, Baltimore, Maryland.
100. Hiram Powers, *George Washington*, 1853. Marble. The Minneapolis Institute of Arts, Minneapolis, Minnesota. Gift of the Minneapolis Tower Co.
101. Giuseppe Ceracchi, *George Washington*, ca. 1791–1795. Marble. Carolina Art Association, Gibbes Art Gallery, Charleston, South Carolina.
102. Thomas Crawford, *Washington Monument*, 1850–1857. Bronze. Richmond, Virginia, Photograph courtesy of the state of Virginia.

100

101

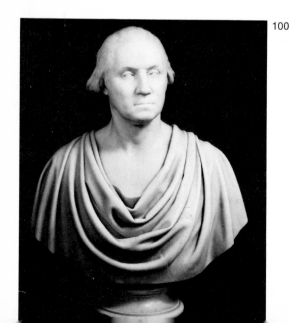

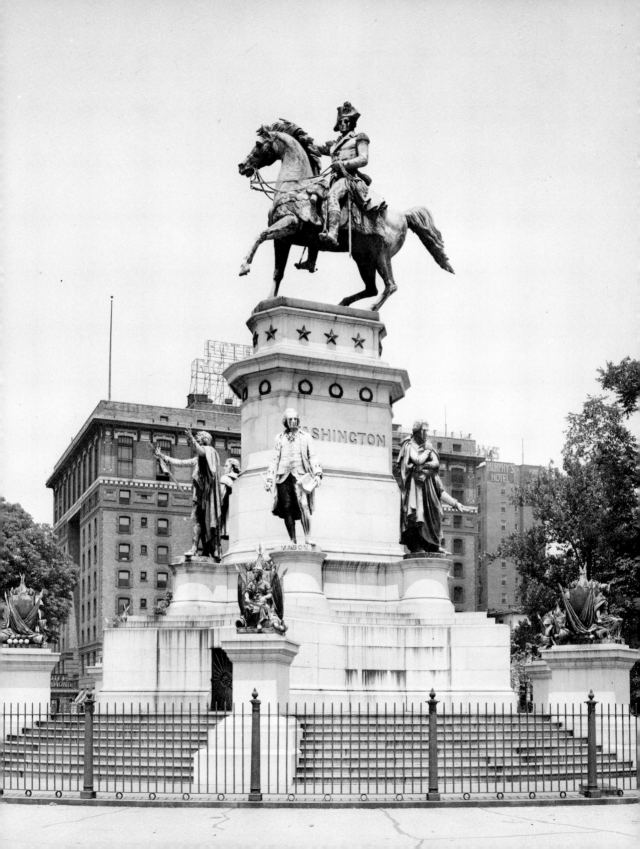

103

104

In 1857 the House of Representatives moved from its original home in the Captol to the new South wing constructed for it. The question then arose as to a suitable use for the vacated space. It had already been suggested that American historical paintings might be displayed there, but the spaces between the columns were too cramped and limited for monumental canvases, and an alternate suggestion, that the hall be used to display statues of distinguished Americans, became law in 1864, with the creation of the National Statuary Hall.

The President was authorized to invite each state to furnish statues, in either marble or bronze, depicting deceased and illustrious citizens worthy of national commemoration. Each state was allowed to send no more than two such statues; in 1933, because of the increased number of states, only one statue representing each state was allowed to remain in the Hall, the others being relocated elsewhere in the building. Most states have furnished the Capitol with two statues each; those remaining in Statuary Hall today divide almost equally between marble and bronze.

Naturally, such commissions were eagerly sought after. Not only did the states pay handsomely, but the works were intended for the most impressive sort of permanent public exhibition. At the same time, most states sought to favor native sons, if such could be

103. Chauncey B. Ives, *Jonathan Trumbull*, 1868. Marble. United States Capitol, Washington, D.C. Photograph courtesy of the Architect of the Capitol.
104. Richard Greenough, *Governor John Winthrop*, 1876. Marble. United States Capitol, Washington, D.C. Photograph courtesy of the Architect of the Capitol.
105. Preston Powers, *Jacob Collamer*, by 1881. Marble. United States Capitol, Washington, D.C. Photograph courtesy of the Architect of the Capitol.
106. Franklin Simmons, *Roger Williams*, by 1872. Marble. United States Capitol, Washington, D.C. Photograph courtesy of the Architect of the Capitol.

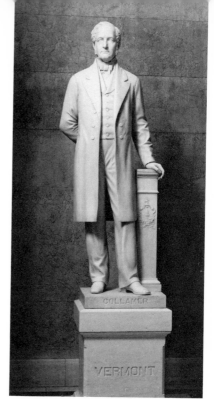

105

106

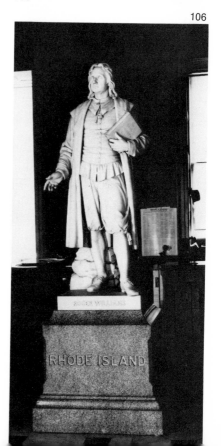

found. While the enactment of the law as late as 1864 precluded the participation of some of our earlier neoclassicists, many of the second generation were able to take part. Chauncey B. Ives, for instance, received the commission from Connecticut for both the *Roger Sherman* and the *Jonathan Trumbull* (fig. 103), later duplicating the statues for the State Capitol in Hartford. Most states, however, preferred to divide the commissions between two native artists; thus, Massachusetts awarded the commission for the *Samuel Adams* to Anne Whitney, while that for *John Winthrop* went to Richard Greenough (fig. 104). The figure of Winthrop is standing; Greenough had previously modeled a seated statue of the same subject for the Bigelow Chapel in St. Auburn Cemetery in Cambridge —now at Harvard University. Rhode Island appears to have had no adequately competent native sculptors, so the commission for the statue of *Nathaniel Greene* went to New York's Henry Kirke Brown, and the *Roger Williams* to Maine's Franklin Simmons (fig. 106). Vermont, on the other hand, had an abundance of native sculptors. Larkin Goldsmith Mead was selected to create the *Ethan Allen*, and the aging Hiram Powers received the commission for the *Jacob Collamer* early in 1873. Powers died soon after, however, and the *Collamer* statue was then entrusted to Hiram's sculptor son, Preston Powers (fig. 105).

Artist Portraits

Most of the works carved by the neoclassic sculptors were portraits and, outside of official commissions, these were mainly portrait busts. Some artists were more proficient at portraiture than others (several critics thought Hiram Powers a finer sculptor of portraits than of ideal works), and some artists seem to have been primarily interested in

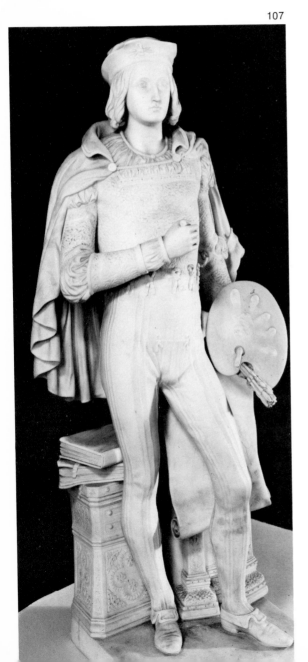

portraiture (few ideal pieces by Clevenger and Hart, for instance, are known). Story, on the other hand, wealthy and well connected, did not have to sculpt many portraits for a livelihood, and few examples by him exist.

In addition to fulfilling specific commissions for which Americans on the Grand Tour would pose in Europe, returning home to await the arrival of the finished marble, artists would occasionally model busts of eminent artists and writers. Portraits of artists are shown here; the following section is devoted to literary portraits.

Washington Allston represented the spirit of ideal art in his beliefs, in his work, and in the encouragement he gave to both painters and sculptors. It is not surprising that several sculptors paid tribute to him by modeling his portrait. The Brackett bust was commissioned by the family after Allston's death (fig. 110) because the bust by Clevenger (fig. 108) done from life was felt to be too harsh and uncompromising, emphasizing as it did the illness of the painter in his later years. It was Allston who encouraged the first American neoclassicist, Horatio Greenough, to go to Italy and pursue his career. In turn, Greenough welcomed the young Hiram Powers to Florence and aided him in settling there. Powers then created a portrait of his colleague, one of Powers' most notable likenesses (fig. 109).

A special category of artistic portraiture consists of idealized depictions of artists of the past which were produced in great numbers by nineteenth-century painters, starting with the series of paintings of the life of Raphael by Ingres. Sculptural equivalents by Americans are extremely few. There are several examples known of Crawford's *Raphael* (fig. 107). When this form of portraiture was undertaken, the artists naturally chose those painters and sculptors whom they themselves most respected, and Raphael was probably the most celebrated and venerated artist in the nineteenth century. His art represented the rebirth of the classical spirit of harmony, logic, and sentiment; he was the artist who led art from the medieval into the modern world (and the date of 1499 on the base of the sculpture thus has particular significance).

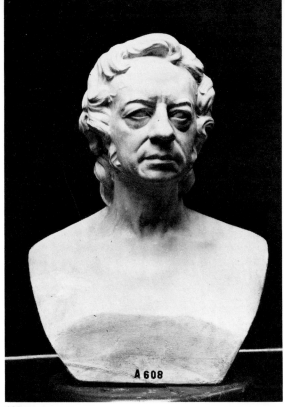

108

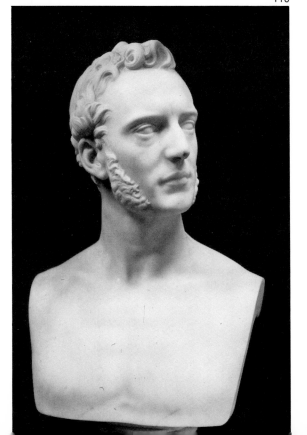

107. Thomas Crawford, *Raphael*, 1855. Marble. Private collection, New York City.

108. Shobal Vail Clevenger, *Washington Allston*, 1839–40. Plaster. The Pennsylvania Academy of the Fine Arts, Philadelphia, Pennsylvania.

109. Hiram Powers, *Horatio Greenough*, 1838. Marble. Museum of Fine Arts, Boston, Massachusetts. Bequest of Charlotte (Gore) Greenough Hervasches du Quillou.

110. Edward Augustus Brackett, *Washington Allston*, 1843–44. Marble. The Metropolitan Museum of Art, New York City. Gift of the children of Jonathan Sturges, 1895.

110

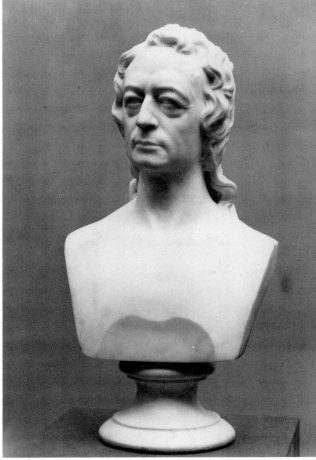

109

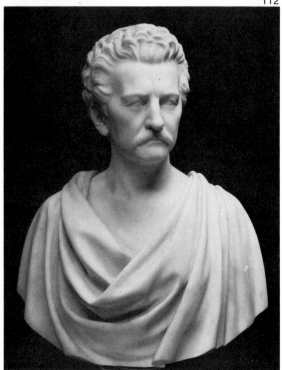

Portraits of Writers

Since many of the subjects that inspired our sculptors were drawn from literary sources, it is not surprising that some of the finest of their sculptured portraits were of writers. Some of these were idealized historical portraits, but this section is devoted to portraits of nineteenth-century authors, most of whom the sculptors knew personally. They were writers whose prose or poetry either provided the actual subjects for sculptures or embodied the spirit for which many of our artists strove. Although most of these were commissioned portraits, they constituted more than ordinary "bread-and-butter" work for the sculptors.

American artists and writers had a tradition of close communion from the early days of the nineteenth century; in New York, for instance, there were such fraternal clubs as the Sketch Club and the Bread and Cheese Club. Also many of the artists of nineteenth-century America were themselves writers— usually of poetry—from Washington Allston to Albert Pinkham Ryder; this was not so true of our sculptors, since they were usually not so well educated; the exceptions were Horatio Greenough and William Wetmore Story, who both wrote fairly copiously.

None of the characters from Nathaniel Hawthorne's novels seem ever to have been put into marble, but Hawthorne was a keen critic and observer of the expatriate art scene of the middle of the century and a friend of many of the sculptors. His novel *The Marble Faun* is laid in their midst, and the sculpture of its hero, Kenyon, is drawn from that of Akers and Story, and the heroine, Miriam, has been variously attributed to Louisa Lander and Harriet Hosmer. Hawthorne's portrait was sculptured by a number of artists, both American and Italian (fig. 112).

111. Anne Whitney, *John Keats*, original 1873. Marble. Keats Memorial House, Hampstead, England.
112. Preston Powers, *Nathaniel Hawthorne*. Marble. Museum of Fine Arts, Boston, Massachusetts. M. & M. Karolik Collection.
113. William Wetmore Story, *Elizabeth Barrett Browning*, 1866. Marble. The Boston Athenaeum, Boston, Massachusetts.

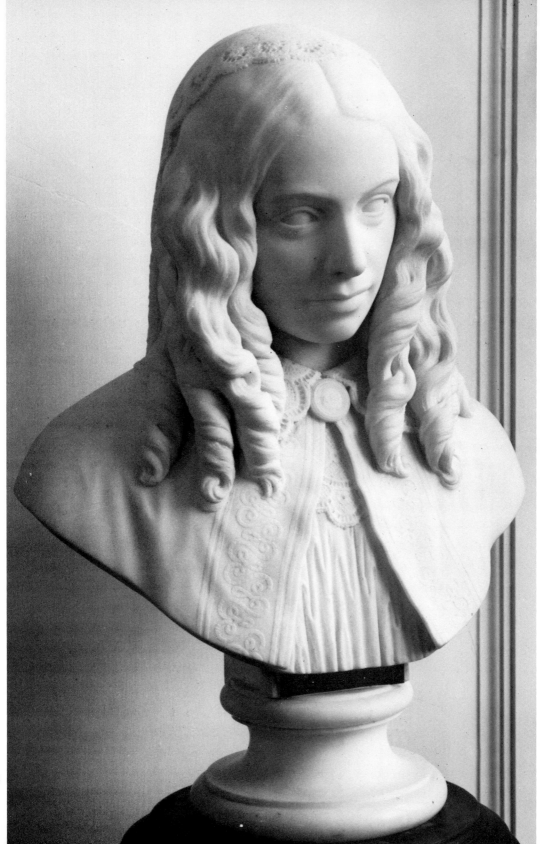

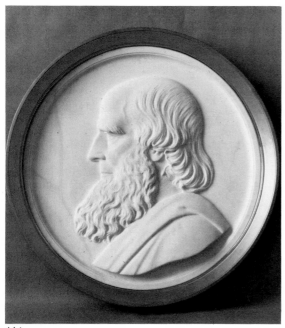

114

115

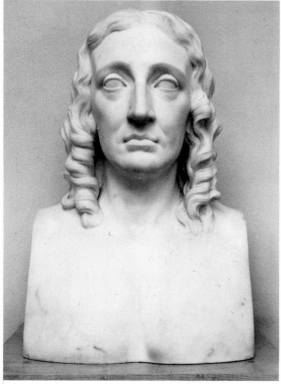

William Cullen Bryant had been extremely close to the early Hudson River School painters, and his "Indian Girl's Lament" was interpreted by the sculptor Joseph Mozier; here Margaret Foley depicts him in one of her typical relief medallions (fig. 114). Elizabeth and Robert Browning, whose home was the fulcrum of the Anglo-American artistic and literary community in Italy, were both portrayed by their close friend Story. The bust of Mrs. Browning (fig. 113) is a sensitive, moving work, modeled after her death for her bereaved family.

Anne Whitney (fig. 111) could not have known John Keats, of course, since the young poet had died in 1821, the year she was born, but Keats's poetry and the English romantic poets in general provided inspiration for much neoclassic sculpture. William Henry Rinehart had been involved with a memorial for Keats in the Protestant Cemetery in Rome, and one replica of Miss Whitney's bust, erected in the Parish Church in Hampstead in 1894, became the first memorial to the author in England. William Wetmore Story also modeled a bust of Keats.

Themes from Shakespeare and Milton were very popular with the neoclassic sculptors (see page 116), but portraits of the authors themselves were also made. William Wetmore Story not only carved a bust of Juliet and a statuette of Lear, but did several full-length seated statues of Shakespeare (fig. 116). Richard Greenough, too, carved a bust of Shakespeare, and Anne Whitney designed a fountain with reliefs of Puck, Titania, and Bottom, surmounted by a full-length statue of Shakespeare. A bust of Milton is one of the rare surviving works by Benjamin Paul Akers (fig. 115).

114. Margaret Foley, *William Cullen Bryant*, 1862. Marble. Mead Art Gallery, Amherst College, Amherst, Massachusetts.
115. Benjamin Paul Akers, *John Milton*, 1857. Marble. Colby College, Waterville, Maine. Photograph Wendell A. Ray.
116. William Wetmore Story, *Shakespeare*, 1872. Marble. The Redwood Library and Athenaeum, Newport, Rhode Island.

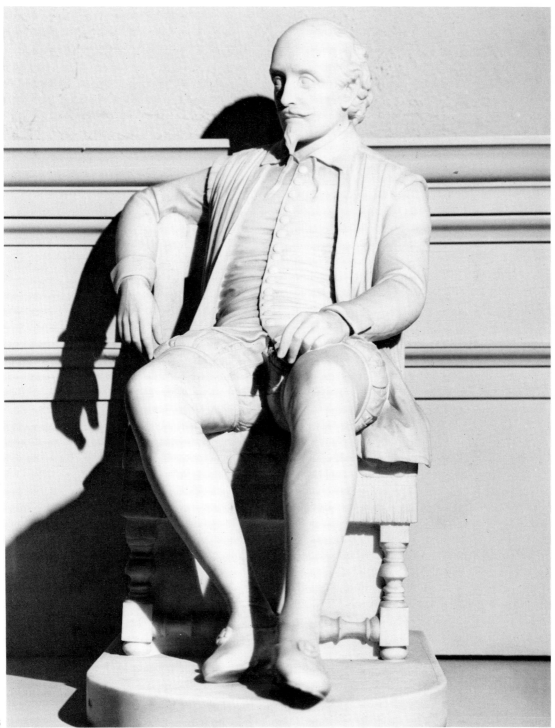

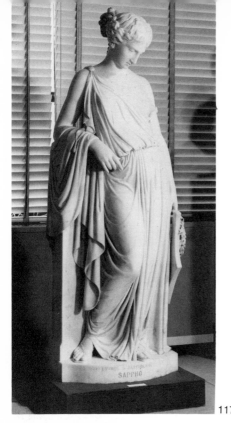

117

118

Sappho

One of the most popular of all the subjects for our neoclassicists was that of Sappho, the Greek poetess of Lesbos who flourished about 600 B.C. The great interest in Sappho in the nineteenth century was not related to the lesbian aspects of her poetry, emphasized from the late nineteenth century onward, but rather with the legend that the poetess threw herself into the sea after her advances had been rejected by the beautiful youth, Phaon. Thus, Sappho stood for rejected love and watery demise, two themes often emphasized in neoclassic painting and sculpture.

However, the appeal of Sappho as a subject was probably even greater. She was known as the "tenth Muse," and, as the spirit of poetry, she would have had special appeal to sculptors who were searching to express a sculptural equivalent of poetic inspiration. Furthermore, as we have seen, these sculptors, in attempting to extend the range and romantic impact of their work, often suggested musical analogies in their work, and Sappho is always accompanied by her lyre. Thus, she serves, symbolically at least, as a kind of musical equivalent of the visual spirit of sculpture.

Thomas Crawford's depictions of *Sappho* are probably the earliest of these (fig. 118). He put into marble a now unlocated bust, and modeled in plaster a smaller full-length statuette, which was presented by Crawford's widow to Henry Wadsworth Longfellow after the sculptor's death. More monumental depictions in marble exist by Bartholomew, Story, and Vinnie Ream Hoxie, and the subject was modeled also by Galt, Robert Park, and in relief by Erastus Dow Palmer. Bartholomew's is a standing figure (fig. 117), very classic of face, and gracefully swaying, the downward pull of bodily form and her drapery and the bend of her head emphasizing her mournful melancholy. Story's sculpture (fig. 120), typically seated in a classical chair, was, he thought, his best work, and he described it to a friend as "very tender, very sweet, very sentimental." He also considered it his "Greek" subject, as the *Cleopatra* was his Egyptian one, and his Libyan *Sibyl* his African. As with his *Cleopatra* and other works, he also wrote a poem on the subject.

Vinnie Ream Hoxie's *Sappho* (fig. 119) is a monumental standing figure, perhaps posed in contrast to Story's previous seated one; a bronze copy of it adorns Mrs. Hoxie's grave in Arlington.

119

117. Edward Sheffield Bartholo-
mew, *Sappho*, ca. 1856. Marble.
Wadsworth Atheneum, Hartford,
Connecticut.
118. Thomas Crawford, *Sappho*,
1855. Plaster. Longfellow House,
Cambridge, Massachusetts.
119. Vinnie Ream Hoxie, *Sappho*,
ca. 1870. Marble. National Collec-
tion of Fine Arts, Smithsonian In-
stitution, Washington, D.C. Gift of
General Richard L. Hoxie.
120. William Wetmore Story,
Sappho, 1863. Marble. Arnette An-
tiques, Murfreesboro, Tennessee.

120

Classical Literary Themes

The most classically oriented of all the American sculptors was William Wetmore Story, and more of his subjects were inspired by classical literature than by classical mythology. These include his *Clytemnestra, Electra, Helen, Polyxena, Orestes, Orpheus,* and those illustrated here, *Alcestis* and *Medea* (figs. 122 and 124). Smoldering violence and restrained powerful passions are characteristic of his subjects and of his interpretations of them, as contemporary critics pointed out in his most famous sculpture, the *Cleopatra.* This certainly characterizes also his *Medea,* the full title of which is *Medea Contemplating the Murder of Her Children.* Story was inspired for both subject and appearance by the interpretation of the role of *Medea* by the great tragedienne, Adelaide Ristori, whom the artist is supposed to have followed around "like a shadow." Most of Story's literary subjects represent the approved neoclassic—and Victorian—virtues of family and paternal respect, or noble sacrifice, as in the respective cases of *Electra* and *Polyxena.* The *Alcestis* is typical of this too—the story of the noble wife who was willing to take the place of her husband, Admetus, in death, only to be rescued by Hercules, a tale that thus combines the themes of sacrifice and grieving widowhood. Both the *Medea* and the *Alcestis* are standing statues rather than Story's more typical seated ones; Harriet Hosmer praised the drapery of Story's *Alcestis* highly.

The same subject was interpreted by Franklin Simmons in his two-figure group of *Hercules and Alcestis.* Simmons seems to have been very much influenced by Story, both in his subject matter and in his style. His *Penelope* (fig. 123), depicting the grieving, faithful wife of Ulysses, is another tribute to familial respect and fidelity, and she is seated, "Story-like." The other side of the Homeric tale of Ulysses is found in Richard Greenough's *Circe,* also seated (fig. 121). His depiction of the sorceress who vainly sought to seduce Ulysses over a period of seven years displays a more than usual abandon, but then the younger Greenough was something of an aesthetic maverick among our sculptors. Ovid was used by Simmons and Louisa Lander in their *Galateas,* by Rogers in his *Lost Pleiad,* and also by Thomas Crawford; we know that Rinehart based his *Antigone* on the writings of Sophocles, and Story seems to have interpreted Sophocles and especially Euripides in his art.

121. Richard Greenough, *Circe*, 1882. Marble. The Metropolitan Museum of Art, New York City. Gift of the Misses Alice and Evelyn Blogler and Mrs. W. P. Thompson, 1904.
122. William Wetmore Story, *Alcestis*, after 1874. Marble. The Wadsworth Atheneum, Hartford, Connecticut.
123. Franklin Simmons, *Penelope*, ca. 1880. Marble. Portland Art Museum, Portland, Maine. Photograph courtesy of the Index of American Sculpture, University of Delaware, Newark, Delaware.
124. William Wetmore Story, *Medea*, 1868. Marble. The Metropolitan Museum of Art, New York City. Gift of Henry Chauncey, 1894.

122

124

123

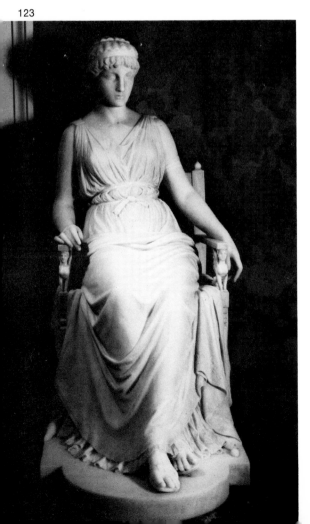

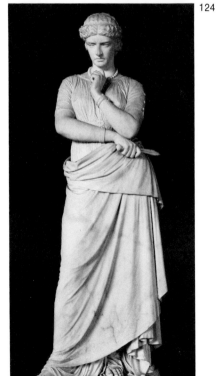

Literary Sources—Poetry

Among the early English writers, Spenser, Shakespeare, and Milton provided many sculptural themes. Spenser had earlier served the leading American painters of "history" subjects—Benjamin West, John Singleton Copley, and Washington Allston—and it is not surprising that the *Faerie Queene* often inspired our neoclassic sculptors; here the principal figure was Una, the heroine of the first book, who was a symbol both of Protestantism and of Truth. She was the subject of sculptures by Peter Stephenson, Paul Akers, and Emma Stebbins, all unlocated today.

Of the three giants of early English literature, Shakespeare, naturally enough, was consulted most often. Palmer, for instance,

125

125. Thomas Ridgeway Gould, *The Ghost of Hamlet's Father*. Marble. Worcester Art Museum, Worcester, Massachusetts.
126. Joseph Bailly, *Paradise Lost (The Expulsion)*. Marble. The Pennsylvania Academy of the Fine Arts, Philadelphia, Pennsylvania. Bequest of Henry C. Gibson, 1896.

sculptured an *Imogen* from *Cymbeline*, and *Midsummer Night's Dream* provided not only the popular *Puck* by Harriet Hosmer, but a *Titania and Nick Bottom* by John Adams Jackson. Several artists seem to have been especially drawn to Shakespeare; Pierce Connelly, for instance, was best known for his many interpretations of Shakespearean heroines, such as *Cordelia* (fig. 128) and *Ophelia*; Connelly was one of the last of the neoclassicists; thus, the growing preoccupation with meticulous textural patterns in costumes and rather fussy surface patterns is conspicuous in his work.

Thomas Ridgeway Gould was another who favored Shakespeare. He carved an *Imogen* also, an *Ariel* from *The Tempest*, and a *Timon of Athens*. But one of the most spectacular of his works was a relief of the *Ghost of Hamlet's Father* (fig. 125). Again, as in his *West Wind*, we see Gould striving, in stone, for the effects of immateriality!

Milton's *Paradise Lost* also stood our sculptors in good stead. There are Greenough's several depictions of *Abdiel*, the faithful seraph, a subject also undertaken by Horatio Stone. *Moloch*, a heathen god of sacrifice, was depicted by James Haseltine, and Joseph Bailly did a sculpture with the general title of *Paradise Lost (The Expulsion)* (fig. 126). Milton's poem *Il Penseroso*, celebrating the goddess of melancholy and contemplation, was the subject of two extremely similar full-length statues by Mozier and Powers, and of a lovely bust by Rinehart (fig. 130). It should be remembered that depictions of Adam and Eve are often taken not directly from the Bible but from Milton, a factor frequently indicated both in the titles of the sculptures and in the formal and iconographic relationship between the American works and European prototypes—naturally English ones.

American nineteenth-century poetry was a popular source for much neoclassic sculpture; works by William Cullen Bryant, Joseph Rodman Drake, John Greenleaf Whittier, and especially Henry Wadsworth Longfellow were most often drawn upon for subject matter. But it was the English romantic poets especially who seem to have embodied the same spirit in verse that our artists were trying to express in marble. A point rarely made, but of significance here, is that classical or religious subjects often should *not* be traced directly back to Biblical or mythological source, but

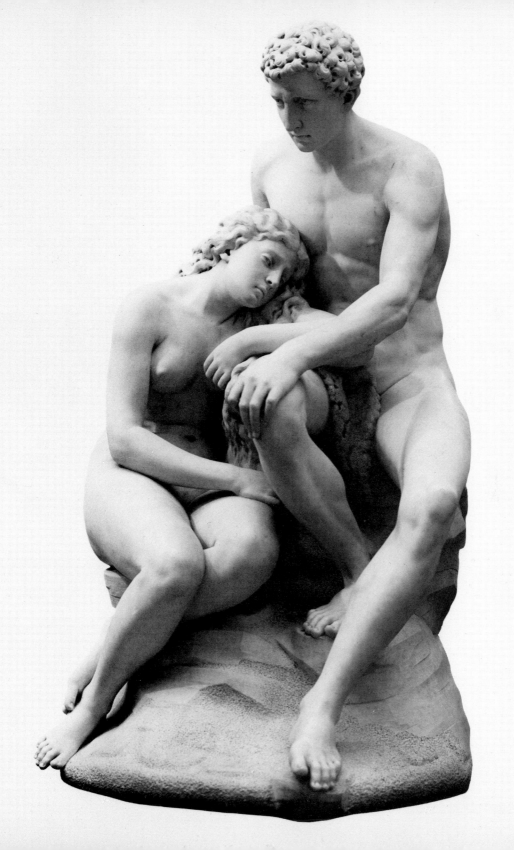

127. Anne Whitney, *Lady Godiva*, ca. 1859–1864. Marble. Isadore Bromfield, East Boston, Massachusetts.
128. Pierce Connelly, *Cordelia*. Marble. National Collection of Fine Arts, Smithsonian Institution, Washington, D.C.
129. Thomas Crawford, *The Bride of Abydos*, 1842. Marble. Sewell Biggs, Middletown, Delaware.
130. William Henry Rinehart, *Il Penseroso*. Marble. The Corcoran Gallery of Art, Washington, D.C. Gift of William Wilson Corcoran.
131. Hiram Powers, *Ginevra*, 1838. Marble. Cincinnati Art Museum, Cincinnati, Ohio. Gift of the heirs of Catherine Anderson.
132. Horatio Greenough, *Medora*, 1831–1833. Marble. Mrs. Sumner Parker, Baltimore, Maryland.

128

127

rather to their interpretation in English poetry. We know, for instance, that Henry Kirke Brown's *Ruth*, illustrated previously, drew upon Keats's *Ode to a Nightingale*, specifically in these lines:

Through the sad heart of Ruth, when,
sick for home,
She stood in tears amid the alien corn;

Keats's "Endymion" inspired Rinehart's tender sculpture on the subject, a bronze replica of which crowns the sculptor's grave; we know that Rinehart was devoted to the poet's memory and wanted to create an impressive memorial for him. Hiram Powers modeled three versions of a bust of *Ginevra* (fig. 131)—it was, in fact, his first ideal work; the story of the tragic young bride who died when playfully hiding in a trunk was drawn from Samuel Rogers' poem, "Italy."

In general, Powers and also Ives and several others seem to have been disinclined toward literary subjects, but others, such as Akers, Story, and Hosmer—who were among the better educated of the sculptors—based many works upon such sources. Tennyson, for instance, wrote an early poem on the otherwise

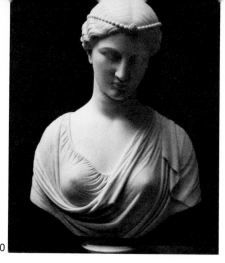
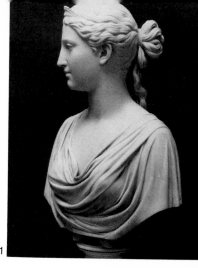

130

131

little-known subject of Oenone, a rustic bride whom Paris deserted for Helen, and the subject of Miss Hosmer's first full-length ideal statue. Two of Anne Whitney's works also relate to Tennyson, *Lotus Eater* and the extremely modest *Lady Godiva* (fig. 127), who is shown loosening the belt of her voluminous garment.

Byron, too, had great appeal. Horatio Greenough carved a bust of him, and his first full-length ideal statue was his dead *Medora* (fig. 132), derived from Byron's *Corsair*. The poet's *Bride of Abydos* (fig. 129) served Crawford for one of his most beautiful busts, and both Byron's poetry and his duplication of Leander's feat in swimming the Hellespont undoubtedly encouraged Rinehart to carve his beautiful figures of *Hero* and *Leander,* as well as another unlocated work on the subject by Story. In some cases, of course, we cannot be sure that a source is poetic, although it is not unlikely that Story, for instance, drew upon Byron's *Sardanapalus* and Ives and Mozier upon his poem, "Jephthah's Daughter," for their sculptures of those titles. Shelley, too, served our sculptors, notably in his verse drama *The Cenci*. In Act V, Scene II, Beatrice Cenci's brother says about his sleeping sister:

"How gently slumber rests upon
 her face..."

And Beatrice, awakening, states:

"I was just dreaming that we were
 all in Paradise."

Harriet Hosmer's beautiful monument of *Beatrice Cenci* corresponds to this moment of the poem, and the general spirit of virtue and Christian innocence likewise corresponds to Shelley's interpretation of the heroine.

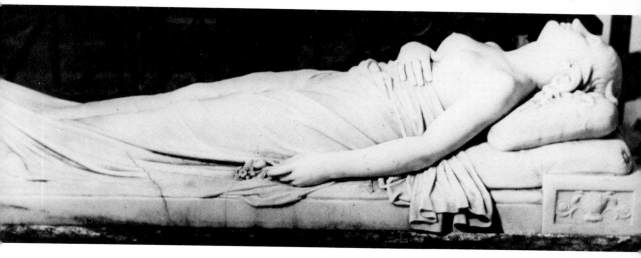

Literary Sources—Novels

Generally speaking, poetry was a more frequent inspiration than prose, but a number of novels figure as the source for some of the most important sculpture of the period. Neither Italian nor German literature seems to have offered much inspiration to our sculptors, though there are exceptions, such as Story's early *Marguerite* from Goethe's *Faust*, and the many examples of De La Motte-Fouqué's *Undine*. French literature provided a slightly more varied fare—notably the fairy tale subjects of *Red Riding Hood* and *Cinderella*, Louisa Lander's *Elizabeth of Siberia* from a novel by Marie Cottin, and Horatio Stone's *Corinne at Rome*, from Mme. de Stael's *Corinne*. The two most famous Rousseauesque novels of the turn of the century, Chateaubriand's *Atala* (fig. 133) and Ber-

133

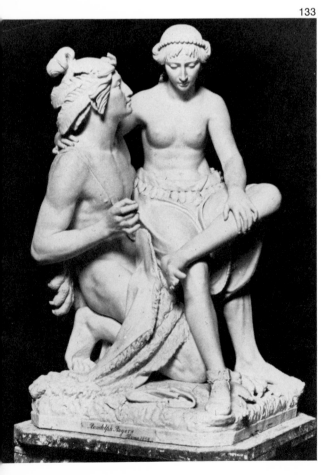

134

nardin de Saint-Pierre's *Paul et Virginie,* both served, respectively, for Randolph Rogers and Erastus Dow Palmer. The appeal must have been heightened by the American settings of these novels, dealing with the virtues of the primitive wilderness.

English prose literature was naturally more fruitful, not only because of the common language but because American (and English) patrons were likely to be familiar with the literary sources. Dickens' provided Richard Park with the source for his *Little Nell* in his *Old Curiosity Shop,* and Mozier drew upon *The Monastery* of Sir Walter Scott for his rather spectacular *White Lady of Avenel* complete with marmoreal fire (fig. 135) ! The most popular of all the full-length sculptures by an American artist was Randolph Rogers' *Nydia* (fig. 136), drawn from Bulwer-Lytton's fa-

135

American prose subject is Mozier's famous *Wept of Wish-ton-Wish* (fig. 134), derived from James Fenimore Cooper's 1829 romance of that name, one of a number of depictions of a white girl, held captive by Indians, who chose to remain with her brave and her adopted tribe rather than return to "civilization."

133. Randolph Rogers, *Atala and Chacas*, 1854. Marble. Present location unknown. Photograph courtesy of Michigan Historical Collections, Ann Arbor, and Millard F. Rogers, Jr.
134. Joseph Mozier, *The Wept of Wish-ton-Wish*, 1869. Marble. Arnot Art Gallery, Elmira, New York.
135. Joseph Mozier, *The White Lady of Avenel*, 1864 or after. Marble. Private collection, Piermont, New York.
136. Randolph Rogers, *Nydia, the Blind Girl of Pompeii*, after 1856. Marble. The Brooklyn Museum, Brooklyn, New York.

136

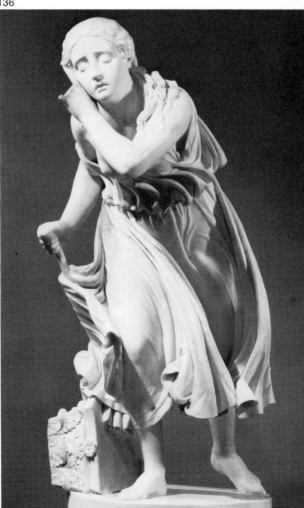

mous novel of 1834, *The Last Days of Pompeii*, and carved in 1855–1856, of which more than fifty examples seem to have been made. Nydia stood as a symbol of feminine sacrifice and fidelity, in the face of handicap and deprivation, and her blindness also satisfied Victorian America as a sign of sensual renunciation, which brought on higher truth and greater virtue. Edward Brackett had also modeled a *Nydia*, and one wonders if Harriet Hosmer's unlocated *Pompeiian Sentinel* did not owe its existence to the popularity of Rogers' work.

American novels provided only a few sources for our sculptors; these included Hannah Foster's *Coquette*, the subject of a major work by Barbee, and Harriet Beecher Stowe's famous *Uncle Tom's Cabin* which was interpreted in relief by the little-known Negro sculptor Eugene Warbourg. The best-known

Historical Heroines

Historical heroines were extremely popular among our sculptors in Italy; here undoubtedly the most favored subject was *Cleopatra*. Full-length statues were created of her by Story and Gould, and busts were made by James Haseltine, Margaret Foley, and Edmonia Lewis. The various intepretations of the Egyptian monarch are fascinating— Haseltine's sensuous image is quite unlike

137

137. Louisa Lander, *Virginia Dare*, 1859. Marble. Elizabeth Gardens, Fort Raleigh National Historic Site, Roanoke Island, North Carolina.
138. Harriet Hosmer, *Zenobia, the Queen of Palmyra*, ca. 1857. Marble. The Wadsworth Atheneum, Hartford, Connecticut.
139. William Wetmore Story, *Cleopatra*, after 1860. Marble. Goldsmith Guild Hall, London.
140. Harriet Hosmer, *Beatrice Cenci*, 1853–1855. Marble. The Mercantile Library of St. Louis, St. Louis, Missouri.

Miss Foley's very chaste one, and critics spoke of the horrific realism of Miss Lewis's depiction of Cleopatra in her death throes. Story's version is the most famous, and three replicas of the statue are known today (fig. 139); its fame was greatly aided by Nathaniel Hawthorne's long, laudatory account of the work in *The Marble Faun*, as well as by Story's own poem on the subject. Gould's *Cleopatra* was called passionate and sensual as opposed to Story's, more beautiful and fascinating. Much was made of ethnic suggestions—Gould's was more European and Story's more African— but critics then observed that Cleopatra was of Macedonian, not Egyptian origins, anyway!

Naturally, such heroic ladies of history appealed particularly to the women sculptors in Rome, and other similar subjects were essayed by them. Harriet Hosmer's most ambitious sculpture was her statue of *Zenobia, the Queen of Palmyra* (fig. 138). Its somewhat ponderous monumentality and carefully studied costume likens Miss Hosmer's work to many figures by Story. Miss Hosmer also created a much-praised but now lost statue of the last Bourbon Queen of Naples, Maria Sophia. Hosmer's most beautiful and moving sculpture is her *Beatrice Cenci* (fig. 140), based upon the historical young lady who participated in the murder of her evil father and was put to death in 1599; it is based upon Guido Reni's famous portrait of the young Cenci, then the most admired seventeenth-century Italian painting. Assassination was not always so well received, however, and Paul Akers changed his bust of Charlotte Corday to one of Lady Jane Grey.

Louisa Lander, while on her way to Rome, studied in England the writings of Richard Hakluyt concerning the story of Virginia Dare, the first white woman born in the New World. In 1859–1860 Miss Lander created a statue of the subject, an upright figure contrasting with her *Sleeping Evangeline*, her other famous work. The *Virginia Dare* (fig. 137) is really a symbolic portrait, since the fate of the young lady who disappeared with the whole "Lost Colony" of Roanoke Island is not known; both the nudity of the figure and the fishnet she holds are rather unusual interpretations, though the former may refer to her position as a kind of primal American Eve, and the latter to her birth in a coastal settlement.

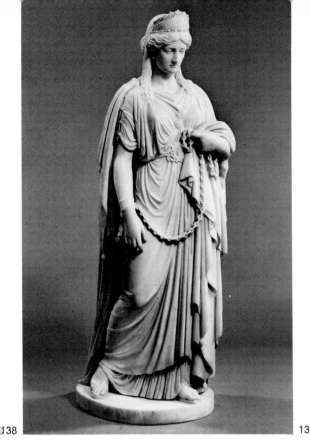

138

139

140

In addition to classical, religious, and literary subjects, our sculptors occasionally dealt with general allegorical themes. There were several representations of *Truth,* for instance, by Mozier and Joseph Bailly. Mozier and Saint-Gaudens did allegories of *Tacita,* or *Silence,* and such general moralistic allegories as *Fidelity, Innocence,* and the like were interpreted by Ives and Palmer, among others.

National allegories were made by several sculptors. The most famous of these and, in fact, the largest figure created by an American neoclassicist is Thomas Crawford's *Armed Freedom* (fig. 144)—a work dwarfed only by its pedestal, since the figure caps the United States Capitol. It was the artist's last govern-

141

142

141. Hiram Powers, *California,* 1858. Marble. The Metropolitan Museum of Art, New York City. Gift of William B. Astor, 1872.
142. Alexander Galt, *The Spirit of the South,* 1862. Plaster. The Confederate Museum, Richmond, Virginia.

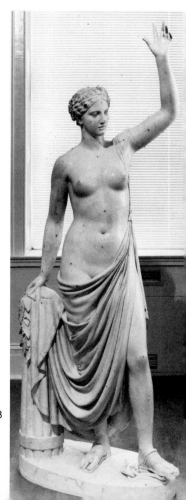

143

ment commission and was cast in bronze post-humously by the sculptor Clark Mills. Crawford's original conception was a figure wearing a liberty cap, but when the Secretary of War, Jefferson Davis, objected to this because it was a symbol of freed slaves, Crawford obligingly changed it to an Indian headdress. In creating the gigantic sculpture, Crawford may have had in mind the monumental *Bavaria* of his friend the Munich artist Ludwig von Schwanthaler.

Among other national allegories were two by Hiram Powers: *California* and *America* (figs. 141 and 143). The former was the most ill-fated of his works, finally destroyed in a fire in a Brooklyn warehouse. Only the plaster of the full-length work survives, and even that did not escape damage when transported from Florence to Washington in the mid-1960s. His *California* is perhaps the best known of his ideal statues after *The Greek Slave*. That there was a certain amount of flexibility in its allegorical interpretation is indicated by his alternate title—*La Dorada*—and he evinced no objections when it had a chance of being acquired by Australia instead of California, both centers of the wealth—and the treacherousness—of new-found gold strikes.

Most of our sculptors came from the North and evinced Union sympathies during the Civil War, but Alexander Galt was a Southern artist and created an ideal bust of *The Spirit of the South* (fig. 142) for the Confederacy. Galt had returned home to Virginia before the outbreak of the struggle and was on the staff of the governor of that state when he died of smallpox in 1862, the same year he created his Confederate allegory.

143. Hiram Powers, *America*, 1845. Plaster. National Collection of Fine Arts, Smithsonian Institution, Washington, D.C. Purchased in memory of Ralph Cross Johnson. 144. Thomas Crawford, *Armed Freedom*, 1856–1863. Bronze. United States Capitol, Washington, D.C. Photograph courtesy of the Architect of the Capitol.

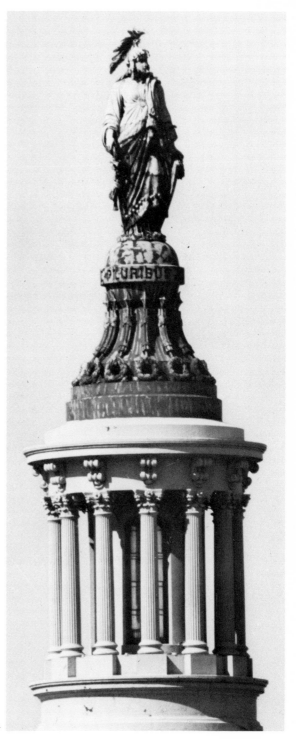

144

Columbus

American history provided a fertile field of subjects for our neoclassic sculptors, particularly in regard to those historical figures involved with the discovery and settlement of America. Leif Ericson, Henry Hudson, John Smith, Pocahontas, Miles Standish, and Virginia Dare all figure in the neoclassic pantheon. But the most popular historical figure by far was Christopher Columbus.

Pictorial treatment of the story of Columbus preceded these sculptural interpretations and may, in turn, have been spurred on by Washington Irving's fictionalized histories of 1828 and 1831. John Vanderlyn's painting of *The Landing of Columbus* for the Rotunda of the Capitol, painted between 1837 and 1847, was poorly received, but Emanuel Leutze, the American artist working in Düsseldorf, Germany, first won international fame for a series of historical pictures dramatizing the key events in Columbus's life. Aided by repro-

duction through engravings, these works became well known on both sides of the Atlantic. Many of the same scenes, including *Columbus before the Council at Salamanca* and *Columbus before Ferdinand and Isabella,* were portrayed in bronze relief by Randolph Rogers in the set of doors that he designed for the Capitol between 1855 and 1860, and installed in 1870 at the East entrance of the Rotunda (fig. 145). The doors, which were

146

modeled on Ghiberti's great doors at the East entrance of the Florentine Baptistery, were cast into bronze at the Royal foundry in Munich, Germany, in 1859.

Columbus had figured in the sculpture at the Capitol even before 1855; a small figure adorns the chair of Greenough's *Washington* (fig. 93), and a monumental Columbus is featured in the *Discovery* group by Luigi Persico (fig. 149), erected on the East front steps in 1844. Alexander Galt created a dignified, carefully archaeologized bust of *Columbus* (fig. 147). In 1867 Emma Stebbins created a heroic, more than life-size statue of *Columbus* for Central Park, near 102nd Street, which, after various vicissitudes, including a stay near the Bowery on Mulberry Street, was installed at the Brooklyn Civic Center in 1971 (fig. 148).

The most ambitious of all the statues of

145

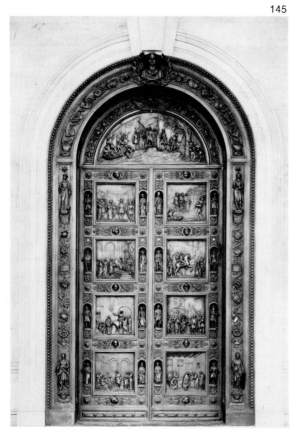

126

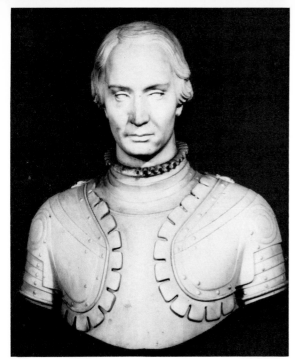

Columbus was carved by Larkin Goldsmith Mead in 1870, a rare three-figured group of Columbus and Isabella with a page (fig. 146). It represents Columbus receiving his commission to sail and was done for the home of a Connecticut merchant. It is incredibly detailed in costumes and accessories, and contemporary critics spoke of it as the largest work created by an American sculptor. It is now in the State Capitol in Sacramento, California.

147

149

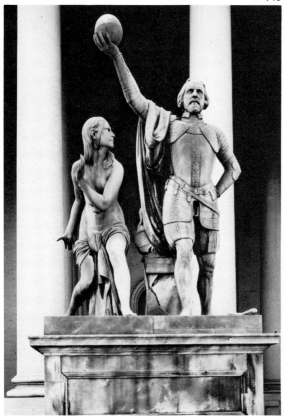

145. Randolph Rogers, *Columbus Doors*, 1855–1859/1860. Bronze. Rotunda, United States Capitol, Washington, D.C. Photograph courtesy of the Architect of the Capitol.
146. Larkin Goldsmith Mead, *Columbus and Isabella*, 1870. Marble. California State Capitol, Sacramento, California.
147. Alexander Galt, *Christopher Columbus*, 1853. Marble. Chrysler Museum of Art, Norfolk, Virginia. Gift of Mrs. Hugh Blair Grisby Galt.
148. Emma Stebbins, *Christopher Columbus*, 1867. Marble. Brooklyn Civic Center, Brooklyn, New York.
149. Luigi Persico, *The Discovery*, 1837–1843. Marble. United States Capitol, Washington, D.C. Photograph courtesy of the Architect of the Capitol.

The American Indian—Male

One theme that was particularly American, although not exclusively so, was that of the American Indian, first depicted in heroic terms by Shobal Vail Clevenger in a now lost work. Eighteenth-century European allegories of America in both painting and sculpture nearly always depicted the continent as an

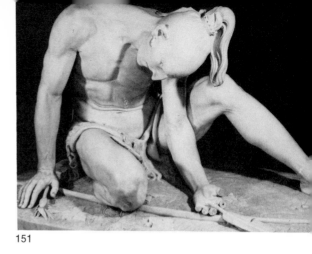

151

Indian with feathered headdress, and nineteenth-century European sculptures of Indians are known as well. But the subject matter had a natural appeal to Americans and was represented by many neoclassic sculptors.

Interpretations of the American Indian varied. Horatio Greenough, in his *Rescue* group for the Capitol (fig. 89), showed the Indian as a savage figure, restrained by the Pioneer, the symbol of civilization. Although this definition of the Indian corresponds to the painted figures of John Vanderlyn in his earlier *Murder of Jane McCrea*, this was not a common interpretation. The Indian was generally shown as either the noble, contemplative primitive, as in Rogers' *Atala and Chacas* (fig. 133) and Ives's *Willing Captive,* or as the representative of a dying way of life, making way for the coming of the white man. Greenough used the latter for his Indian on the back of the chair of Washington, and contrasted the figure with that of Columbus (fig. 92). This was the attitude adopted by Thomas Crawford in his *Dying Chief* for the pediment of the Capitol (fig. 153). A replica of this figure is known to exist today, and a bronze example of it was suggested, though not actually created, as a memorial for the artist. Crawford's figure is only superficially an Indian; both the square-jawed face and the heroic muscularity seem directly descended from classical prototypes. Far more realistic, and more moving and tragic as well, is Peter Stephenson's *Wounded Indian* (fig. 151), which is, compositionally speaking, a distant modern cousin of the ancient *Dying Gaul.*

The Indian was occasionally depicted as a specific historical figure, as in the superb

150

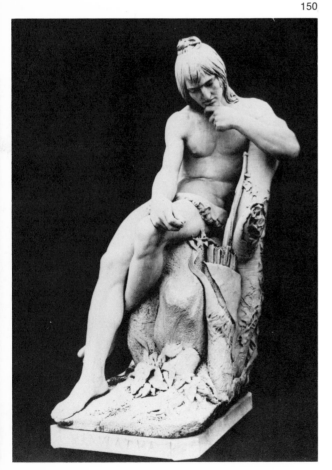

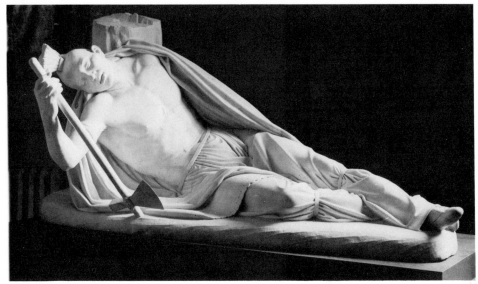

152

153

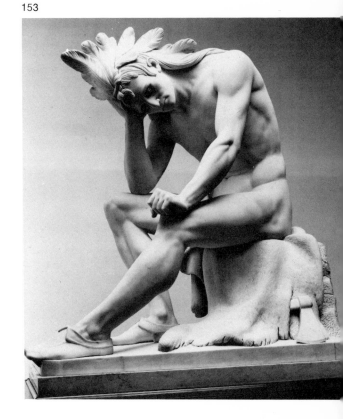

Dying Tecumseh (fig. 152) by Ferdinand Pettrich, a German working in America. The Indian figures also in literary representations, particularly in illustrations of Longfellow's *Hiawatha,* the most notable example of which is by Augustus Saint-Gaudens (fig. 150).

The Indian figure suggested a general aura of romance and nostalgia, but the male Indian often came to express a certain sexual prowess that the white man could not. He was usually depicted as a powerful physical being, frequently seminude, while Caucasian males were almost invariably clothed, except for adolescent or youthful types. The Indian alone was a match for the nude marmoreal ladies, in terms of physicality and sensuality—a symbol of primitive virility.

150. Augustus Saint-Gaudens, *Hiawatha,*1872. Marble. Formerly Henry Hilton estate, Saratoga Springs, New York. Photograph courtesy of the Saint-Gaudens National Historic Site, Cornish, New Hampshire.
151. Peter Stephenson, *Wounded Indian,* 1850. Marble. Private collection, Piermont, New York.
152. Ferdinand Pettrich, *The Dying Tecumseh,* 1856. Marble. National Collection of Fine Arts, Smithsonian Institution, Washington, D.C. Transfer from the United States Capitol.
153. Thomas Crawford, *The Dying Chief,* 1856. Marble. The New-York Historical Society, New York City.

The American Indian—Female

THE GIFT OF HAMILTON FISH

154

The interpretations of the Indian women were, in some respects, quite unlike their male counterparts. They were even less accurately depicted than the male figures—those of Greenough and Stephenson, for instance. Their representations never involved the savagery or brutality which we find in Greenough's *Rescue*. On the other hand, they often shared with the Indian braves the image of a vanishing way of life, thus emphasizing a primitive, almost Arcadian idyllicism. Such a conception was probably heightened in the aftermath of the Civil War when the whole conception of America as a new Eden gave way to the harsh realities of the horrors of war and its grim consequences.

Certainly this was the case in Hiram Powers' final, touching statue, *The Last of the Tribe* (fig. 157). where a fleet-footed, half-nude young woman rushes away from the onslaught of civilization. (A counterpart in painting is *The Last of His Tribe* by the Virginia artist John Adams Elder.) Mozier's rather moving statue of *The Indian Girl's Lament* (fig. 155) reflects this view as well,

155

though this piece has a specific literary source in a poem that was written by William Cullen Bryant.

Another approach to the depiction of the Indian woman was to suggest the beneficial effects that civilization and Christianity offered to her sweet, innocent, but essentially simple mind. This is the basic theme of Erastus Dow Palmer's first full-length sculpture, his *Indian Girl*, or *The Dawn of Christianity* (fig. 154). Here again is a half-clothed girl, who has discovered a cross in the wilderness which fills her with awe. The same theme of spiritual awakening is offered more concretely in Mozier's interpretation of the historical figure of *Pocahontas* (fig. 156), who also discovers a cross (the cross now lost) as she wanders through the wilderness, here accompanied by a deer. In this case the woman is more modestly clothed than she is in Palmer's sculpture where nudity is equated with both innocence and a primitive way of life. Some Indian figures are now lost, such as *Indian Girl* by Vinnie Ream Hoxie and the figures in Edmonia Lewis's *Hiawatha* sculptures.

156

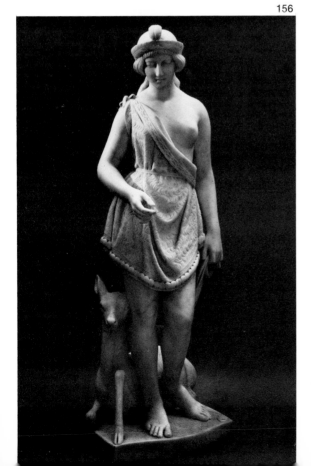

157

154. Erastus Dow Palmer, *Indian Girl*, or *The Dawn of Christianity*, 1856. Marble. The Metropolitan Museum of Art, New York City. Gift of the Hon. Hamilton Fish, 1894.
155. Joseph Mozier, *The Indian Girl's Lament*. Marble. Present location unknown; possibly New Orleans, Louisiana. Photograph courtesy of the New York Public Library.
156. Joseph Mozier, *Pocahontas*, 1877. Marble. Private collection, Piermont, New York.
157. Hiram Powers, *The Last of the Tribe*, 1873. Marble. National Collection of Fine Arts, Smithsonian Institution, Washington, D.C. Purchased in memory of Ralph Cross Johnson.

131

Edmonia Lewis

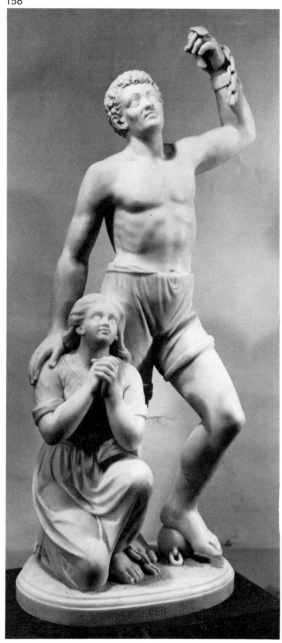

158

159

The most exotic of all the women sculptors in Rome arrived there in 1865, although some authorities suggest the later date of 1867. This was Edmonia Lewis. Her mother was a Chippewa Indian, her father a Negro. After studying at Oberlin College in Ohio, she moved on to Boston with the idea of pursuing a musical career, but there William Lloyd Garrison gave her an introduction to Edward Brackett, who encouraged her in sculpture. By selling about a hundred plaster copies of her bust of Robert Gould Shaw, the Civil War leader of a Negro regiment, she managed to raise enough money to go to Europe, where she was eagerly welcomed by Charlotte Cushman and her band of women sculptors.

Nearly all of Miss Lewis's work related to her varied background. In 1866 she made a

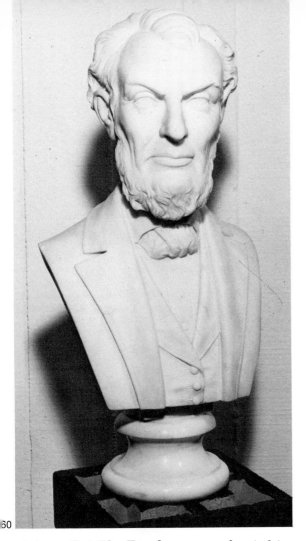

158. Edmonia Lewis, *Forever Free*, 1867. Marble. The Gallery of Art, Howard University, Washington, D.C. Photograph courtesy of the Shepherd Gallery, New York City.
159. Edmonia Lewis, *The Old Indian Arrow Maker and His Daughter*. Marble. Private collection, Piermont, New York.
160. Edmonia Lewis, *Abraham Lincoln*. Marble. San Jose Public Library, San Jose, California.
161. Edmonia Lewis, *Hiawatha* and *Minnehaha*. Marble. Kennedy Galleries, New York City. Photograph courtesy of Frank Sahulka, Bronxville, New York.

161

statue called *The Freedwoman*, unlocated today; the sculpture illustrated in fig. 158, *Forever Free*, which was formerly entitled *The Morning of Liberty*, is a similar work. Even her Biblical statue of *Hagar* may be related to her Negro background, for Hagar, like the nineteenth-century Negro, was "lost in the wilderness" and as an Egyptian woman represented Africa to nineteenth-century viewers. In addition, Miss Lewis modeled busts of various figures involved in the Civil War and Emancipation, including *Charles Sumner* and *Abraham Lincoln* (fig. 160).

Many of her sculptures were connected to her Indian origins also. There were several derived from the most famous Indian theme in nineteenth-century poetry—Longfellow's *Hiawatha*. These include *The Wooing of Hia-watha* and *The Marriage of Hiawatha*, both created around 1867; the latter is known to have been destroyed in a fire, and the other is lost. However, there do exist small busts of *Hiawatha* and *Minnehaha* (fig. 161), the same figure used by Miss Lewis in another Indian sculpture, of which three examples are known: *The Old Indian Arrow Maker and His Daughter* (fig. 159). Miss Lewis carved other religious figures besides *Hagar,* and some conceits similar to those made by Harriet Hosmer. She was known to have been in Rome during the late 1860s and was in San Francisco in 1873. After exhibiting in the Philadelphia Centennial in 1876, however, references to her become fewer, though she seems to have been in Boston in 1886 and back in Rome the following year.

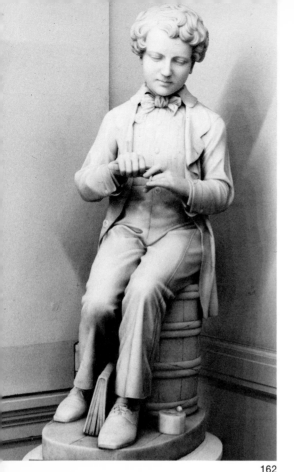

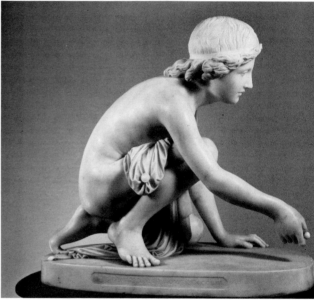

162

163

162. Joseph Mozier, *Boy Mending a Pen*. Marble. Arnot Art Gallery, Elmira, New York.
163. Thomas Crawford, *Boy Playing Marbles*, 1853. Marble. Worcester Art Museum, Worcester, Massachusetts. Bequest of Stephen Salisbury III.
164. Chauncey B. Ives, *The Truant*, after 1871. Marble. The New-York Historical Society, New York City. Gift of John B. Henderson.
165. Thomas Crawford, *Apollo and Diana*, 1848. Marble. Rollins College, Winter Park, Florida.

Another major area for the neoclassic ideal sculptors was that of genre. It is customary to think of this form in terms of the cheerful, anecdotal plaster groups of John Rogers—which were part of the reaction to neoclassicism. But Rogers' groups, which were produced from 1860 onward, reflect in a cheap, reproducible medium a type of subject already popular in marble during the previous decade. Genre—as the most "American" expression—became the most popular theme in mid-century painting, and it was not long before sculptural counterparts of William Sidney Mount's painting, for instance, were created. These sculptures emphasized particularly the delights of childhood.

Thomas Crawford was the earliest of the neoclassic sculptors to create a significant body of genre sculpture (fig. 163). Of the later artists, Randolph Rogers and particularly Chauncey B. Ives modeled many such works, and Ives's reputation rested more on this kind of subject than on any other (fig. 164). In America Erastus Dow Palmer was also active in genre subject matter, though nearly all of the neoclassic sculptors created at least one or two such works. A few must have felt the theme not suitably elevating, however, and thus, as indeed one might expect, there are no truly genre examples in the work of Hiram Powers or William Wetmore Story.

Sometimes genre sculpture could be made

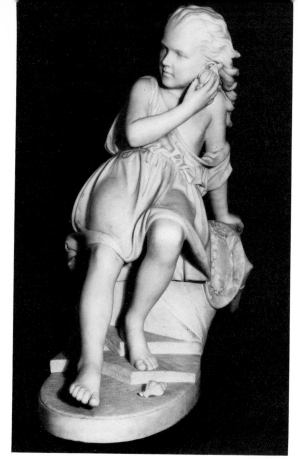

164

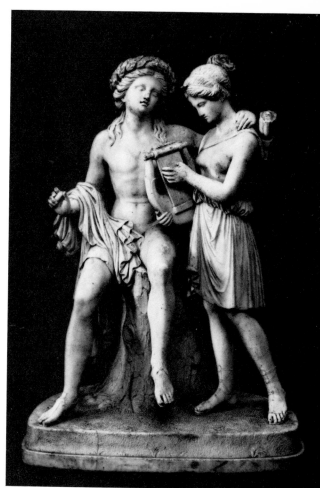

165

to embody themes of significance. Crawford's *Schoolmaster, Merchant, Soldier,* and *Schoolboy* found an elevated setting—figuratively *and* literally—in his Capitol pediment, where they represented the advance of civilization. Sometimes portraits were created in the style of genre; the most startling were probably the spectacular pair of children of a Colonel Thompson modeled by Horatio Greenough, who intended them to stand at opposite ends of a room, sculpturally caught in the act of playing shuttlecock! Mozier's *Boy Mending a Pen* is known in a number of versions (fig. 162), and several of these bear the titles of *Young Thomas Moore* and *Young Ben Franklin,* though it is not known if Mozier originally intended either of these.

Even ostensibly classical or literary subjects were occasionally treated in a genre fashion. Crawford's *Apollo and Diana* (fig. 165) may depict classical gods, but they are represented rather as two children, and the emphasis is upon the sibling relationship, as

Apollo instructs his sister on the lute. Rogers' treatment of the literary *Atala and Chacas* (fig. 133) is interpreted similarly. The most monumental piece of genre sculpture was Larkin Goldsmith Mead's *The Returned Soldier,* depicting a Union soldier relating a battle tale to a little girl; the work was appropriately installed at a Connecticut institution for soldiers' orphans, but is, unfortunately, unlocated today.

Conceits

One category of ideal sculpture popular with American artists, though less morally or thematically ambitious than the religious or classical works, were the "conceits" or "fancy pieces." These were often in the form of children and made no attempt at monumentality. By far the most famous of these was Harriet Hosmer's *Puck* (fig. 166), her most popular sculpture, of which at least thirty replicas were created. Contemporaries found the work delightfully spontaneous and felt the subject "native to a woman's fancy." Miss Hosmer created a companion piece, *Will-o'-the-Wisp* (fig. 167), a figure representing the "foolish fire" or natural phosphorescence which has come to take on the meaning of purposeful elusiveness.

It is probably this set of "paired conceits" that led Edmonia Lewis to create another pair, *Awake* and *Asleep* (figs. 168 and 169), though these are not single but paired infant figures. Several examples of this pair are known today. Haseltine's paired *Grateful Love* and *Ungrateful Love* were probably similar in type. Variants on the theme are the floral personifications, such as Gould's *Lily* and *Rose* and the various *Morning Glories* by Vinnie Ream Hoxie and John Adams Jackson.

166

168

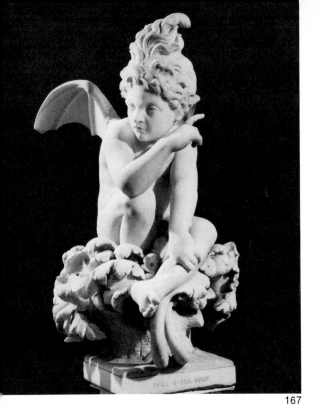

167

169

Conceits were often drawn from fairy subjects. Miss Hosmer's conceits are of this category, as was also Jackson's *The Culprit Fay*. Fairy tales also offered subject matter to our sculptors. It is strange to imagine an artist of William Wetmore Story's stature as the creator of *Cleopatra* or *Medea* depicting *Little Red Riding Hood*, a subject that also appealed to contemporary painters, including George Caleb Bingham and Robert Loftin Newman. Little-known Blanche Nevin achieved some fame with her *Cinderella*.

In the same general category belong such personifications as Vinnie Ream Hoxie's *Spirit of the Carnival* and some of the chimney pieces of Florence Freeman, who specialized in this form of sculpture. Her best-known piece, for instance, was her *Children and Yule Log with Fireside Spirits*, unlocated today.

166. Harriet Hosmer, *Puck*, 1856. Marble. National Collection of Fine Arts, Smithsonian Institution, Washington, D.C. Gift of Mrs. George Merrill.
167. Harriet Hosmer, *Will-o'-the-Wisp*. Marble. Private collection, Piermont, New York.
168. Edmonia Lewis, *Awake*, 1872. Marble, San Jose Public Library, San Jose, California.
169. Edmonia Lewis, *Asleep*, 1871. Marble. San Jose Public Library, San Jose, California.

Industrial Themes

While the American neoclassic sculptors were more concerned with continuing an established artistic tradition than with establishing or exploring innovative directions, it would be an oversimplification or perhaps an error to suggest that they ignored or disdained more progressive aesthetic ideas. Certainly, as we look at their work over a fifty-year period, we can see changes and developments within their aesthetic, and at least a slight reflection of the new naturalism of such sculptors as the contemporary Italian Lorenzo Bartolini. The revival of rococo exuberance as embodied in the work of the major French sculptor Jean Baptiste Carpeaux can also be seen in late neoclassic works. A significant testimonial to American interest in the progressive tendencies of nineteenth-century sculpture is seen in the relationship between William Wetmore Story and Giovanni Dupré. Dupré was the most powerful of the realistic sculptors of mid-nineteenth-century Italy; his *Dead Abel*, for instance, amazed the Florentine art world in 1842. Story's daughter, who had married the Marquese Peruzzi, translated Dupré's memoirs into English, and Story himself wrote the introduction to this volume.

In the sculpture itself, however, there was little evidence of either this new realism or of the succeeding impressionism of Rodin. There were a few works, however, that reflected the new social realist interests in modernity and the working classes. These sculptures did not embody the powerful strength of the Belgian Constantin Meunier or of the Italian Vincenzo Vela, but they dealt with contemporary themes. Two examples of modern subjects are both paired sculptures, a duality that occurs in American art of the period with surprising frequency. One such pair, now unlocated, is Gould's *Steam* and *Electricity*, which once stood in the vestibule of the Herald Building in Boston. *Steam* bears a full, strong face representing power and force; *Electricity*, embodying energy, is less robust but more energetic. The other pair is that by Emma Stebbins, variously referred to as *Industry* and *Commerce*, or *Miner* and *Sailor* (figs. 170 and 171). These figures were commissioned by Phillip M. Lydig of Paris for August Heckscher, the New York coal merchant, and thus represent in modern allegory his commercial interests—the source of his wealth and the means of transporting it.

170

170. Emma Stebbins, *Industry*, 1859. Marble. Heckscher Museum and Art Gallery, Huntington, Long Island, New York.
171. Emma Stebbins, *Commerce*, ca. 1859. Marble. Heckscher Museum and Art Gallery, Huntington, Long Island, New York.

138

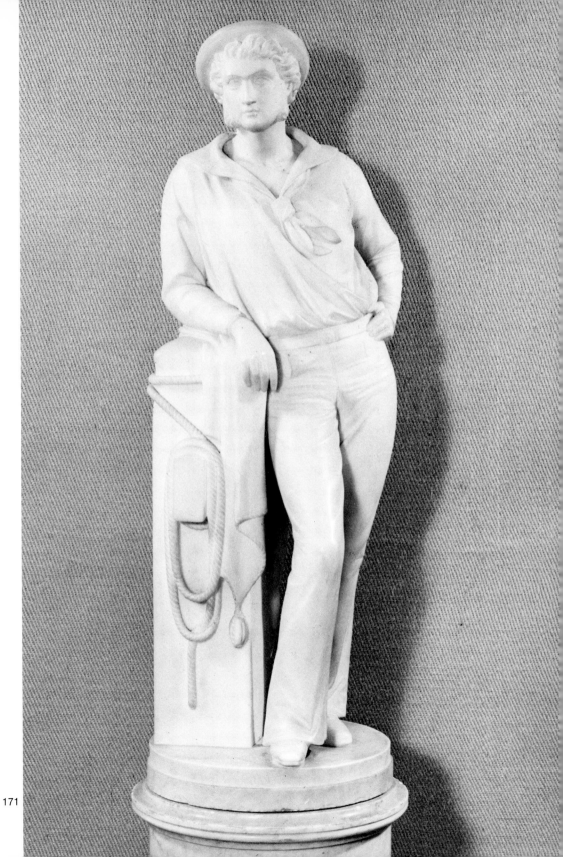

171

Hand and Foot Sculptures

To twentieth-century eyes and tastes, the strangest category of forms popular in the neoclassic period is probably that of fragmentary parts of the human anatomy. The head and the bust are, of course, fragmentary forms, but their history and tradition are as old as sculpture itself. Far stranger are the hand and foot sculptures which are also among the smallest works produced at the time. While such sculptures bespeak a certain sentimentality—that is, they celebrate a certain intimate admiration for a specific feature, somewhat like the equally strange "eye" miniatures popular around 1800—they also bespeak a certain fetishism, if not a macabre quality.

Hand sculptures are certainly not limited to American artists; many European examples of the mid-nineteenth century are known today as well. Probably the most famous such American work was *Loulie's Hand* by Hiram Powers (fig. 175), which represented the hand of the artist's infant daughter resting on a daisy. Powers modeled the work in 1839, and it was later transferred into marble by his artisan carvers as a surprise and a gift for him. Such a work thus had a

172. Erastus Dow Palmer, *Foot of The White Captive*, 1860(?). Plaster. Walters Art Gallery, Baltimore, Maryland.
173. Vinnie Ream Hoxie, *Hand*. Marble. State Historical Society of Wisconsin, Madison, Wisconsin.
174. Harriet Hosmer, *Clasped Hands of Elizabeth and Robert Browning*, 1853. Bronze. Armstrong Browning Library, Baylor University, Waco, Texas.
175. Hiram Powers, *Loulie's Hand*, after 1839. Marble. Fogg Art Museum, Harvard University, Cambridge, Massachusetts.

very personal quality to it, but its appeal obviously went beyond the immediate family, since replicas were owned by others, including members of the nobility of England and Prussia. Captain John Grant, the purchaser of the first *Greek Slave,* also owned an example, and Mrs. Horatio Greenough owned two. The sculpture was mentioned in Hawthorne's novel *The Marble Faun.*

Almost equally famous was Harriet Hosmer's *Clasped Hands of Elizabeth and Robert Browning* (fig. 174), of which a number of bronze replicas are known. Harriet Hosmer was part of the circle of Americans and Englishmen who clustered around the Brownings in Rome and Florence. Miss Hosmer had met the writers in 1853, the year she created the sculpture, and she cast the hands herself at the request of Elizabeth Browning. At the time of his death, the sculptor wrote the following lines:

> "Parted by death," we say,
> Yet, "hand in hand they went their
> eternal way."

The Hosmer sculpture surely inspired the similar work by her fellow American, Vinnie Ream Hoxie (fig. 173).

Even more bizarre are the rare foot sculptures of the period. An Englishman, Charles Griswald, purchased not only a bust of *The*

Greek Slave, but her foot as well, and Erastus Dow Palmer made a cast of the foot of his popular *White Captive* (fig. 172). While today such works seem grotesque and are treated as curios, in their own times they were meaningful memorials and tributes to either personal or ideal beauty.

175

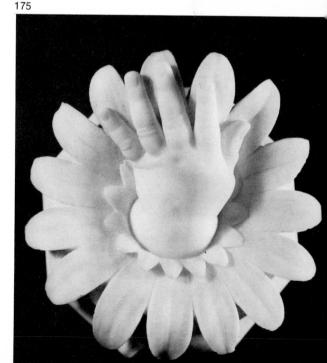

Animals

176

The range of sculpture has always been far more limited than that of painting, at least until recent years when sculptors have turned to the traditional painting subjects of landscape and still life. But in the nineteenth cen-

177

tury the human figure, either whole, in part, or grouped, was almost the only subject for the sculptor. Occasionally, however, animals were included in sculptural monuments. This was most often the case, of course, with equestrian monuments, but except for Thomas Crawford's *Washington* in Richmond, most of our neoclassic sculptors did not attempt equestrian groups; it was rather the next generation of realist artists in bronze who found this a rewarding field of endeavor.

Animals other than horses figure as subsidiary but meaningful elements in a number of works, such as Richard Greenough's *Cupid and Tortoise*. One of the most beautiful animal sculptures is the *Deer* (fig. 179) that accompanies Mozier's *Pocahontas* (fig. 156), a very sleek and stylized animal, which may have its origin in one of the animal sculptures preserved in the Vatican Museum. The deer here

has several symbolic functions, as well as formal and technical ones. It symbolizes the virgin wilderness of America and at the same time reflects the sweet, gentle spirit of the Indian maiden, who inspires no fear in the untamed beast.

There were, in addition, a few pure animal sculptures created by American neoclassicists. The most famous of these was the *St. Bernard Dog* that Horatio Greenough modeled for the prominent Boston merchant and art patron, Colonel Thomas Handasyd Perkins, for the Perkins lot in Mount Auburn Cemetery (fig. 178).

In 1835 Greenough acquired a greyhound, which he named Arno, and a few years later executed a stylized but anatomically precise statue of the animal (fig. 176), which was eventually acquired by Edward Everett.

Dogs, the traditional symbol of fidelity, seem to have been the only animal subject to receive important independent treatment; besides those by Greenough, Harriet Hosmer carved a favorite *Staghound* belonging to her friend, the Empress of Austria (fig. 177).

178

LIST OF ILLUSTRATIONS

146

ACKNOWLEDGMENTS

The museums, libraries, historical societies, and colleagues that have aided me over the years in bringing together the material presented here are too numerous to be individually listed. However, special thanks are due to the National Collection of Fine Arts in Washington, particularly to David Scott, the former Director; Joshua Taylor, the present Director; and to William Truettner and Robin Bolton Smith. The students enrolled in several seminars on the topic, both at the National Collection and at the University of Maryland, contributed a great deal of information and made many incisive observations which furthered the course of this study. My special gratitude goes also to Mrs. Bernardo Seeber, the great-granddaughter of Hiram Powers; Clara Dentler, who produced a rich biographical manuscript and an invaluable check list of Powers' works; the late James Porter of Howard University; Professor Wayne Craven and Michael Richman of the University of Delaware and the Index of American Sculpture; Mrs. Wilson F. Payne, who provided information and photographs of the work of Anne Whitney and other women sculptors; John Richard Craft, Director of the Columbia Museum of Art, Columbia, South Carolina; Barry Delaney of the Staten Island Institute of Arts and Sciences; Richard Wunder, at present working on a *catalogue raisonné* of Powers' work; John Dryfhout, Curator of the Saint-Gaudens National Historical Site; Eugenia Holland of the Maryland Historical Society; Mrs. E. Ives Bartholet, the granddaughter of Chauncey B. Ives; George Heard Hamilton, of the Clark Art Institute, who generously lent me his unpublished thesis on Hezekiah Augur; Professor Francis Grubar of George Washington University and Martha Morris of the Corcoran Gallery of Art, who gave me assistance in regard to the work of Horatio Stone; Peter de Brandt, a descendant of William Wetmore Story; Millard F. Rogers, Jr., who has recently published a book on Randolph Rogers; Professor Nathalia Wright, who has published a volume on Horatio Greenough; Professor Robert Gale, who has written a book on Thomas Crawford; Professor William B. Miller, who has published a study of the work of Paul Akers—all of these authors have been exceedingly helpful, particularly in the matter of photographs—Professor J. Carson Webster, who is working on Erastus Dow Palmer; Ian Grant who aided me in locating works in English collections; and Mario Praz.

A special note of thanks is due also to several dealers: Robert Vose, Jr., of the Vose Galleries of Boston; Elizabeth Clare of M. Knoedler & Co.; Robert Kashey of The Shepherd Gallery; Robert Schoelkopf; and Victor D. Spark, all of whom often brought works to my attention and assisted me in obtaining photographs. I owe my appreciation to Louise Segal, whose echoing of my own enthusiasm for this field produced concrete scholarly results; Theodore Stebbins, Jr., Garvan Curator at Yale University, for his constant interest and support; Marchal Landgren of the faculty and Art Gallery of the University of Maryland, particularly in the matter of thematic problems; Russell Burke, a colleague here, as in our joint study of American still-life painting; and above all, to James H. Ricau, who did much to revive contemporary interest in this field. Without his enthusiasm, my own interest and study, resulting in this book, would not have been.

BIBLIOGRAPHY

The bibliography is divided into three parts. The first is devoted to general books and other published material dealing with or referring to neoclassic sculpture, and to works treating some of the European artists who preceded and were contemporary with the American neoclassicists. The second part is concerned with the individual American sculptors and is divided into sections concerning each of them. If a publication deals with two or three of the artists, it is repeated in each section, where pertinent. If it deals with more than three, it is relegated to the general part of the bibliography. A few articles are listed in both the first and second parts of the bibliography: those of and by Powers, Palmer, Story, and Hosmer; although the subject matter is of general interest, the articles also figure in the sections relating to the artists who wrote them.

The third part of the bibliography lists those travel books in which the authors describe their visits with American sculptors in Florence and Rome, and their general reactions to sculpture seen on their European Grand Tour. The aim of the bibliography is to be comprehensive and parts I and II are, it is hoped, quite complete, although some material has, inevitably, escaped my attention. Part III, however, cannot claim such comprehensiveness. I have consulted hundreds of such travel books, and the ones here listed are all those I have seen that deal strongly with artistic matters. However, no single library has a total inventory of such travel books, and some must have escaped my attention. Furthermore, most of the books consulted deal with travel between 1826 and 1876; some of the travel books of the last twenty-five years of the century must also have described visits with the later neoclassicists. Finally, most of the travel books consulted were written by Americans; there were also some English and Continental writers who described visits to American studios, although, presumably, they were far fewer in number than the native authors. In a few cases, where the travelers were in Florence and Rome so early that only Horatio Greenough and Thomas Crawford, respectively, were residents there, the books are listed rather in the second part of this bibliography.

Part I

Abbot, Jacob. *Rollo's Tour in Europe: Rollo in Rome.* 1858.
About, Edmond F. V. *Rome Contemporaine.* 1861.
Adams, Adeline. *The Spirit of American Sculpture.* 1923.
Agard, Walter R. *The Greek Tradition in Sculpture.* 1930.
Akers, Benjamin Paul. "Sculpture in the United States." *Atlantic Monthly,* vol. XXII, no. LXXXIII, November 1868, pp. 558–564.
"American Artists in Italy." *Harper's New Monthly Magazine,* vol. XLI, August 1870, pp. 420–425.
American Art Annual. 1898–.
Arnold, John Nelson. *Art and Artists of Rhode Island.* 1905.
"Art in the United States." *The Art Union,* vol. VI, May 1844.
Baker, Paul R. *The Fortunate Pilgrims, Americans in Italy 1800–1860.* 1964.
Ball, Thomas. *My Threescore Years and Ten. An Autobiography.* 1892.
Bassi, Elena. *Canova.* 1943.

Beck-Friis, Johan. *The Protestant Cemetery in Rome.* 1956.
Bell, Millicent. *Hawthorne's View of the Artist.* 1962.
Benjamin, Samuel G. W. *Art in America.* 1880.
———. "Sculpture in America." *Harper's New Monthly Magazine,* vol. LVIII, no. CCCLVII, April 1879, pp. 657–671.
Benson, Eugene. *Art and Nature in Italy.* 1882.
Bolton, Ethel Stanwood. *American Wax Portraits.* 1929.
Bonfigli, Salvatore. *The Artistical Director; or, Guide to the Studios in Rome with much Supplementary Information.* 1858.
———. *Guide to the Studios in Rome.* 1860.
Brewster, Anna. "American Artists in Rome." *Lippincott's Magazine of Literature, Science, and Education,* vol. III, February 1869, p. 196.
Brooks, Van Wyck. *The Dream of Arcadia; American Writers and Artists in Italy 1760–1915.* 1958.
Brown, William Wells. *The Rising Sun: or, The Antecedents and Advancement of the Colored Race.* 1876.

Buckingham, J. T. "The Art of Sculpture," *New England Magazine,* vol. V, December 1833, pp. 480–485.

Caffin, Charles. *American Masters of Sculpture.* 1903.

Calvert, George. "The Process of Sculpture." *The Literary World,* vol. II, no. 33, September 18, 1847, pp. 159–160.

Catalogue of Pictures and Statuary in the Art Galleries at Woodward's Gardens, San Francisco, n.d.

"Central Park Bronzes." *The Aldine,* vol. VI, no. 10, October 1873, p. 207.

Chamberlain, Georgia Stamm. *Studies on American Painters and Sculptors of the Nineteenth Century.* 1965.

Channing, William Ellery. *Conversations in Rome: Between an Artist, a Catholic, and a Critic.* 1847.

Chapin, Howard M. "George Annable, Sculptor." *Rhode Island Historical Society Collections,* vol. XXII, 1929.

Chase, Mary Ellen, *et al. Maine and Its Role in American Art, 1740–1963.* 1963.

Cheney, Ednah D. *Memoir of Seth W. Cheney, Artist.* 1881.

Cist, Charles. *Cincinnati in 1841—Its Early Annals and Future Projects.* 1841.

Clark, Edna M. *Ohio Art and Artists.* 1932.

Clark, William J. *Great American Sculptures.* 1877.

"Classical America 1815–1845." Catalogue of exhibition, April 26–September 2, 1963. The Newark Museum, Newark, New Jersey.

Clement, Clara E., and Laurance Hutton. *Artists of the Nineteenth Century.* 1879.

Colvin, Sir Sidney. *Memories and Notes of Persons and Places, 1852–1921.* 1921.

Compilation of Works of Art and Other Objects in the United States Capitol. 1965.

Conner, R. D. W. *Canova's Statue of Washington.* 1910.

Cowdrey, Mary Bartlett. *American Academy and American Art Union, Exhibition Record 1816–1852.* 1953.

———. *National Academy of Design Exhibition Record, 1826–1860.* 1943.

Crane, Sylviae. *White Silence, Greenough, Powers, and Crawford, American Sculptors in Nineteenth-Century Italy.* 1972.

Craven, Wayne. *Sculpture in America from Colonial Period to the Present.* 1968.

———. "The Index of American Sculpture: A New Research Archive." *Antiques,* vol. XCIV, no. 5, November 1968, pp. 712–713.

Cummings, Thomas S. *Historical Annals of the National Academy of Design.* 1865.

Cunnington, Cecil Willett. *Feminine Attitudes in the Nineteenth Century.* 1935.

Davis, Miss E. M. *Early Nineteenth Century Artists in Pittsburgh, Cleveland, and St. Louis.* Ms. at the Frick Art Reference Library, New York.

"Development of Nationality in American Art," by "W." *Bulletin of the American Art-Union,* December 1, 1851, pp. 137–139.

Didier, Eugene L. "American Authors and Artists in Rome." *Lippincott's Magazine,* vol. 34, November 1884, pp. 491–495.

Dodge, Pickering. *Sculpture and the Plastic Age.* 1850.

Downes, William Howe. "Monuments and Statues in Boston." *New England Magazine,* vol. XI, no. 3, November 1894, pp. 353–372.

Dunlap, William. *History of the Rise and Progress of the Arts of Design in the United States.* 1834.

Dupré, Giovanni. *Thoughts on Art and Artists. Biographical Memoirs of Giovanni Dupré.* Translated by Mme. E. M. Peruzzi. Introduction by William Wetmore Story. 1886.

Ellet, Elizabeth Fries. *Women Artists in All Ages and Countries.* 1858.

Emerson, Ralph Waldo. *The Letters of Ralph Waldo Emerson.* 6 vols. 1939.

Everett, Edward. "American Sculptors in Italy." *The Boston Miscellany of Literature and Fashion,* vol. I, no. 1, January 1842, pp. 4–9.

Fairhold. "Rambles in Rome." *The Art Journal,* vol. XIX, 1857, pp. 153–154.

Fairman, Charles E. *Art and Artists of the Capitol of the United States of America.* 1927.

"The Famous Quarries of the World." *Putnam's Monthly Magazine,* vol. IV, October 1854, pp. 404–408.

Fielding, Mantle. *Dictionary of American Painters, Sculptors, and Engravers.* 1926.

Flagg, Wilson. *Mount Auburn Cemetery.* 1861.

"Florentia." "A Walk Through the Studios of Rome." *The Art Journal,* vol. XVI, no. 6, 1854, pp. 184–187, 287–289, 322–324, 350–355.

Forbes, Harriette M. "Early Portrait Sculpture in New England." *Old Time New England,* vol. XIX, no. 4, April 1929, pp. 159–173.

Freeman, James E. *Gatherings from an Artist's Portfolio.* 1877.

———. *Gatherings from an Artist's Portfolio in Rome.* 1883.

French, Henry W. *Art and Artists of Connecticut.* 1879.

Gardner, Albert TenEyck. *American Sculpture, a Catalogue of the Collection of the Metropolitan Museum of Art.* 1965.

———. "The Statuary Gallery of 1870." *The Metropolitan Museum of Art Bulletin,* new series vol. IV, no. 8, April 1946, pp. 214–220.

———. *Yankee Stonecutters, the First American School of Sculpture: 1800–1850.* 1945.

Gerdts, William H. "American Sculpture." *American Artist,* vol. XXVI, no. 7, September 1962, pp. 40–47.

———. "American Sculpture: the Collection of James H. Ricau." *Antiques,* vol. LXXXVI, no. 3, September 1964, pp. 291–298.

———. "I Dreamt I Dwelt in Marble Halls: a Century of American Sculpture." *Antiques,* vol. LXXXII, no. 2, August 1962, pp. 146–149.

———. "Marble and Nudity." *Art in America,* vol. LIX, no. 3, May–June 1971, pp. 60–67.

———. "Sculpture by 19th Century American Artists." *The Museum,* vol. XIV, no. 4, Fall 1972. Quarterly publication of The Newark Museum, Newark, New Jersey.

———. Essay, "A Survey of American Sculpture," in catalogue of exhibition, May 10–October 20, 1962. The Newark Museum, Newark, New Jersey.

———. Essay, "The White Marmorean Flock," in catalogue of exhibition, April 4–April 30, 1972. Vassar College Art Gallery, Poughkeepsie, New York.

———. Essay, "Women Artists of America 1707–

1964," in catalogue of exhibition, April 2–May 16, 1965. The Newark Museum, Newark, New Jersey.

Geske, Norman A. Essay, "American Sculpture," in catalogue of exhibition, September 11–November 15, 1970. Presented by the Nebraska Art Association at the University of Nebraska.

Gillon, Edmund V., Jr. *Victorian Cemetery Art.* 1872.

Gilman, Roger. "Harvard Gains Early Sculpture." *Art News,* vol. XXXIII, May 18, 1935, p. 5.

Greeley, Horace, ed. *Art and Industry as Represented in the Exhibition at the Crystal Palace, New York, 1853–1854.* Rev. ed. 1853.

Green Mount Cemetery One Hundredth Anniversary 1838–1938, n.d.

Greenough, Henry. *Ernest Carroll or Artist-Life in Italy.* 1858.

Groce, George C., and David H. Wallace. *The New-York Historical Society's Dictionary of Artists in America: 1564–1860.* 1957.

Gschaedler, André. *True Light on the Statue of Liberty and Its Creator.* 1966.

Gunnis, Rupert. *Dictionary of British Sculptors.* 1954.

Hanaford, Phebe. *Daughters of America.* 1882.

Harris, Neil. *The Artist in American Society.* 1966.

Hartmann, Sadikichi. *A History of American Art.* 2 vols. 1902.

Hawthorne, Nathaniel. *The Marble Faun.* (See especially edition entitled *Transformation—or, The Romance of Monte Beni.*) 2 vols. Leipzig, 1860.

Henderson, Helen T. *The Art Treasures of Washington.* 1912.

Holland, John. *Memorials of Sir Francis Chantrey, R.A. Sculptor, in Hallamshire and Elsewhere.* 1851.

Hosmer, Harriet. "The Process of Sculpture." *Atlantic Monthly,* vol. XIV, no. LXXXVI, December 1864, pp. 734–737.

Hubert, Gerard. *La sculture dans l'Italie Napolienne.* 1964.

H. W. "Lady-Artists in Rome." *The Art Journal,* vol. XXVIII, new series V, 1866, p. 177.

Jarves, James Jackson. *The Art-Idea.* 1864.

——. *Art Thoughts.* 1869.

——. "Progress of American Sculpture in Europe." *The Art Journal,* vol. XXXIII, new series vol. X, 1871, pp. 6–8.

Johnson, Allen, and Dumas Malone, eds. *Dictionary of American Biography.* 1928–1936.

Kauffmann, Samuel H. "Equestrian Statuary in Washington." *Records of the Columbia Historical Society, Washington, D.C.,* vol. V, 1902.

La Piana, Angelina. *La cultura Americana e l'Italia.* 1938.

Larkin, Oliver. *Art and Life in America.* 1949.

Larabee, Stephen A. *English Bards and Grecian Marbles.* 1943.

Leach, Joseph. *Bright Particular Star: The Life and Times of Charlotte Cushman.* 1970.

Lee, Hannah. *Familiar Sketches of Sculpture and Sculptors.* 1854.

"Letter from Florence." *Bulletin of the American Art-Union,* August 1851, p. 80.

Licht, Fred. *Sculpture—the 19th & 20th Centuries.* 1967.

Locke, Alain L. *The Negro in Art: A Pictorial Record of the Negro Artist and of the Negro Theme in Art.* 1940.

Lynes, Russell. *The Tastemakers.* 1954.

McSpadden, Joseph Walker. *Famous Sculptors of America.* 1924.

Marrard, Howard. "American Travels in Rome." *Catholic Historical Review,* vol. 29, no. 4, January 1944, pp. 470–509.

Matthews, T. *The Biography of John Gibson, R.A. Sculptor.* 1911.

Mechlin, Leila. "Art Life in Washington." *Records of the Columbia Historical Society, Washington, D.C.,* vol. XXIV, 1922.

Medwin, T. "Canova." *The Corsair,* vol. I, no. 30, October 5, 1839, pp. 469–471.

Miller, Lillian B. *Patrons and Patriotism, The Encouragement of the Fine Arts in the United States 1790–1860.* 1966.

"Naked Art." *The Crayon,* vol. VI, part 12, December 1859, pp. 377–378.

Nealy, Mary E. "Art at the Capitol." *The Aldine,* vol. IX, no. 4, 1878–1879, p. 147.

Negro, Silvio. *Seconda Roma 1850–1870.* 1943.

The New-York Historical Society. *Catalogue of American Portraits.* 1941.

19th Century American Paintings and Sculpture. Catalogue of exhibition, April 16–September 7, 1970, The Metropolitan Museum of Art.

Osgood, Samuel. "American Artists in Italy." *Harper's New Monthly Magazine,* vol. XLI, no. 243, August 1870, pp. 420–425.

Palmer, Erastus Dow. "Philosophy of the Ideal." *The Crayon,* vol. III, part 1, January 1856, pp. 18–20.

Partridge, William Ordway. "An American School of Sculpture." *The Arena,* vol. XLII, May 1893, pp. 641–653.

Philadelphia Official Catalogue, part II; Art Gallery, Annexes, and Outdoor Works of Art. 1876.

Pinckney, Pauline A. *American Figureheads and Their Carvers.* 1940.

Plon, Eugene. *Thorwaldsen: His Life and Works.* 1874.

Porter, James A. *Modern Negro Art.* 1943.

Post, Chandler Rathfon. *A History of European and American Sculpture from the Early Christian Period to the Present Day.* 2 vols. 1921.

Powers, Hiram. "Perception of Likeness." *The Crayon,* vol. I, no. 15, April 11, 1855, pp. 229–230.

——. "Powers on Color in Sculpture." *The Crayon,* vol. I, no. 10, March 7, 1855, p. 149.

Prezzolini, Giuseppe. *Come gli Americani scoprirono l'Italia 1750–1850.* 1933.

"The Processes of Sculpture." *Cosmopolitan Art Journal,* vol. II, no. 1, December 1857, p. 33.

Quinby, Florence Cole. *The Equestrian Monuments of the World.* 1913.

Radcliffe, Alida Graveraet. *Schools and Masters of Sculpture.* 1902.

Radcliffe, Anthony. "Monti's Allegory of the Risorgimento." *Victoria and Albert Museum Bulletin,* vol. I, no. 3, July 1965, pp. 25–38.

Randall, Lilian M. C. "An American Abroad: Visits to Sculptors' Studios in the 1860s." *The Journal of the Walters Art Gallery,* vols. XXXIII–XXXIV, 1970–1971, pp. 42–51.

Robbins, E. W. "Our Sculptors." *American Literary Magazine,* vol. III, no. 6, December 1848, p. 368.

Rossetti, W. M., ed. and arr. *Ruskin: Rossetti: Preraphaelitism Papers 1854–1862.* 1899.

Rusk, William Sener. *Art in Baltimore—Monuments and Memorials.* 1924.

Rutledge, Anna Wells. *Artists in the Life of Charleston, through Colony and State from Restoration to Reconstruction.* 1949.

————. *Cumulative Record of Exhibition Catalogues, The Pennsylvania Academy of Fine Arts, 1807–1870; The Society of Artists, 1800–1814; The Artists Fund Society, 1835–1845.* 1955.

Sandhurst, Phillip T. *The Great Centennial Exhibition.* 1876.

Scarpellini, Pietro. *Canova e l'ottocento.* 1968.

"Sculpture in Cincinnati." *United States Magazine and Democratic Review,* vol. VIII, no. 33, September 1840, pp. 247–251.

"Sculpture 1850 and 1950." Catalogue of exhibition, May–September 1957, London County Council Exhibition, Holland Park, London.

"Sculpture and the Fine Arts vs. the Spirit of the Age." *American Monthly Magazine* (New York), vol. IV, no. 4, January 1835, pp. 242ff.

"Sculpture and Sculptors in the United States." *The American Monthly Magazine* (Boston), vol. I, no. 2, May 1829, pp. 124ff.

"Sculptors and Sculpture." *Cosmopolitan Art Journal,* vol. IV, no. 4, December 1860, pp. 181–182.

"Sculpture in the United States." *Atlantic Monthly,* vol. XXII, no. 123, November 1868, pp. 558–564.

Sharf, Frederic A. "The Garden Cemetery and American Sculpture: Mount Auburn." *The Art Quarterly,* vol. XXIV, no. 1, Spring 1961, pp. 80–88.

Shedd, Julia Ann. *Famous Sculptors and Sculpture.* 1896.

"Statue Making." *The Aldine,* vol. II, no. 8, August 1869, p. 75.

Stillman, William James. "American Sculpture." *Cosmopolitan Art Journal,* vol. IV, no. 1, March 1860, pp. 1–4.

————. *The Autobiography of a Journalist.* 2 vols. 1901.

Story, William Wetmore. *Conversations in a Studio.* 2 vols. 1890.

Strahan, Edward (pseud. for Earl Shinn). *Art Treasures of America.* 3 vols. 1879.

Sturges, Russell. "Sculpture." *The Forum,* vol. XXXIV, no. 2, October–November 1902, pp. 248–268.

Sumner, Charles. "Art in the National Capitol." Speech of the Hon. Charles Sumner in the Senate of the United States, July 17, 1866. 1866.

Swan, Mabel M. *The Athenaeum Gallery, 1827–1873.* 1940.

Swett, Lucia Gray. *John Ruskin's Letters to Francesca Alexander, and Memoirs.* 1931.

Taft, Lorado. *The History of American Sculpture.* New edition, with supplementary chapter by Adeline Adams. 1924.

Tait, John R. "Reminiscences of a Poet-Painter." *Lippincott's Magazine of Popular Literature and Science,* vol. XIX, March 1877, pp. 309–310.

Tarchiani, N. *La scultura italiana dell'Ottocento.* 1936.

Thornton, Ward, ed. *The Letters of Mrs. Henry Adams.* 1936.

Thorp, Margaret Farrand. *The Literary Sculptors.* 1965.

————. "The White Marmorean Flock." *New England Quarterly,* vol. XXXII, no. 2, June 1959, pp. 147–169.

Thurston, R. B. Essay, in *Eminent Women of the Age.* 1868.

Ticknor, George. *Life, Letters, and Journals of George Ticknor.* 2 vols. 1876.

Tinti, Mario, *L. Bartolini.* 1936.

Townsend, Henry C. *A Memoir of T. Buchanan Read.* 1889.

Trollope, Frances M. *Domestic Manners of the Americans.* 1832.

————. *A Visit to Italy.* 2 vols. 1842.

Tuckerman, Henry Theodore. *Book of the Artists.* 1867.

————. *Italian Sketchbook.* 1848.

————. *Leaves from the Diary of a Dreamer.* 1853.

Vedder, Elihu. *Digressions of V.* 1910.

Vermeule, Cornelius, III. "America's Neoclassic Sculptors: Fallen Angels Resurrecter." *Proceedings of the Massachusetts Historical Society,* vol. 83, no. 1971; same in *Antiques,* vol. CII, no. 5, November 1972, pp. 868–875.

Viardot, Louis. *Wonders of Sculpture.* 1873.

Vigezzi, Silvio. *La scultura italiana dell'Ottocento.* 1932.

"Visits to Studios of Rome." *The Art Journal,* vol. XXXIII, new series vol. X, 1871, pp. 162–164.

Walker, Katherine C. "American Studios in Rome and Florence." *Harper's New Monthly Magazine,* vol. XXXIII, no. 193, June 1866, pp. 101–105.

Walter, Cornelia. *Mount Auburn, Rural Cemeteries of America.* 1847.

Waters, Clara Erskine Clement. *Women in the Fine Arts.* 1904.

Whittenmore, Frances Davis. *George Washington in Sculpture.* 1933.

Wilson, James Grant, and John Fiske, eds. *Appleton's Cyclopaedia of American Biography.* Rev. ed. 1898–1900.

"Woman's Position in Art." *The Crayon,* vol. VIII, part 2, February 1860, pp. 25–28.

See also the various yearly guidebooks to Italy of the period for artists' addresses and listings and comments on their sculpture, especially those of Piale and John Murray.

Part II

Note also articles on Brown, Palmer, Powers, John Rogers, Saint-Gaudens, and Story, in *American Art Journal,* vol. 2, no. 2, Fall 1972, in preparation at this time.

Akers, Benjamin Paul

"Benjamin Paul Akers." *Maine Library Bulletin,* vol. XIII, January 1928, pp. 65–71.

Cary, Richard. "The Misted Prism: Paul Akers and Elizabeth Akers Allen." *Colby Library Quarterly,* series VII, no. 5, March 1966, pp. 193–226.

"Editor's Easy Chair." *Harper's New Monthly Magazine,* vol. 20, no. CXX, May 1860, pp. 845–847.

Miller, Roscoe R. "An American Sculptor of Note." *Americana,* vol. XXVII, No. 4, October 1933, pp. 452–455.

Miller, William B. "A New Review of the Career of Paul Akers 1825–1861." *Colby Library Quarterly,*

series VII, no. 5, March 1966, pp. 227–255.

"The Sculptor and *The Pearl Diver.*" *Maine in History and Romance.* 1915, pp. 191–197.

Tuckerman, Henry Theodore. "Two of Our Sculptors: Benjamin Paul Akers and Edward Sheffield Bartholomew." *Hours at Home,* vol. II, no. 6, April 1866, pp. 525–535.

Usher, Leila. "Paul Akers." *New England Magazine,* new series vol. XI, 1894, pp. 460–468.

Augur, Hezekiah

Baldwin, Ebenezer. "Augur." *American Historical Magazine and Literary Record,* vol. I, no. 2, February 1836, pp. 44–53.

Hamilton, George Heard. "Hezekiah Augur." Unpublished Ph.D. dissertation. Yale University, 1934.

Ball, Thomas

Ball, Thomas. *My Three Score Years and Ten.* 1892.

Craven, Wayne. "The Early Sculptures of Thomas Ball." *North Carolina Museum of Art Bulletin,* vol. V, nos. 1 and 2, Fall 1964–Winter 1965, pp. 3–12.

Partridge, William Ordway. "Thomas Ball." *New England Magazine,* new series vol. VII, no. 3, May 1895, pp. 291–304.

Barbee, William Randolph

"Editor's Easy Chair." *Harper's New Monthly Magazine,* vol. XX, no. CXX, May 1860, pp. 845–847.

Richmond Enquirer. October 1–12, 1858.

Richmond Enquirer. June 19, 1868. (Obit.)

Wayland, John W. *A History of Shenandoah County, Virginia.* 1927, pp. 524–525, 582–583.

Bartholomew, Edward Sheffield

Crane, Susan U. "Edward Sheffield Bartholomew." *Connecticut Quarterly,* vol. II, 1896, pp. 204–214.

The Crayon, vol. V, part 7, July 1858, p. 211. (Obit.)

"Edward S. Bartholomew." *Cosmopolitan Art Journal,* vol. II, no. 4, September 1858, pp. 184–185.

Tuckerman, Henry Theodore. "Two of Our Sculptors: Benjamin Paul Akers and Edward Sheffield Bartholomew." *Hours at Home,* vol. II, no. 6, April 1866, pp. 525–535.

Wendell, William. "Edward Sheffield Bartholomew, Sculptor." *Wadsworth Atheneum Bulletin,* Winter 1962, pp. 1–8.

Brackett, Edward Augustus

Newark Daily Advertiser. April 3, 1852.

Brackett, Edward Augustus. *My House, Chips the Builder Threw Away.* Poems. 1904.

———. *Twilight Hours; or, Leisure Moments of an Artist.* Poems. 1845.

Gardner, Albert TenEyck. "Memorials of an American Romantic." *The Metropolitan Museum of Art Bulletin,* new series vol. III, no. 2, October 1944, pp. 54–59.

Brown, Henry Kirke

Boston Transcript. July 12, 1886. (Obit.)

Bulletin of the American Art-Union, vol. II, no. 2, May 1849, p. 28.

Craven, Wayne. "Henry Kirke Brown in Italy, 1842–1846." *The American Art Journal,* vol. I, no. 1, Spring 1969, pp. 65–77.

"Crawford's *Hebe and Ganymede*; H.K. Brown's *Indian and Panther.*" *The Crayon,* vol. II, no. 6, August 8, 1855, pp. 82–83.

Gibbes, Robert W. *A Memoir of James De Veaux of Charleston, South Carolina.* 1846.

"Henry Kirke Brown." *Studio,* new series vol. II, no. 2, August 1886, 29–32.

Kip, William Ingraham. *The Christmas Holidays in Rome.* 1846.

"Three Artists." *Pocumtuck Valley Memorial Association (Deerfield) History and Proceedings,* vol. VII, 1929.

Ceracchi, Giuseppe

Desportes, Ulysses. "Giuseppe Ceracchi in America and His Busts of George Washington." *The Art Quarterly,* vol. XXVI, no. 2, Summer 1963, pp. 140–179.

Gardner, Albert TenEyck. "Fragment of a Lost Monument." *The Metropolitan Museum of Art Bulletin,* new series vol. VI, no. 7, March 1948, pp. 189–198.

Clevenger, Shobal Vail

American Collector, vol. XV, May 1946, p. 13. Reproduction.

Brumbaugh, Thomas B. "Letters of an American Sculptor, Shobal Clevenger." *The Art Quarterly,* vol. XXIV, no. 4, Winter 1961, pp. 370–377.

———. "Shobal Clevenger: An Ohio Stonecutter in Search of Fame." *The Art Quarterly,* vol. XXIX, no. 1, 1966, pp. 29–45.

"Clevenger." *United States Magazine and Democratic Review,* vol. VIII, February 1844, pp. 202–205.

"Powers and Clevenger." *Bulletin of the American Art-Union,* July 1850, p. 65.

Tuckerman, Henry Theodore. "Clevenger." *The Columbian,* vol. I, 1844, pp. 10–11.

———. *Italian Sketchbook.* 1848.

Crawford, Thomas

"American Sculptors in Rome." *Bulletin of the American Art-Union,* October 1851, pp. 13–14.

"Art in America." *The Art Journal,* vol. XII, new series vol. II, 1850, p. 295.

Brumbaugh, Thomas B. "The Evolution of Crawford's Washington." *The Virginia Magazine of History and Biography,* vol. LXX, January 1962, pp. 3–29.

"Crawford's *Beethoven.*" *The Crayon,* vol. I, no. 21, May 23, 1855, p. 330.

"Crawford, and His *Washington.*" *Cosmopolitan Art Journal,* vol. I, no. 2, November 1856, p. 46.

"Crawford's *Hebe and Ganymede*; H.K. Brown's *Indian and Panther.*" *The Crayon,* vol. II, no. 6, August 8, 1855, pp. 82–83.

Eliot, S. "Thomas Crawford." *American Quarterly Church Review and Ecclesiastical Register,* vol. XI, April 1858.

"Fine Art Gossip." *Bulletin of the American Art-Union,* vol. II, no. 2, May 1849, pp. 25–26.

Fraser, Mrs. Hugh (Mary Crawford). *A Diplomatist's Wife in Many Lands.* 2 vols. 1910.

Gale, Robert L. *Thomas Crawford, American Sculptor.* 1964.

———. "Thomas Crawford, Dear Lou, and the Horse." *Virginia Magazine of History and Biography,* vol. LXVIII, 1960, pp. 171–192.

Gillespie, William M. *Rome: As Seen by a New-Yorker in 1843–44.* 1845, pp. 182ff.

Greene, George Washington. "Crawford." *Biographical Studies.* 1860.

Hicks, Thomas. *Eulogy of Thomas Crawford.* 1865.
———. *Thomas Crawford; Career, Character, and Works.* 1858.
Hillard, George S. "Thomas Crawford: A Eulogy." *Atlantic,* vol. XXIV, no. CXLI, July 1869, pp. 40–54.
Ingersoll, W. H. "Crawford the Sculptor as Represented in Central Park." *The Aldine,* vol. II, no. 9, August 1869, pp. 87–88.
Launitz, Robert E. "Reminiscences of Thomas Crawford." *The Crayon,* vol. VI, part 1, January 1859, p. 28.
Lester, Charles Edwards. *The Artists of America.* 1846.
Nye, W. A. R. *Historical Account of the Washington Monument in Capitol Square, Richmond.* 1869.
Osgood, Samuel. "Crawford the Sculptor." *Cosmopolitan Art Journal,* vol. III, no. 2, March 1859, p. 59.
Pierce, Edward L. *Memoirs and Letters of Charles Sumner.* 4 vols. 1877.
"Portrait Sculpture." *The Crayon,* vol. II, no. 11, September 12, 1855, p. 165.
Sumner, Charles. "Thomas Crawford's *Orpheus.*" *United States Magazine and Democratic Review,* vol. XII, May 1843, pp. 451–455.
Taliaferro, Robert, ed. *Mr. Hunter's Oration Delivered at the Inauguration of Crawford's Equestrian Statue at Richmond.* 1858.
Tharp, Louise Hall. *Three Saints and a Sinner; Julia Ward Howe, Louise, Annie, and Sam Ward.* 1956.
"Thomas Crawford." *Art Journal,* new series vol. III, XIX, 1857, p. 348. (Obit.)
"Thomas Crawford." *Cosmopolitan Art Journal,* vol. II, no. 1, December 1857, pp. 27–28.
"Thomas Crawford." *Littell's Living Age,* vol. LVI, no. 713, January 23, 1858, pp. 274–280.
Il Tiberino; Giornale Artistico. Rome, February 17, 1840.
Tuckerman, Henry Theodore. "Crawford and Sculpture." *Atlantic Monthly,* vol. II, no. VIII, June 1858, pp. 64–78.
———. "The Funeral of Crawford." Poem. *Cosmopolitan Art Journal,* vol. II, nos. 2 and 3, March and June 1858, p. 146.
Wyatt, Montague Dudley, and J. B. Waring. *The Italian Court in the Crystal Palace.* 1854.
Dexter, Henry
Albee, John. *Henry Dexter, A Memorial.* 1898.
Ezekiel, Sir Moses Jacob
Wrenshall, Katherine H. "An American Sculptor in Rome." *The World's Work,* vol. XIX, November 1909, pp. 12256–12264.
Zebulon, Vance Hooker II. "Moses Jacob Ezekiel: The Formative Years." *Virginia Magazine of History and Biography,* vol. LX, no. 2, 1952, pp. 241–254.
Foley, Margaret
Chatterton, Elsie B. "A Vermont Sculptor." *News and Notes* (Vermont Historical Society), vol. VII, October 1955, pp. 10–14.
Cole, Gertrude S. "Some American Cameo Portraitists." *Antiques,* vol. L, no. 3, September 1946, pp. 170–171.
Howitt, Mary, ed. *An Autobiography.* 2 vols. 1889.
Robinson, Harriet H. *Loom and Spindle.* 1898, pp. 150–154.
Frazee, John
"The Autobiography of John Frazee." *American Collector,* vol. XV, no. 8, September 1946, pp. 15ff; no. 9, October 1946, pp. 10ff.; no. 10, November 1946, pp. 12ff.
Ms. Autobiography in the New Jersey Historical Society.
Caldwell, Henry Bryan. "John Frazee, American Sculptor." Unpublished M. A. thesis. New York University, 1951.
Fuller, Charles F.
"Charles F. Fuller." *The Art Journal,* vol. XXXVII, new series vol. XIV, 1875, p. 178. (Obit.)
Galt, Alexander
Fine Arts Review, vol. I, May–October 1863, p. 215.
O'Neal, William B. "Chiselled Lyrics." *Arts in Virginia,* vol. VII, no. 1, Fall 1966, pp. 4–19.
Richmond Dispatch. January 21, 1863. (Obit.)
Greenough, Horatio
Adams, John Quincy. *Memoirs of John Quincy Adams.* 12 vols. 1874–1877.
Amory, Martha Babcock. *The Wedding Journey of Charles and Martha Babcock Amory.* vol. I, 1922, p. 176.
Beard, James Franklin, ed. *The Letters and Journals of James Fenimore Cooper.* 6 vols. 1968.
Brumbaugh, Thomas. *Horatio and Richard Greenough: A Critical Study with a Catalogue of Their Sculpture.* Unpublished Ph. D. dissertation. Ohio State University, 1955.
Chamberlain, Georgia Stamm. "Horatio Greenough's Proposed Designs for the United States Coinage." *The Art Quarterly,* vol. XXII, no. 3, Autumn 1959, pp. 257–271.
Cooper, Susan. "*The Chanting Cherubs.*" *Putnam's Magazine,* new series vol. V, February 1870, pp. 241–242.
Craven, Wayne. "Horatio Greenough's Statue of Washington and Phidias' Olympian Zeus." *The Art Quarterly,* vol. XXVI, no. 4, Winter 1963, pp. 429–440.
Dana, Richard Henry. *Poems and Prose Writings,* vol. 1, 1833, p. 119.
"Etchings with a Chisel." *United States Magazine and Democratic Review,* vol. XVIII, no. XCII, February 1846, pp. 118–119.
Everett, Alexander. "Greenough's Statue of Washington." *United States Magazine and Democratic Review,* vol. XIV, no. LXXII, June 1844, pp. 618–621.
"Fine Art Gossip." *Bulletin of the American Art-Union,* vol. II, no. 9, December 1849, pp. 21–23.
Fitch, James Marston. "Horatio Greenough and the Art of the Machine Age." *Columbia University Forum,* vol. 2, no. 4, Fall 1959, pp. 20–27.
Greenough, Frances, ed. *Letters of Horatio Greenough to His Brother, Henry Greenough.* 1887.
Greenough, Horatio. *Travels, Observations and Experiences of a Yankee Stonecutter.* Intro. by Nathalia Wright. 1958 (reprint).
"Greenough." *The Art-Union,* vol. I, Febrary 1839.
"Greenough the Sculptor." *Putnam's Magazine,* vol. I, no. 3, March 1853, pp. 317–321.
"Greenough the Sculptor." *Bulletin of the American Art-Union,* May 1851, p. 61.

G. S. H. "Mr. Greenough's New Group of Statuary."
The New-England Magazine, vol. VIII, January
1835, pp. 41–44.

Jewett, Isaac Appleton. *Passages in Foreign Travel*. 2 vols. Vol. II, 1838, p. 296.

J. N. B. "Horatio Greenough." *The Knickerbocker*,
vol. VII, no. 4, April 1836, pp. 343–346.

Memory and Hope. 1851, pp. 1–2.

Metzger, Charles Rein. *Emerson and Greenough,
Transcendental Pioneers of an American Esthetic*. 1954.

Peale, Rembrandt. *Notes on Italy, Written on Tour,
1829–30*. 1831, pp. 242–243.

Quincy, Edmund. *Life of Josiah Quincy of Massachusetts*. 1868.

Salisbury, Edward S. "Two Letters of Horatio
Greenough." *Magazine of American History*, vol.
XVIII, no. 4, October 1887, pp. 330–332.

Stone, William J. "Horatio Greenough's Sculpture
at Washington." *The Crayon*, vol. II, no. 25, December 19, 1855, pp. 392–393.

Trollope, Frances. *A Visit to Italy*, 2 vols. 1842.

Tuckerman, Henry Theodore. *Memorial to Horatio
Greenough*. 1853.

Wright, Nathalia "The Chanting Cherubs, Horatio
Greenough's Marble Group for James Fenimore
Cooper." *New York History*, vol. 38, no. 2, April
1957, pp. 177–197.

———. "Horatio Greenough, Boston Sculptor, and
Robert Gilmor, Jr., His Baltimore Patron."
Maryland Historical Magazine, vol. LI, no. 1,
March 1956, pp. 1–13.

———. *Horatio Greenough, The First American
Sculptor*. 1963.

———. "Richard Henry Wilde on Greenough's
Washington." *American Literature*, vol. XXVII,
1956, pp. 556–557.

Wright, Nathalia, ed. *Letters of Horatio Greenough, American Sculptor*. 1972.

———. "Letters by Horatio Greenough in the Library," *Boston Public Library Quarterly*, vol.
XI, 1959, pp. 82, 85–86.

Wynne, Nancy, and Beaumont Newhall, "Horatio
Greenough, Herald of Functionalism." *Magazine
of Art*, vol. 32, no. 1, January 1939, pp. 12–15.

Greenough, Richard

Brumbaugh, Thomas B. "The Art of Richard
Greenough." *Old-Time New England*, vol. LIII,
no. 3, January–March 1963, pp. 61–78.

———. "Horatio and Richard Greenough: A Critical Study with a Catalogue of Their Sculpture."
Unpublished Ph. D. dissertation. Ohio State University, 1955.

"Franklin and His Statue." *The Crayon*, vol. I., no.
12, March 21, 1855, p. 186.

"Portrait Sculpture." *The Crayon*, vol. II, no. 11,
September 12, 1855, p. 165.

Prescott, William Hickling. *The Correspondence of
William Hickling Prescott, 1833–1847*. 1925, p.
455.

Shurtleff, Nathaniel. *Memorial Inauguration of the
Statue of Franklin*. 1857.

Hart, Joel Tanner

Breckinridge, Issa Desha. *"The Work Shall Praise
the Master" a Memorial to Joel T. Hart, the
Kentucky Sculptor, from the Women of the Blue
Grass*. 1884.

Coleman, J. Winston, Jr. "Joel T. Hart; Kentucky
Sculptor." *Antiques*, vol. LII, no. 5, November
1947, p. 367.

Price, Samuel Woodson. *Old Masters of the Blue
Grass*. 1902, pp. 149–181.

Warfield, Ethelbert Dudley. "Joel T. Hart, the
Kentucky Sculptor." *Magazine of Western History*, vol. II, no. 5, September 1885, pp. 424–433.

Hosmer, Harriet G.

"The Beatrice Cenci." *The Crayon*, vol. IV, part 12,
December 1857, p. 379.

Bidwell, W. H. "Harriet G. Hosmer." *Eclectic Magazine*, vol. LXXVII, new series vol. XIV, August
1871, pp. 245–246.

Bradford, Ruth A. "The Life and Works of Harriet
Hosmer." *New England Magazine*, new series
vol. XLV, no. 2, October 1911, pp. 265–269.

Carr, Cornelia, ed. *Harriet Hosmer, Letters and
Memories*. 1912.

Child, L. Maria. "Miss Harriet Hosmer." *Littell's
Living Age*, vol. LVI, no. 720, March 13, 1858,
pp. 697–698.

"Harriet Hosmer." *Cosmopolitan Art Journal*, vol.
III, no. 5, December 1859, pp. 214–217.

"Miss Hosmer's Statue of Zenobia." *The New Path*,
vol. II, no. 4, April 1865, pp. 49–53.

"The Process of Sculpture." *Atlantic Monthly*, vol.
XIV, no. 86, December 1864, pp. 734–737.

"Puck." *The Art Journal*, vol. XXXVII, new series
vol. XIV, 1875, p. 312.

Thurston, Reverend R. B. "Harriet Hosmer." *Eminent Women of the Age*. 1869, pp. 566–598.

Van Rensselaer, Susan. "Harriet Hosmer." *Antiques*, vol. LXXXIV, no. 4, October 1963, pp.
424–428.

Ives, Chauncey B.

*Catalogue of Important Sculptures by the Late
C. B. Ives*. American Art Galleries, New York.
1899.

"Chauncey B. Ives." *Cosmopolitan Art Journal*,
vol. IV, no. 4, December 1860, p. 163.

Gerdts, William H. "Chauncey Bradley Ives, American Sculptor." *Antiques*, vol. XCIV, no. 5, November 1968, pp. 714–718.

Lander, Louisa

Belknap, Henry W. *Artists and Craftsmen of Essex
County, Massachusetts*. 1927.

Cosmopolitan Art Journal, vol. IV, no. 1, March
1860, p. 31.

"Editor's Easy Chair." *Harper's New Monthly
Magazine*, vol. XX, no. 70, May 1860, pp. 845–847.

Powell, William S. *Paradise Preserved*. 1865, pp.
59–61.

Sharf, Frederic A. "'A More Embracing Atmosphere,' Artistic Life in Salem, 1850–1859."
Essex Institute Historical Collections, vol. XCV,
1959, pp. 160–162.

Launitz, Robert

Bartlett, Trumann H. "Early Settlers' Memorials
—XI and XII." *The American Architect and
Building News*, vol. XXII, no. 606, August 6,
1887, pp. 59–61; vol. XXII, no. 610, September 3,
1887, pp. 107–109.

Prang, Louis, and Company, Publishers. Collection
of Monuments and Head Stones Designed by
R. E. Launitz, 1860.

Lewis, Edmonia
 The Aldine, vol. II, no. 8, August 1869, p. 76.
 Blodgett, Gregory. "John Mercer Langston and the Case of Edmonia Lewis: Oberlin, 1862." *The Journal of Negro History,* vol. LIII, no. 3, July 1968, pp. 201–218.
 Brown, William Wells. *The Rising Sun.* 1874, pp. 465–468.
 Bullard, Laura C. "Edmonia Lewis." *The Revolution,* April 20, 1871.
 Dannett, Sylvia G. L. "Mary Edmonia Lewis 1846–1890, the First American Negro to Achieve Recognition in the Field of Sculpture." *Profiles of Negro Womanhood,* vol. I, 1965, pp. 118–123.
 Dover, Cedric. *American Negro Art.* 1960.
 "The Evolution of Afro-American Artists: 1800–1950." Catalogue of exhibition, October 16–November 5, 1967. The City University of New York.
 The Freedman's Record, vol. II, no. 4, 1866, p. 67.
 Freeman, Murray. *Emancipation and the Freed in American Sculpture.* 1916.
 Gerdts, William H. Essay in catalogue of the exhibition "Ten Afro-American Artists of the Nineteenth Century," February 3–March 30, 1967. The Gallery of Art, Howard University.
 Hanaford, Phebe. *Daughters of America.* 1882.
 H. W. "A Negro Sculptress." *The Athenaeum,* no. 2001, March 3, 1866, p. 302.
 Locke, Alain. *Negro Art Past and Present.* 1936.
 Majors, M. A. *Noted Negro Women and Their Triumphs.* 1893, p. 27.
 Montesano, Philip M. "The Mystery of the San Jose Statues." *Urban West,* vol. I, no. 4, March–April 1968, pp. 25–27.
 The Negro History Bulletin, vol. II, no. 6, March 1939, p. 51.
 New National Era, vol. II, no. 17, May 4, 1871, p. 1.
 Porter, James A. "Versatile Interests of Early Negro Artists: A Neglected Chapter of American Art History." *Art in America,* vol. XXIV, January 1936, pp. 16–27.
 Progressive American Coloured Weekly. September 28, 1876.
 Wyman, Lillian Buffum and Arthur C. *Elizabeth Buffum Chase, 1806–1899, Her Life and Its Environment.* 1911.
McIntire, Samuel
 Kimball, Sidney Fiske. *Mr. Samuel McIntire, Carver, the Architect of Salem.* 1940.
Mead, Larkin G.
 Sartain, John. *Reminiscences of a Very Old Man, 1808–1897.* 1899, pp. 237–240.
Mills, Clark
 Hopkins, Rosemary. "Clark Mills: The First Native American Sculptor." Unpublished M. A. thesis. University of Maryland, 1966.
 Rutledge, Anna Wells. "Cogdell and Mills, Charleston Sculptors." *Antiques,* vol. XLI, no. 3, March 1942, pp. 192–193, 205–207.
Mozier, Joseph
 The Art Journal, vol. XXXIII, new series vol. X, 1871, p. 6.
 Picture file in the Art Room of the New York Public Library.
 Scheirr, Rodman. "Joseph Mozier and His Handiwork." *Potter's American Monthly,* vol. VI, January 1876, pp. 24–28.

Palmer, Erastus Dow
 Bigelow, L. J. "Palmer, the American Sculptor." *Continental Monthly,* vol. V, February 1864, pp. 258–264.
 "Fine Art Gossip." *Bulletin of the American Art-Union,* vol. II, no. 9, December 1849, pp. 20–21.
 Ingram, Charles. "Erastus Dow Palmer, a Great American Sculptor." *Americana,* vol. XXIV, 1930, pp. 7–21.
 "Masters of Art and Literature, Erastus D. Palmer." *Cosmopolitan Art Journal,* vol. I, no. 2, November 1856, pp. 47–48.
 "Palmer's Marbles." "Editor's Easy Chair." *Harper's New Monthly Magazine,* vol. XIV, no. 81, February 1857, pp. 414–415.
 "Palmer, the Sculptor." *The New Path,* no. 3, July 1863, pp. 25–30.
 Palmer, Erastus Dow. "Philosophy of the Ideal." *The Crayon,* vol. III, part 1, January 1856, pp. 18–20.
 The Palmer Marbles. 1856.
 "The Palmer Marbles." *Cosmopolitan Art Journal,* vol. I, no. 3, March 1857, p. 85.
 "Palmer's *White Captive.*" *Atlantic Monthly,* vol. V, no. 27, January 1860, pp. 108–109.
 Richardson, H. E. "Erastus Dow Palmer, American Craftsman and Sculptor." *New York History,* vol. XXVIII, 1868, pp. 324–340.
 "The Sculptor Palmer." *Cosmopolitan Art Journal,* vol. II, nos. 2 and 3, March and June 1868, p. 141.
 Webster, J. Carson. "A Check List of the Works of Erastus D. Palmer." *The Art Bulletin,* vol. XLIX, June 1967, pp. 143–151.
Persico, E. Luigi
 "Persico's Columbus." *United States Magazine and Democratic Review,* vol. 15, no. LXXIII, July 1844, pp. 95–97.
 Hensel, W. U. "An Italian Artist in Old Lancaster." Papers read before the Lancaster County Historical Society, XVI, 1912, pp. 67–107.
Pettrich, Ferdinand
 Chamberlain, Georgia Stamm, "Ferdinand Pettrich, Sculptor of the President Tyler Indian Peace Medal." *The Numismatist,* vol. LXX, no. 4, April 1957, pp. 387–390.
 ———. "Pettrich, the Sculptor of Washington, Clay and Poinsett." *Antiques Journal,* February 1955.
 Geller, Hans. *Franz und Ferdinand Pettrich.* 1955.
Powers, Hiram
 Akers, Benjamin Paul. "Our Artists in Italy: Hiram Powers." *Atlantic Monthly,* vol. V, no. 27, January 1860, pp. 1–6.
 "The 'America' of Hiram Powers." *Cosmopolitan Art Journal,* vol. I, No. 2, November 1856, pp. 55–56.
 "American Art." *The Illustrated Magazine of Art,* vol. III, 1854, pp. 211–216.
 "Art in America." *The Art Journal,* vol. XIII, new series vol. III, 1851, p. 147.
 The Art Journal, vol. XXXV, new series vol. XII, 1873, p. 231. (Obit.)
 Atlee, Y. Samuel. "Hiram Powers." *Littell's Living Age,* vol. XLII, no. 539, 1854, p. 569.
 Bellows, Henry W. "Seven Sittings with Powers the Sculptor." *Appleton's Journal,* vol. I, 1869, pp. 342–343, 359–361, 402–404, 470–471, 595–597;

vol. II, 1870, pp. 54–55, 106–108.

Bethune, G. W. *The Home Book of the Picturesque: Or, American Scenery, Art, and Literature.* 1852, pp. 185ff.

Boynton, Henry. "Hiram Powers." *New England Magazine,* new series vol. XX, no. 5, July 1899, pp. 519–533.

Calvert, George H. "The Process of Sculpture; The Greek Slave." *The Literary World,* vol. II, no. 33, September 18, 1847, pp. 159–160.

Catalogue of the Manchester Art Treasures Exhibition. 1857.

Chambrun, Clara. *The Making of Nicholas Longworth.* 1933.

Cohen, Merrie Conoway. "His Columbian Friends Helped Sculptor Rise to Fame." *The Columbia Record,* Columbia, South Carolina, August 12, 1948.

"Concerning Hiram Powers' Statue of Washington" *Louisiana Historical Quarterly,* vol. 2, no. 3, July 1919, pp. 272–275.

Connolly, Louise. *Hiram Powers the Sculptor.* The Newark Museum, Newark, New Jersey, 1926.

Dentler, Clara Louise. "White Marble: The Life and Letters of Hiram Powers, Sculptor." Unpublished manuscript in the collection of The National Collection of Fine Arts.

Everett, Edward. *A Defense of Powers' Statue of Webster.* 1859.

———. "Hiram Powers the Sculptor." *Littell's Living Age,* vol. XV, no. 179, 1847, pp. 97–100.

Exhibition of Paintings by Joseph Oriel Eaton and Sculpture by Hiram Powers. Cincinnati Museum of Art. 1934.

"Fine Art Gossip." *Bulletin of the American Art-Union,* vol. II, no. 9, December 1849, pp. 21–23.

Gardner, Albert TenEyck. "Hiram Powers and the Hero." *The Metropolitan Museum of Art Bulletin,* new series vol. II, no. 2, October 1943, pp. 102–108.

———. "Hiram Powers and William Rimmer, Two 19th Century American Sculptors." *The Magazine of Art,* vol. XXXVI, February 1943, pp. 42–47.

———. "A Relic of the California Gold Rush." *The Metropolitan Museum of Art Bulletin,* new series vol. VIII, no. 4, December 1949, pp. 117–122.

"Genius and *The Greek Slave.*" *The Crayon,* vol. IV, part 8, September 1857, p. 266.

"The Greek Slave." *The Art Journal,* vol. XII, new series vol. II, 1850, p. 56.

"The Greek Slave." *Cosmopolitan Art Journal,* vol. II, no. 1, December 1857, p. 40.

"The Greek Slave by Powers." *The Art-Union,* vol. VII, June 1845.

Hawthorne, Nathaniel. "The Studio of Hiram Powers." *Every Saturday,* vol. XI, 1871.

"Hiram Powers." *Eclectic Magazine,* vol. LXXI, new series vol. VIII, August 1868, pp. 1028–1029.

The Home Book of the Picturesque: or, American Scenery, Art, and Literature. Essay by G. W. Bethune. 1852, pp. 185ff.

Jarves, James Jackson. "Hiram Powers and His Works, Pen-Likenesses of Art-Critics and Artists." *The Art Journal,* vol. XXXVI, new series vol. XIII, 1874, pp. 37–39.

Kellogg, Miner K. *Justice to Hiram Powers.* 1848.

———. *Mr. Miner K. Kellogg to His Friends.* 1858.

Lester, Charles Edwards. *The Artist, the Merchant, and the Statesman of the Age of the Medici and of Our Own Time.* 2 vols. 1845, pp. 56ff.

———. "The Genius and Sculpture of Hiram Powers." *American Whig Review,* vol. II, 1845, pp. 199–204.

Lewis, E. Anna. "Art and Artists of America: Hiram Powers." *Graham's Magazine,* vol. XLVI, no. 11, November 1855, pp. 397–401.

Lockett, Annie Hoge. "Hiram Powers: Clockmaker's Apprentice." *Bulletin of the Historical and Philosophical Society of Ohio,* vol. 12, no. 4, October 1954, pp. 282–292.

"Powers and Clevenger." *Bulletin of the American Art-Union,* July 1850, p. 65.

Powers, Ellen Lemmi. "Reminiscences of My Father." *The Vermonter,* vol. XII, no. 2, February 1907, pp. 46–51; no. 3, March 1907, pp. 72–85.

Powers, Hiram. "Letters of Hiram Powers to Nicholas Longworth." *Historical and Philosophical Society of Ohio, Quarterly Publication,* vol. I, 1906.

———. "Perception of Likeness." *The Crayon,* vol. I, no. 15, April 11, 1855, pp. 229–230.

———. "Powers on Color in Sculpture." *The Crayon,* vol. I, no. 10, March 7, 1855, p. 149.

Preston, William C. *Reminiscences.* Edited by Minnie Clare. Yarborough. 1933.

Roberson, Samuel A., and William H. Gerdts. "*The Greek Slave.*" *The Museum,* new series vol. XVII, nos. 1 and 2, Winter–Spring 1965, pp. 1–32. The Newark Museum, Newark, New Jersey.

Robinson, C.S. "A Morning with Hiram Powers." *Hours at Home,* vol. VI, no. 1, November 1867, pp. 32–37.

Simmons, Robert H. "A Yankee Stonecutter in Florence." *Falmouth Enterprise,* Falmouth, Massachusetts, May 24, 1968, pp. 6–7.

Stevens, Reverend A. "Powers, the Sculptor." *The Ladies' Repository, and Gatherings of the West,* vol. VIII, November 1848, pp. 322–327.

Sylvan, Frances. "Work of Hiram Powers Still Adorns Columbia Places." *The State,* Columbia, South Carolina, April 7, 1940.

T., B. B. "Sketch of a Selfmade Sculptor." *The Knickerbocker,* vol. V, no. 4, April 1835, pp. 270–276.

Trollope, Thomas Adolphus. "Recollections of Hiram Powers When a Youth." *The New York Times,* January 24, 1878.

———. "Some Recollections of Hiram Powers." *Lippincott's Magazine of Popular Literature and Science,* vol. XV, February 1875, pp. 205–215.

Ward, Samuel G. "Powers' Greek Slave," *Massachusetts Quarterly Review,* vol. 1, no. 1, December 1847, pp. 54–62.

Quiner, Joanna

Hanaford, Phebe A. "Joanna Quiner." *Essex Institute Historical Collections,* vol. XII, January 1874, pp. 35–45.

Ream, Vinnie

Ames, Mary Clemmer. *The Independent,* New York City, February 16, 1871.

"Art in Arkansas—Sculpture." *Arkansas Historical Quarterly,* Winter 1944, p. 324.

Baker, Isadore. "The Ream Statue of Farragut."

Carter's Monthly, vol. XV, May 1899, pp. 405–410.

———. "Vinnie Ream Hoxie: Her Statue of Lincoln and Other Works." *The Midland Monthly*, vol. VIII, November 1897, pp. 405ff.

Brandes, Georg Morris Cohen. *Recollections of My Childhood and Youth*. 1906.

Il Buonarroti. Rome, February 1870.

Haefner, Marie. "From Plastic Clay." *The Palimpsest*, vol. XI, no. 11, November 1930, pp. 473–482.

Hall, Gordon Langley. *Vinnie Ream, the Story of the Girl Who Sculptured Lincoln*. 1963.

Hoxie, Richard L. *Vinnie Ream*. 1908.

Hoxie, Vinnie Ream. "Lincoln and Farragut." *The Congress of Women, Held in the Woman's Building, World's Columbian Exposition, Chicago, U.S.A., 1893.* Ed. by Mary Kavanaugh Oldham Eagle. 1894.

Rinehart, William Henry

Brumbaugh, Thomas B. "A Recently Discovered Letter of William Henry Rinehart." *The Journal of the Walters Art Gallery*, vol. XXXIII–XXXIV, 1970–1971, pp. 53–57.

Ross, Marvin C., and Anna W. Rutledge. *William Henry Rinehart, Maryland Sculptor*. 1948.

Ross, Marvin C., and Anna W. Rutledge, eds. "William H. Rinehart's Letters to Frank B. Mayer 1856–1870." *Maryland Historical Magazine*, vol. XLIII, no. 2, June 1948, and vol. XLIV, no. 1, March 1949.

Rusk, William Sener. "New Rinehart Letters." *Maryland Historical Magazine*, vol. XXXI, no. 3, November 3, 1936, pp. 225–242.

———. "Notes on the Life of William Henry Rinehart, Sculptor." *Maryland Historical Magazine*, vol. XIX, no. 4, 1924.

———. "Rinehart's Works." *Maryland Historical Magazine*, vol. XX, no. 4, December 1925, pp. 380–383.

———. *William Henry Rinehart, Sculptor*. 1939.

Rogers, John

Smith, Chetwood, and Mary Smith. *Rogers Groups, Thought and Wrought by John Rogers*. 1934.

Wallace, David H. *John Rogers, the People's Sculptor*. 1967.

Rogers, Randolph

DePuy, E. Cora. "Randolph Rogers, Reminiscences of the Great Sculptor." *Detroit Sunday and News-Tribune*, February 17, 1895.

D'Ooge, Martin. *Catalogue of the Gallery of Art and Archaeology of the University of Michigan*. 1892.

Dunning, W. H. "Randolph Rogers, a Glimpse of His Life in New York City." *Detroit News-Tribune*, February 24, 1895.

Frieze, Henry S. "Randolph Rogers." *Michigan Alumnus*, vol. IV, December 1897, pp. 59–63.

Rogers, Millard F., Jr. "The Michigan Soldiers' and Sailors' Monument and Its Sculptor, Randolph Rogers." *Michigan History*, vol. XLII, June 1958, pp. 237–244.

———. "Nydia, Popular Victorian Image." *Antiques*, vol. XCVII, no. 3, March 1970, pp. 374–377.

———. *Randolph Rogers, American Sculptor in Rome*. 1971.

———. "Randolph Rogers and the University of Michigan." *Michigan Alumnus Quarterly Review*, Winter 1958, pp. 169–175.

"Randolph Rogers' Early Career." *Boston Transcript*, n.d. Clipping in American Antiquarian Society, Worcester, Massachusetts.

"Randolph Rogers, the Sculptor." *Public Opinion*, vol. XII, February 6, 1892, p. 465.

Rogers, Rosa G. *Biography of Randolph Rogers*. Unpublished manuscript in Michigan Historical Collections, Ann Arbor, Michigan.

"Rome." *The Crayon*, vol. VI, part 6, June 1859, pp. 183–185.

"The Sculptor of the Doors of the Capitol." *Harper's Weekly*, vol. XXXVI, January 30, 1892, p. 116.

Rush, William

Marceau, Henri. *William Rush, 1756–1833, the First Native American Sculptor*. 1937.

Saint-Gaudens, Augustus

Cortissoz, Royal. *Augustus Saint-Gaudens*. 1907.

Cox, Kenyon. "Augustus Saint-Gaudens." *Century Magazine*, vol. XXXV, November 1887, pp. 28–37.

Saint-Gaudens, Homer, ed. *The Reminiscences of Augustus Saint-Gaudens*. 2 vols. 1913.

Tharp, Louise Hall. *Saint-Gaudens and the Gilded Age*. 1969.

Simmons, Franklin

Burrage, Henry. "Franklin Simmons, Sculptor." *Maine Historical Memorials*, 1922, pp. 109–147.

Cammett, Stephen. "Franklin Simmons, a Maine-Born Sculptor." *Pine Tree Magazine*, vol. VIII, August 1907, pp. 92–96.

Heffernan, John Paul. *The New England Galaxy*, Winter 1966, pp. 26ff.

"Jochebed." *The Art Journal*, vol. XXXV, new series vol. XII, 1873, p. 304.

Whiting, Lilian. "'A Veteran Sculptor." *Outlook*, vol. XCVIII, May 27, 1911, pp. 213–215.

Stebbins, Emma

The Aldine, vol. VI, no. 10, October 1873, p. 207.

Stebbins, Emma. *Charlotte Cushman: Her Letters and Memories of Her Life*. 1879.

Stone, Horatio

Morris, Martha. *Horatio Stone (1801–1875), Nineteenth Century American Sculptor*. Unpublished M. A. thesis. George Washington University, February 1969.

Nealy, Mary E. "Art at the Capital." *Forney's Sunday Chronicle*, December 5, 1875.

Story, William Wetmore

"American Artists and American Art, part V: William Wetmore Story." *American Magazine of Art*, vol. II, 1879.

The Art Journal, vol. XXXVI, new series vol. XIII, 1874, p. 223.

The Art Journal, vol. XLI, new series vol. XVIII, 1879, p. 142.

"Editor's Easy Chair: Healy's Charges Against Story." *Harper's New Monthly Magazine*, vol. XLIX, no. 242, September 1874, pp. 587–588.

"Editor's Easy Chair: William W. Story." *Harper's New Monthly Magazine*, vol. XXVII, no. 27, June 1863, p. 133; no. 30, September 1863, pp. 566–567.

Hudson, Gertrude Reese, ed. *Browning to His American Friends*. 1965.

Gardner, Albert TenEyck. "William Story and Cleopatra." *The Metropolitan Museum of Art*

Bulletin, new series vol. II, no. 4, December 1943, pp. 147–152.

James, Henry. *William Wetmore Story and His Friends*. 2 vols. 1903.

· *"Jerusalem in Her Desolation." The Art Journal*, vol. XXXV, new series vol. XII, 1873, p. 255.

Phillips, Mary E. *Reminiscences of William Wetmore Story*. 1897.

"Portrait Sculpture." *The Crayon*, vol. II, no. 11, September 12, 1855, p. 165.

Story, William Wetmore. *Conversations in the Studio*. 2 vols. 1890.

———. *Excursions in Art and Literature*. 1891.

———. *Graffiti d'Italia*. 1868.

———. *Roba di Roma*. 2 vols. 1894.

Wallace, Mrs. Lew. "William Wetmore Story; a Memory." *Cosmopolitan Magazine*, vol. XXI, September 1896, pp. 464–472.

Thom, James

"The Group of Tam O'Shanter." *New England Magazine*, vol. 5, September 1833, pp. 243–246.

Warbourg, Eugene

Desdunes, Rodolf. *Nos Hommes et Notre Histoire, Notices Biographiques Accompagnées de Réflexions et de Souvenirs Personnels*. 1911, pp. 95–98.

Field, Maunsell B. *Memories of Many Men and Some Women*. 1874, pp. 138–140.

Porter, James A. Essay in catalogue of the exhibition "Ten Afro-American Artists of the Nineteenth Century," February 3–March 30, 1967. The Gallery of Art, Howard University.

Whitney, Anne

Livermore, Mary A. "Anne Whitney." *Our Famous Women*. 1888.

Payne, Elizabeth Rogers. "Anne Whitney, Art and Social Justice." *The Massachusetts Review*, Spring 1971.

———. "Anne Whitney, Sculptor." *Art Quarterly*, vol. XXV, no. 3, Autumn 1962, pp. 244–261.

Spofford, Harriet. *A Little Book of Friends*. 1916.

Whitney, Anne. *Poems*. 1859.

Willard, Frances E., and Mary Livermore. *A Woman of the Century*. 1893.

Wright, Joseph

Kimball, Sidney Fiske. "Joseph Wright and His Portraits of Washington." *Antiques*, vol. XV, May 1929, pp. 376–382; vol. XVII, January 1930, pp. 35–39.

Wright, Patience

Hart, Charles H. "Patience Wright, Modeller in Wax." *Connoisseur*, vol. XIX, September 1907, pp. 18–22.

Lesley, Everett Parker, "Patience Lovell Wright, America's First Sculptor." *Art in America*, vol. XXIV, October 1936, pp. 148–154, 157.

Part III

Allen, Harriet Trowbridge. *Travels in Europe and the East; During the Years 1858–59 and 1863–64*. 1879.

Allen, Henry Watkins. *The Travels of a Sugar Planter, or, Six Months in Europe*. 1861.

Armstrong, D. M. *Day before Yesterday*. 1920.

Bellows, Henry W. *The Old World in Its New Face, Impressions of Europe in 1867–1868*. 2 vols. 1868–1869.

Benedict, Erastus Cornelius. *A Run Through Europe*. 1860.

Blewitt, Octavian. *A Hand-book for Travelers in Central Italy*. 1850.

Bronson, Charlotte Brinckerhoff. *The Letters of Charlotte Brinckerhoff Bronson, Written during Her Wedding Journey in Europe in 1838*. 4 vols. 1928.

Bruen, Matthias. *Essays, Descriptive and Moral; on Scenes in Italy, Switzerland, and France*. 1823.

Bryant, William Cullen. *Letters of a Traveller, or Notes of Things Seen in Europe and America*. 1850.

Bullard, Anne T. J. *Sights and Scenes in Europe; a Series of Letters from England, France, Germany, Switzerland, and Italy in 1850*. 1852.

Calvert, George Henry. *Scenes and Thoughts of Europe*. 1855.

Channing, Walter. *A Physician's Vacation; or, a Summer in Europe*. 1856.

Clarke, James Freeman. *Eleven Weeks in Europe; and What May Be Seen in That Time*. 1852.

Colman, Henry. *European Life and Manners; in Familiar Letters to Friends*. 2 vols. 1849.

Corson, John W. *Loiterings in Europe; or Sketches of Travel in France, Belgium, Switzerland, Italy, Austria, Prussia, Great Britain, and Ireland*. 1848.

Cox, Samuel Sullivan. *A Buckeye Abroad; or Wanderings in Europe and in the Orient*. 1852.

Crowninshield, Clara. *The Diary of Clara Crowninshield, A European Tour with Longfellow, 1835–1836*; ed. by Andrew Hilen. 1956.

Dana, William Coombs. *A Transatlantic Tour*. 1845.

De Forest, John W. *European Acquaintance: Being Sketches of People in Europe*. 1858.

Derby, Elias Hasket. *Two Months Abroad; or, a Trip to England, France, Baden, Prussia, and Belgium in August and September 1843*. 1844.

Dodge, Robert. *Diary, Sketches and Reviews, During an European Tour in the Year 1847*. 1850.

Eames, Jane Anthony. *A Budget of Letters, or Things which I Saw Abroad*. 1847.

Eddy, Daniel Clarke. *Europa; or, Scenes and Society in England, France, Italy, and Switzerland*. 1861.

Felton, Cornelius Conway. *Familiar Letters from Europe*. 1865.

Fisk, Wilbur. *Travels in Europe*. 1839.

Fiske, Samuel Wheelock. *Mr. Dunn Browne's Experiences in Foreign Parts*. 1857.

Forbes, S. Russell. *Rambles in Rome, Season 1872–3*. 1872.

Forney, John W. *A Centennial Commissioner in Europe, 1874–6*. 1876.

Fraser, Mrs. Hugh. *A Diplomatist's Wife in Many Lands*. 2 vols. 1910.

Fuller, Hiram. *Sparks from a Locomotive; Or, Life and Liberty in Europe*. 1859.

Furniss, William. *The Land of the Casear and Doge*. 1853.

Gillespie, William Mitchell. *Rome as Seen by a New Yorker in 1843–1844*. 1845.

Goodrich, Samuel Griswold. *Recollections of a Lifetime, or Men and Things I Have Seen*. 2 vols. 1856.

Gould, William M. *Zephyrs from Italy and Sicily*. 1852.

Greeley, Horace. *Glances at Europe*. 1851.

Greenwood, Grace. *Haps and Mishaps on a Tour in Europe*. 1854.

Hale, Edward Everett. *Ninety Days' Worth of Europe.* 1861.

Hawthorne, Nathaniel. *Passages from the French and Italian Note-Books.* 2 vols. 1871.

Hawthorne, Sophia. *Notes in England and Italy.* 1869.

Headley, Joel T. *Letters from Italy.* 1846.

Hillard, George. *Six Months in Italy.* 2 vols. 1853.

Hopkins, James Herron. *European Letters to the Pittsburgh Post 1869–70.* 1870.

Horwitz, Orville. *Brushwood, Picked up on the Continent, or, Last Summer's Trip to the Old World.* 1855.

Howe, Julia Ward. *From the Oak to the Olive; a Plain Record of a Pleasant Journey.* 1868.

Howells, William Dean. *Italian Journeys.* 1867.

Huidekoper, Alfred. *Glimpses of Europe in 1851 and 1867–8.* 1882.

Jarves, James Jackson. *Italian Sights and Papal Principles, Seen through American Spectacles.* 1856.

Kirkland, Caroline. *Holidays Abroad; Or, Europe from the West.* 2 vols. 1849.

Latrobe, John H. B. *Hints for Six Months in Europe in the Summer of 1868.* 1869.

Lester, Charles Edward. *Glances at the Metropolis.* 1854.

Le Vert, Octavia Walton. *Souvenirs of Travel.* 2 vols. 1857.

McCormick, Richard C. *St. Paul's to St. Sophia, or, Sketchings in Europe.* 1860.

McFarland, Andrew. *The Escape, or Loiterings amid the Scenes of Story and Song.* 1851.

MacGavock, Randal W. *A Tennessean Abroad or Letters from Europe, Africa, and Asia.* 1854.

Maney, Henry. *Memories over the Water, or Stray Thoughts on a Long Stroll.* 1854.

Melville, Herman. *Journal of a Visit to Europe and the Levant, October 11, 1856–May 6, 1857.* Ed. by Howard C. Horsford. 1955.

A Memphian's Trip to Europe with Cook's Educational Party. 1874.

Mott, Valentine. *Travels in Europe and the East.* 1845.

Moulton, Louise Chandler. *Lazy Tours in Spain and Elsewhere.* 1898.

Old Sights with New Eyes. 1854.

Osgood, Samuel. *Letters to the New York Evening Post Written at Home and Abroad.* 2 vols. 1889.

Ossoli, Margaret Fuller. *At Home and Abroad, or Things and Thoughts in America and Europe.* 1856.

Peake, Elizabeth. *Pen Pictures of Europe.* 1874.

Putnam, George Palmer. *A Pocket Memorandum Book during a Ten Weeks' Trip to Italy and Germany in 1847.* 1848.

The Rambles and Reveries of an Art-Student in Europe. 1855.

Richards, F. de Bourg. *Random Sketches; Or, What I Saw in Europe, from the Portfolio of an Artist.* 1857.

Sedgwick, Catherine Maria. *Letters from Abroad to Kindred at Home.* 2 vols. 1841.

Smith, Amy Grinnell, and Mary Ermina Smith. *Letters from Europe, 1865–1866.* Ed. by David Sanders Clark. 1948.

Stowe, Harriet Beecher. *Sunny Memories of Foreign Lands.* 2 vols. 1854.

Tappen, Henry P. *A Step from the New World to the Old, and Back Again.* 2 vols. 1852.

Taylor, Bayard. *Views A-Foot; or, Europe Seen with Knapsack and Staff.* 1850.

Taylor, William Henry. *The Book of Travels of a Doctor of Physic.* 1871.

Tousey, Sinclair. *Papers from over the Water, or a Series of Letters from Europe.* 1869.

Wallace, Horace Binney. *Art and Scenery in Europe, with Other Papers.* 1857.

Ware, William. *Sketches of European Capitols.* 1851.

Washington, E. K. *Echoes of Europe, or Word Pictures of Travel.* 1860.

Weed, Thurlow. *Letters from Europe and the West Indies.* 1866.

Willis, Nathaniel Parker. *Pencillings by the Way: Written during Some Years of Residence and Travel in Europe.* 1852.

Witmer, Theodore B. *Wild Oats, Sown Abroad, Or, On and Off Soundings.* 1853.

Wood, Jacob B. *Notes on Foreign Travel.* 1852.

Young, Josephine. *Journals of Josephine Young.* 1915.

Young, Samuel. *A Wall-Street Bear in Europe.* 1855.